The Art and Life of
Lucas Johnson

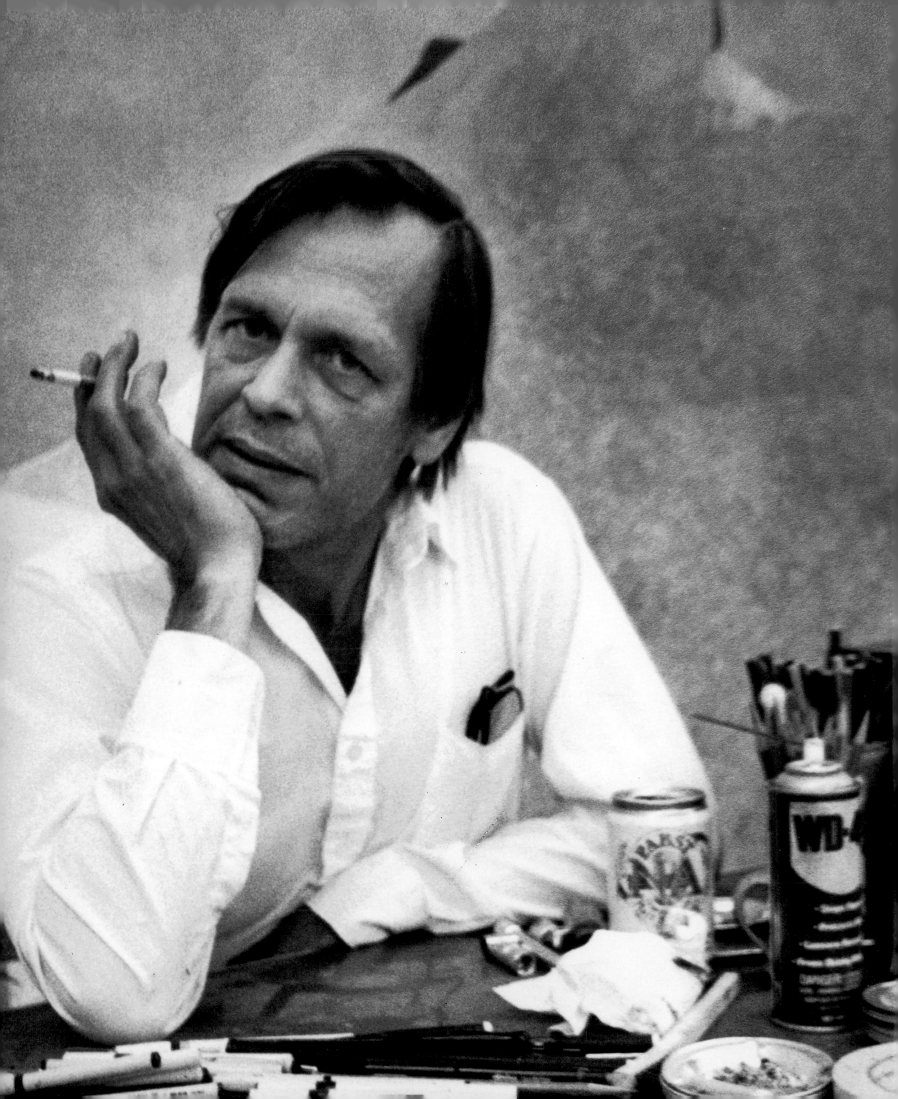

The Art and Life of
Lucas Johnson

Preface by

Walter Hopps

Essay by

Edmund P. Pillsbury

Chronology by

Patricia Covo Johnson

HOUSTON ARTISTS' FUND

Distributed by

UNIVERSITY OF TEXAS PRESS · AUSTIN

The Art and Life of Lucas Johnson is published by the Houston Artists Fund and is made possible by the generous support of the artists and patrons whose names appear on pages 8 and 9.

Cover: *Red Table* (detail), 1999 *(see page 83)*

Frontispiece: Lucas Johnson in his Columbia Street studio, Houston, April 1994

Distributed by
University of Texas Press
Orders and Customer Service
Box 7819
Austin, Texas 78713-7819
Phone orders in the U.S.: 1-800-252-3206
Fax orders in the U.S.: 1-800-687-6046
Fax orders outside the U.S.: 1-512-232-7178
www.utexaspress.com

ISBN 0-9674395-2-3

Library of Congress Control Number: 2005935350

Editor: Polly Koch, Houston
Design: Don Quaintance, Public Address Design, Houston
Design/production assistant: Elizabeth Frizzell
Photography of artworks: George Hixson, Houston, and Rick Gardner, Houston
 (unless otherwise noted)
Color separations, duotones, printing, and binding: Conti Tipocolor, Florence, Italy

CONTENTS

DONORS

The following artists donated works of art to a benefit that provided substantial funding for this publication. The Houston Artists Fund wishes to express its profound thanks for their generosity.

Terry Allen

Dan Allison

Art Guys (Michael Galbreth and Jack Massing)

John Berry

Derek Boshier

Mel Chin

Penny Cerling

Virgil Grotfeldt

Joseph Havel

Robert Helm

Benito Huerta

Terrell James

Luis Jiménez

Nancy Reddin Kienholz

Sharon Kopriva

Annabel Livermore

Chris Lesikar

Joe Mancuso

Colleen McNutt

MANUAL (Ed Hill and Suzanne Bloom)

Suzanne Paul

Al Souza

Gael Stack

Bill Steffy

William Steen

Richard Stout

James Surls

Ed Wilson

Dee Wolff

Troy Woods

This publication has been generously supported by numerous friends, associates, and patrons of the artist. The Houston Artists Fund gratefully acknowledges these individuals and institutions.

Jack and Jan Cato
Roy and Mary Cullen
Houston Endowment Inc.
William Hill Land & Cattle Co.

Thomas and Martha Armstrong
Karen Bryant
Mario Covo
Mary Feeley
Lynn Goode and Tim Crowley
Dana Roy Harper
Houston Chronicle
Richard Moiel and Kathy Poeppel
Marilyn Oshman
Bill Sadler
Stanford and Joan Alexander Foundation
James and Salle Vaughan

Anonymous, from benefit event

Bruno Andrade and Kathy Feeken
Melvin and Rosalind Avedon
Michael and Lydia Balahutrak
Sarah Balinskas
Erik and Suzanne Banning
Jorge and Cara Barer
Gertrude Barnstone
Ann and Dr. Bengt O. S. Bengtson
Booker-Lowe Gallery
Judy Breitenbach
Peter Hoyt Brown
John Bryant
J. Paul and Claire Burney
Patrick Burns and Elizabeth McMahon
Gracie and Robert Cavnar
Bobby Smith Cohn
Michael and Gayle Collins
Alice Cook
Edward Cooper
Caroline Crystal and William Wilkins
Jeremy and Helen Davis
Gayle and Mike DeGeurin
Mary T. de Marigny
Estelle Stair Gallery
Rosario Ferre
Ira and Phyllis Flax
Ronald and Eva Garcia
Clara Kilgore Gilchrist
Dewitt Godfrey and Monica Burczyk
Helaine Gordon
Julia Louise Greer
Joseph Havel and Lisa Ludwig
Kim Hein
Mikael Henderson and Gay Massengill
William and Lynn Herbert
Dorene Herzog
Edward Hill and Suzanne Bloom

Artie Lee Hinds
Ann N. Holmes
Caroline Huber
Jack Meier Gallery
Barbara Jones and Wm. Patrick Southard
Nancy Reddin Kienholz
Emilie Kilgore
Klein Foundation
Koelsch Gallery
Gustav and Sharon Kopriva
Marshal and Victoria Lightman
Jane Lowery
Dean Luse and La Rue Green
Michael Manjarris
Clyde Mason Jr. and Claudia Feldman
Gundula McCandless
Karen Meyers
Ralph Meyers
Elizabeth V. Nelms and Robert L. Ingram
John E. Parkerson
Barbara Paull
Lee Raymond
Thomas and Betty Reddin
Sally Sprout Fine Art
Jim Sanders
Naomi, Johanna, and Robert Siegmann
Mitchell Sinoway
Stephanie Smither
R. T. and Barbara Solis
Richard Stout
Robert Symonds and Priscilla Pointer
MaryRoss Taylor
Emily Todd
Anne Wilkes Tucker
Eleanor Williams
Isabel and Wallace Wilson
Elena Wortham

ACKNOWLEDGMENTS

Lucas Johnson's maturation as an artist in the later decades of the twentieth century paralleled the rise of the Houston scene as a noteworthy arena in American art. This relationship is not merely coincidental: Johnson can rightly be described as one of the crucial figures in this development within the city and region. His work significantly influenced the production of his own and other generations of artists. Also important, as one of a number of American artists deeply moved by the art and culture of Mexico, Johnson and the work he made while living both in Mexico and in the United States, as well as his direct interaction with Mexico's artists and thinkers, provided a pivotal link between artists from both sides of the border.

The art world of Texas still lacks the one important ingredient that would facilitate its further blossoming and recognition: major publications. Most existing books are surveys of artists of the region or the occasional large-scale, single-artist exhibition catalogue. The Houston Artists Fund, publisher of the current volume, is attempting to redress this situation. In recent years Houston Artists Fund has produced a major publication on the late Charles Schorre and exhibition catalogues for James Surls and MANUAL. Commendably, the Fund's distribution partner, the University of Texas Press in Austin, has recently taken up the publishing gauntlet with an ambitious program aimed at exploring Texas artists in depth. It is no surprise that following Johnson's unexpected death in 2002, a number of individuals and institutions collectively arrived at the conclusion that the work of Lucas Johnson needed the wider exposure and exploration that only a major monograph could provide. In his lifetime, Johnson himself was a Houston Artists Fund director and important supporter of its goals.

A core of individuals set about meeting the practical requirements to achieve this goal. Significant contributions came when the project was announced in December 2002. An ad hoc steering committee that included Sallie Diederich, Joseph Havel, Patricia Covo Johnson, Gus Kopriva, Jack Massing, Betty Moody, Don Quaintance, Bill Sadler, and me was established to raise additional funds. The lion's share of funding for this project came from a memorable and rewarding benefit coordinated by this group and hosted by Massing and Michael Galbreth at the Art Guys World Headquarters, Houston, on March 27, 2004. Many members of the Houston art world came together both to celebrate their friendship with Lucas as a person and to recognize his significance as an artist. Thirty generous artists contributed major works to a lottery that helped raise important funds for the project. Sparked by this spontaneous outpouring, attendees and others made significant pledges toward the realization of this publication. The names of both the artists who donated works and the contributors who provided funds are listed on pages 8–9. We heartily thank all of them for their valued assistance.

One mission of the Houston Artists Fund is as a funds facilitator, and it has filled this role for this project by providing it with an institutional umbrella. As an organization, Houston Artists Fund is also determined to provide the enthusiasm and moral support that are necessary for large-scale projects but can rarely be marshaled by individual artists.

This publication has been a labor of love for a felicitous group of friends and associates. Tim Staley, University of Texas Press, Austin, provided valuable advice and help with the distribution. Johnson's fishing buddy Jack Massing was an on-the-spot ombudsman. Ben Russell gave generously of his time and skill, unframing then reframing works

on paper so they could be photographed without glass. The gifted photographer George Hixson worked tirelessly on new photography for much of the work reproduced here. We also thank the numerous other photographers, whose names are listed on page 182, who made important contributions to the plate section and documentary illustrations. Betty Moody cheerfully accommodated researchers' relentless attacks on the archive of paperwork and photography that documents her gallery's unstinting association with the artist. Don Quaintance, with the assistance of Elizabeth Frizzell, spearheaded all aspects of the production of this book and provided its thoughtful design. Polly Koch judiciously edited the texts with a sharp eye for content as well as form. Patricia Covo Johnson dealt meticulously with the countless minutiae of organization and also wrote the detailed and insightful personal chronology of Johnson's life and work.

Special acknowledgment goes to the two renowned authors who readily agreed to discuss Johnson's work and whose essays significantly enhance *The Art and Life of Lucas Johnson*. Before his death in March 2005, the innovative curator Walter Hopps wrote an unpublished essay on Johnson, completing the manuscript in 2001 and subsequently participating in an interview on the subject of the artist in 2004. These two components, which have been combined to form the preface of this volume, are testimony to Hopps's close friendship with Johnson and to his clear-eyed admiration of the artist's work. Edmund P. Pillsbury, another art world stalwart and likewise a Johnson friend, has perceptively looked at Johnson's work against the larger panorama of art history. We are grateful to these two esteemed scholars.

Our ultimate thanks must be delivered posthumously. Lucas Johnson was a humane and visionary individual and artist. Unafraid to explore the darker regions of the human soul, he was nonetheless, in his own words, "an incorrigible optimist." He continued, "Life, such as it is, saddens me, but hope never abandons me." He was a master of many visual media. His early work celebrated the dignity of the disenfranchised and his later work looked with awestruck wonder at the phenomena of the natural world. Our hope is that this selected overview of his art adequately conveys the true nature of his prodigious achievement.

—Jody Blazek
President, Houston Artists Fund

I add my heartfelt thank you to all the individuals named here by Houston Artist Fund and personal thanks to the HAF's talented board and to its president, Jody Blazek, who provided critical tax-exempt organization and accounting expertise. My deepest gratitude goes to Lucas's friends and collectors who enriched his life and who supported this project from the beginning. There are many, among them Jan and Jack Cato, Betty Moody, Walter Hopps, Ted Pillsbury, and the Art Guys.

I also extend my appreciation to Brett Bickham, Sue Green, Nancy Reddin Kienholz, Brian Maguire, and Teodoro Maus, whose memories enriched the biographical text; to tireless friend Sallie Diederich and to Brian Howard, who read the first draft of my text with a cool eye and a warm heart; and to Don Quaintance, whose patience, eagle eye, and sensitive mind shaped this book.

For Lucas. He gave me wings.

Patricia Covo Johnson

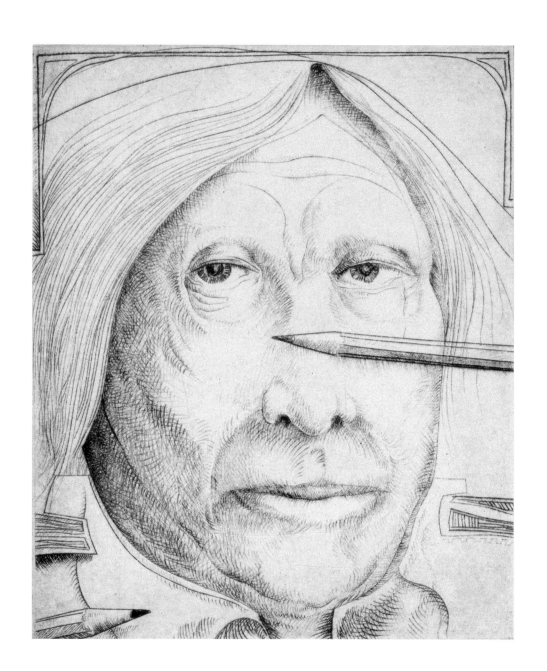

Preface: Reminiscences on the Art of Lucas Johnson

Walter Hopps

At the age of seven, Lucas Johnson visited the venerable Wadsworth Atheneum in his hometown of Hartford, Connecticut, and was "astounded" by what he saw. This was his first encounter with serious art. No art hung on the walls at his home, yet Johnson recalls drawing during his childhood: war pictures, cartoons, hot rods. Later his family relocated to San Gabriel, east of Los Angeles in southern California. In those days the San Gabriel scene was populated with surfer boys and girls listening to rhythm and blues on the beach. In high school there, Johnson took an art class in watercolor and gouache painting, and he remembered winning a prize. This background gives a sense of the world in which Lucas spent his youth.

Johnson, who had a fantastic poetic imagination, somehow taught himself to draw and paint. It's interesting that he began his career in essence a self-taught artist, yet became fluent in most painting, drawing, and printmaking media. As a schoolboy, he visited the galleries at the Huntington Library and Botanical Gardens, where the lush works by eighteenth-century English painters like Thomas Gainsborough, which he had first seen in reproductions, had a strong impact on him. (It's interesting to note that a similar experience at the Huntington was an important early inspiration for Robert Rauschenberg just after he was discharged from the Navy in 1945.) Johnson learned about art both by looking at older paintings and by hanging around the Chouinard Art Institute (now the famous California Institute of the Arts in Valencia that has since produced some interesting artists). Johnson attended UCLA beginning in 1958 and during this era visited the Pasadena Art Museum (now the Norton Simon Museum) and the Museum of Science, History, and Art (predecessor of the Los Angeles County Museum of Art). Originally studying marine biology in college, Johnson soon began to pursue his artwork seriously.

In 1960 Johnson left school to hitchhike around the United States. He survived by selling drawings in bars and doing pickup work in framing shops. In New Orleans he met the American painter George Tooker, who taught Johnson the art of painting with egg tempera. Johnson traveled on to Cape Cod in Massachusetts and then to New York City. Through artists he met along the way, he found places to stay while barely scraping by. In 1962 he went to Mexico at the urging of a friend, poet Joel

fig. 1 Lucas Johnson, *Autorretrato [Self-Portrait]*, 1993, drypoint etching on paper, edition of 10, 5 x 4 inches.

Cohen, who helped pay Johnson's expenses and introduced him to a bohemian community that included the American poet Margaret Randall.

Johnson painted figuratively, often devising scenes with political overtones, and his social conscience caused him to suffer through 1968, the year when liberal forces were violently crushed in Mexico, part of a repressive atmosphere throughout the Western world. In Mexico's galleries he first discovered Surrealist art, including the work of Leonora Carrington, an English Surrealist who had settled in Mexico and was one of the women in Max Ernst's life. In Galería de Arte Misrachi, which had given Johnson his first important exhibition, he found inspiration in the kindred work of adventurous Mexicans like Rufino Tamayo and José Clemente Orozco, as well as Surrealist-related art by Frida Kahlo. In this gallery, too, he met the woman who would become his wife, Patricia Covo, then the assistant director of the gallery. The Mexican experience really stimulated Johnson to make paintings.

Johnson had been living and exhibiting in Mexico City for a number of years when he met Houstonian Dorman David and, at David's invitation, visited Texas for the first time. In Houston Johnson began showing in 1964 in group exhibitions at the David Gallery, owned and directed by Dianne David, Dorman's sister. He also fortuitously acquired several cases of acrylic paint and began to paint more actively. In 1973 Lucas and Patricia Covo Johnson settled in Houston, where since 1975 he has been represented by Moody Gallery.

I would identify the kind of art that Johnson produced as "imagist." Actually older than the term "Surrealism," imagism has its roots in the world of poetry by way of T. S. Eliot, Ezra Pound, and H. D. [Hilda Doolittle]. Like Surrealism, imagist art employs recognizable images in fantastic or unreal juxtapositions. Imagist art depicts recognizable locations, people, and objects, but these figurative elements

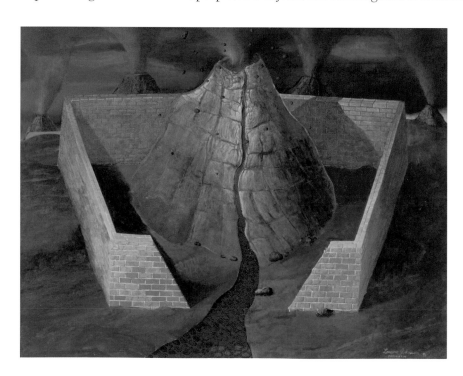

fig. 2 Lucas Johnson, *Paricutín*, 1991, acrylic on canvas, 24 x 30 inches. Jack and Jan Cato, Houston.

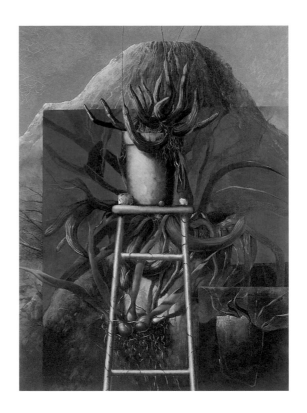

fig. 3 Lucas Johnson, *Studio Triptych*, 1998, oil on canvas, 48 x 36 inches. Betty Moody and Bill Steffy, Houston.

are not put together in a sensible way: instead they often appear disjunctively. Imagist paintings are constructed in the same way as the poetry, using the imagery as visual metaphors. This aesthetic imperative has extended in American art from as early as the work of Man Ray to the present.

Reimagined views of landscapes and volcanoes constitute one of the major themes in Johnson's painting. Johnson once remarked that he considered his volcano paintings to be akin to self-portraits. It is important to stress that these particular paintings, such as *Paricutín* (1991, fig. 2) and *Cloud Forest, Tamaulipas* (1999, p. 78), are unreal in both color and perspective. While working in the United States, the artist remembered the volcanoes that he knew in Mexico and in Hawaii, and began to paint these natural forms in various curious and imaginative ways, sometimes surrounded by man-made stone or brick walls and using very lush, unreal color. The combination of landscapes dominated by volcanoes along with figurative scenes is some of the best painting Johnson did.

Later in life Johnson turned to a fantastic kind of art more closely resembling realism, making still-life paintings that convey the hallucinatory bursts of color found in the orchids that he had collected and nurtured for years. He loved exotic plants, and the last artworks of his life were portraits of these incredible plants. Using the orchids as a point of departure, he produced a remarkable body of vividly colored paintings. I often visited his studio where he painted these works. In some of them, he went back—as an imagist sometimes does—to forms he had used before. Jasper Johns, who is a major American imagist (in the sense I'm using the term here), often recalculates motifs that he has used in earlier art, bringing them into new work from a different perspective. In a similar manner, Johnson couldn't resist painting smoking volcanoes in the background of some of these later still-lifes, introducing quite a foreign element into what he was actually seeing in his studio. This practice reflected his love of Surrealist art and some of the more imaginative and fantastic aspects of Mexican art. For example, in *Studio Triptych* (1998, fig. 3),

Johnson depicted a large still-life painting that seems to rest against a distant and vast volcano, as though two different paintings had been somehow stuck together. In front of these he added a smaller orchid plant on a stand. In this and other paintings from this period, the perspective is often skewed or disrupted, and he used colors—such as the powerful reds and oranges on the table surfaces supporting the potted orchids—that, of course, were not physically present in the studio. Another beautiful example, also with a flaming volcano in the background, is *Laelia rubescens with Dead Encyclia* (1999). In contrast to Johnson's drawings, which are usually in silverpoint or the black and gray tonalities of pen and ink, vibrant colors of red, orange, blue, and green suffuse these later paintings.

At one point Johnson had the opportunity to teach drawing and lecture about Surrealism for a semester at Rice University, Houston, and he was thrilled to do it. The art history students found it very informative to hear an artist's point of view. Johnson, in turn, invited me to conduct one of the classes, and at his urging we met in the galleries at The Menil Collection so we could look at the actual paintings, works by René Magritte and Max Ernst, rather than projected slides. I threw in, rather like the cherry on the sundae, the one Salvador Dalí work which Dominique de Menil had purchased for the collection. This 1935 drawing, titled *Gangsterism and Goofy Visions of New York* (fig. 4), is filled with Dalí's impressions upon coming to America prior to World War II (he later settled there for the duration of the war). It is a berserk drawing with cartoonlike vignettes of different events: the women look

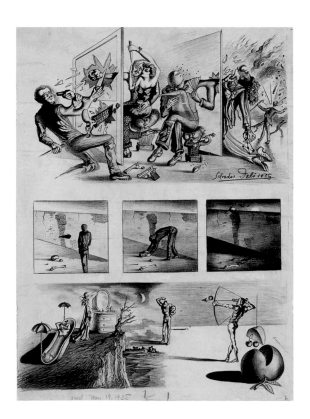

fig. 4 Salvador Dalí, *Gangsterism and Goofy Visions of New York*, 1935, graphite pencil on paper, 21½ x 15¾ inches. The Menil Collection, Houston. © 2005 Salvador Dalí, Gala-Salvador Dalí Foundation / Artists Rights Society (ARS), New York.

fig. 5 Walter Hopps and Lucas Johnson, Houston, c. 2000.

like prostitutes and the men are thugs with guns blasting through a door. One central section is very moody, and I think it suggests Dalí's longing for his home in Figueras, Spain. In it three panels show a gloomy artist walking next to a brick wall that magically transforms into a deserted beach. This part of the drawing reminded me of Johnson, reflecting the affinity he felt for natural settings like those on the Gulf Coast where he spent many rewarding hours.

I miss Lucas Johnson enormously. Often we ended up having lunch at the same place in Houston. He was always willing to talk about art or about his stays along the Gulf Coast in Rockport, Texas, where he loved to work and fish. I'm not much of an ocean or bay fisherman, though Johnson certainly was, so we never could talk about fishing for very long. Instead, he would like to talk about art in a quiet and modest way. He often returned to speaking about natural phenomenon, like the "green flash," an amazing effect that happens at sunrise or at sunset when the sun changes color for just an instant. This combination of attentive observation and inspired vision made Johnson one of the finest artists in America working imaginatively from nature.

This text is edited from an unpublished manuscript written by Hopps in 2001 and includes some of his additional thoughts taken from an interview between Hopps and Jack Massing, June 11, 2004.

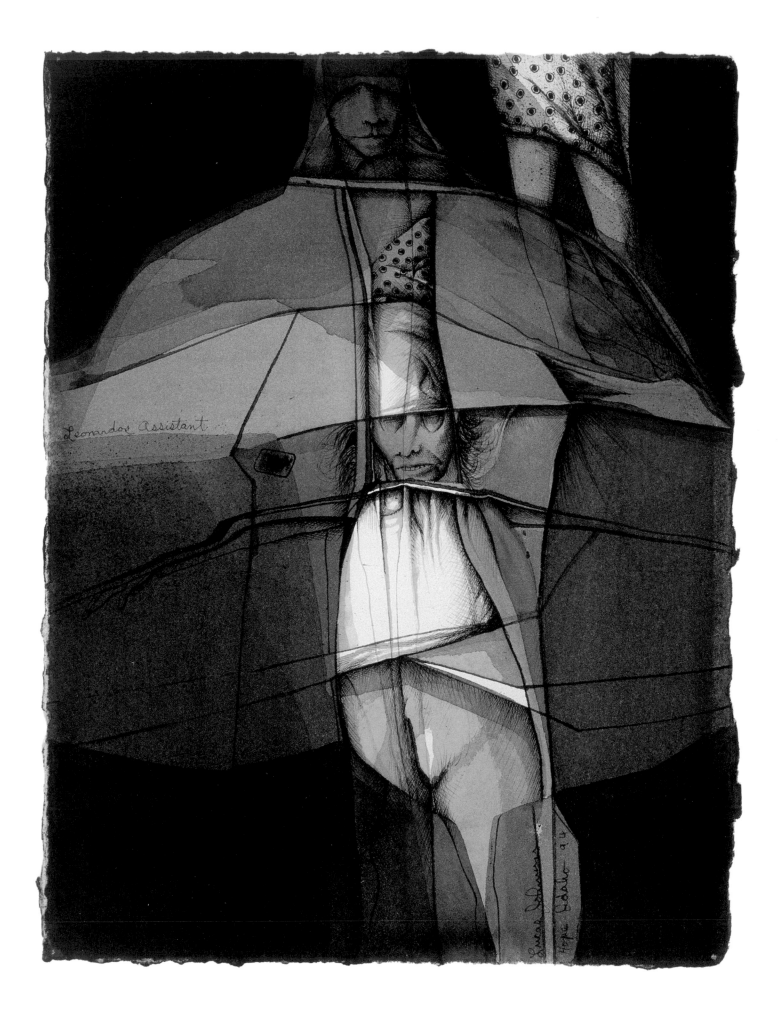

Leonardo's Assistant

Lucas Johnson: A Humanist's Vision

Edmund P. Pillsbury

The word *humanist*, although first applied in fifteenth-century Italy to those committed to the advancement of the liberal arts, later became synonymous with nineteenth-century educational reforms promoting classical studies and, more broadly, with arguments stressing the worthiness and potential of human beings separate from any religious tradition. It is in this context that any discussion of Lucas Johnson's art must begin.

A self-trained artist and agnostic, in whose work the artist's relationship with society is pervasive, Johnson became a painter to express himself first and foremost as a human being. At its core, his work is a metaphor for the social condition—an expression of an abiding preoccupation with what is human or, conversely, with what reveals a lack of humanity. It draws in equal parts upon imagination and memory, fiction and nonfiction, and by doing so, it revives the fortunes of contemporary figure painting, landscape, and still-life genres. It eschews purely formal and aesthetic considerations for ones rooted in universal themes concerning life and death and spiritual values pertaining to good and evil. Stories and images from the past inform his art as vividly as do his rich experiences of events and people encountered on a daily basis.

The genius of his art lies in the virtuosity of his pen, the subtlety of his tonal variations, and the dexterity of his brush, as well as in the power of his mind in conjuring forth subconscious images of exotic, if not sometimes bizarre, content. There are few parallels in American or even Mexican schools of art. For comparisons one must return to *The Disasters of War* etchings by Francisco de Goya (fig. 7)—or even think back to the moral allegories of Pieter Brueghel and the phantasmagoric narratives of Hieronymus Bosch, on the one hand, or Caspar David Friedrich's transcendental landscapes and even the monumentalizing still-lifes of Caravaggio and Juan Sánchez Cotán, on the other.

There are, by his own admission, three phases in Johnson's artistic development: when he first confronted the mystery of life; when he began to make art to express what he understood; and finally, having explored what he understood, when he thought that he had fathomed the meaning of life's mystery, which has since sustained his vision.

fig. 6 Lucas Johnson, *Leonardo's Assistant*, ink on paper, 12¹/4 x 9¹/4 inches. Nan Meltzer, Malibu, California.

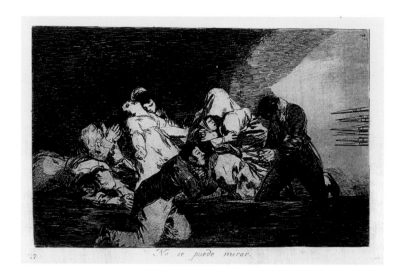

How did it happen? Born in 1940 in Hartford, where his Cuban-born father worked for Pratt & Whitney, Lucas visited the venerable Wadsworth Atheneum at the age of seven and discovered a world of unforgettable images—a new language for him. That same year his family moved to San Gabriel, east of Los Angeles. Subsequently, while growing up on California's beaches, surfing and taking a course of study at UCLA devoted to marine biology, his ambitions lay dormant. Yet before he was twenty, he quit college to devote himself to art.

He hitchhiked to Utah, Colorado, Wyoming, and finally to Louisiana, working odd jobs as a ski bum and cowhand or seeking occasional work in frame shops. In New Orleans he found his first true mentor: the American realist painter George Tooker. Tooker befriended the young student and offered him valuable instruction in traditional techniques of egg tempera painting and silverpoint drawing, not to mention instilling in him an abiding respect for the work of leading American figurative artists of the thirties like Charles Demuth and Charles Sheeler. And in Jackson Square in the late fifties, Johnson was able to make ends meet for the first time by drawing portraits and painting picturesque views for the local tourist market. His subsequent wanderlust took him as far as New York, where Abstract Expressionism hailed a new beginning for American painting and early postmodern trends were beginning to emerge in the work of Jasper Johns and Robert Rauschenberg. As much as New York's art world may have left Johnson in awe, however, it had a relatively minor influence on the direction of his art.

Not until 1962, and after he had left the United States, did Johnson discover himself and begin his development as a professional artist in his own right. In that year he went to Mexico City at the urging of Joel Cohen, a poet friend, who paid his expenses and introduced him to a bohemian community of artists and poets. Mexico City welcomed the charming and energetic young American with open arms. In the 1960s Mexico City was a global village in which the surrealism of daily life had blended into a new cosmopolitanism. An elite of young intellectuals and artists comfortably embraced the aesthetic doctrines of André Breton and mixed them with the more recent currents of contemporary art to produce an eclecticism nurtured

by legend, myth, and magic. Mexican art at the time, in search of a new symbolic language informed by the glories of Maya and Aztec art, sought liberation from the expressive realism of the great muralists: Diego Rivera, José Clemente Orozco, and David Alfaro Siqueiros. Thanks to Rufino Tamayo, a new generation of "humanist" painters was beginning to emerge, and Johnson immediately found a niche that incorporated the lessons of European Surrealism as exemplified in the work of Leonora Carrington, a prominent member of the avant-garde in Mexico City in the early 1960s, and that resonated with the work of younger Mexicans like José Luis Cuevas, whose work drew inspiration from the stories of Edgar Allan Poe and the novels of Charles Dickens, Fyodor Dostoyevsky, and Franz Kafka, as well as from horror movies and the Theatre of the Absurd (Eugene Ionesco, Samuel Beckett, et al.). A consummate draftsman, Cuevas chronicled the realities of life as if it were a new comedy featuring dictators, prostitutes, Coney Island dwarfs, monstrous beings, and pathological characters in general; his art admonishes the viewer to take heed of the misery and vice to which humanity has sunk, and expresses anguish for having to live in an absurd, incoherent, and negative world, one more akin to George Grosz's Berlin in the 1920s than Andy Warhol's New York of the 1960s.

Without any formal training, Johnson first manifested his talent in drawings—meticulous renderings of recognizable images in fantastic or unreal juxtapositions. He quickly established himself as an illustrator of uncommon acuity and versatility. Immediate invitations to exhibit came from sources throughout Mexico as well as from cities in the United States—New Orleans, Woodstock in New York, San Francisco, and Biloxi in Mississippi. In Mexico City Johnson met Dorman David, who invited him to show at the David Gallery owned and operated by his sister, Dianne, in Houston, where Johnson began exhibiting in 1964 and would have annual shows for the next seven years.

These early exhibitions featured his drawings. Johnson did not exhibit any paintings until 1967, and the initial reception was mixed partly because the critics were unfamiliar with his work in this medium. He adopted painting to add more texture and feeling to his work, rather than to advance his career or respond to the growing market for his art, and he went on to balance successfully his interests in painting with his original fondness for purely graphic expression.

Johnson's work from the sixties reveals a preoccupation with rituals and ceremonies. In *Marie Laveaux* (1968–1969, p. 32), a large oil panel, the artist drew on the story of a well-known voodoo queen of New Orleans lore, showing her performing a magic trick by passing an egg over a body to exorcize its ills. *Niños de la guerra [Children of War]* (1967, p. 29), an homage to Rivera and Tamayo, features two mummies in red blankets, voicing Johnson's condemnation of the violence and futility of military action and expressing his own quiet protest against America's involvement in Vietnam. In *Carnaval* (1968, p. 31), a large oil on Masonite, he chronicled a panoply of events in celebration of the Mexican rituals before Lent. *Magician and His Son* or *American Gothic* (1968–1969, p. 33) spoofs Grant Wood's painting while betraying the artist's own quiet admiration for a point of view rooted in the darker, more Gothic side of American arts and letters, expressed in the writings of early Truman Capote

and William Faulkner, or especially in earlier writings of the Polish-born British author Joseph Conrad, among others. In *Crucifixion* (p. 97), a large ink drawing of 1967, he acknowledged an interest in the extravagance of Catholicism without taking a stand on its importance or meaning for himself, a Lutheran without an interest in religion per se, yet someone harboring a general fascination with matters of the spirit. Likewise, *Icarus Falling* (1975, pp. 42–43), a major early oil painting, showing Icarus crashing into a tree among a number of oblivious smaller figures, teaches us that miracles happen all the time, but we do not notice them.

In the work that Johnson produced while he lived in Mexico City from 1962 to 1972, he wrestled with a range of social, literary, and artistic issues, but he always remained conscious of himself and his own place in society. This becomes clear in a painting like his *Self-Portrait* of 1967. It shows two figures, one surmounted by the other, the first beseeching the viewer for sympathy, and the other, more apparition-like, staring at the viewer as if in a dream. The meaning is inescapable. The artist lives in isolation haunted by the idea of himself inherited from his parents. Since Johnson's father was an abusive alcoholic, his staring presence in the painting also serves as a reminder of the artist's own potential for self-destruction, a demon that many individuals face in life, to which artists and writers are particularly prey. Decades later the artist would return to self-portraiture as a way to explore the realms of caricature, satire, and *vanitas*. In his drawing from the 1970s entitled *Lady with Sleeping Elephant* (1975, p. 102), he included a medallion likeness of himself, worn by the old lady embracing the cuddly baby elephant on her lap. Portrayed with an exactitude approaching that of an Albrecht Dürer drawing, this image of motherhood translates superstition into actuality, striving to achieve a balance between natural and supernatural phenomena, which always delighted Johnson.

In the course of the sixties, Mexico City changed dramatically, and by 1968, on the eve of the Summer Olympic Games, student unrest was widespread. The response of the Mexican government was swift and brutal. In the rebellion that ensued, foreigners were increasingly suspect, and Johnson received a warning from an official in the Secretarîa de Educación Pública [Department of Education] that he should leave Mexico, which he heeded. A painting of 1970, *Two Women in a Boxcar* (p. 35), captures the desperation that he may have felt on the eve of his departure. The painting depicts figures in a coffinlike surrounding with their faces turned away from the viewer and peering into the distance where there is light and a possible escape. The painting describes life within boxes—in a real sense, a coffin with its lid ajar.

Johnson returned to Mexico in 1969, where he met and subsequently married Patricia Covo. Covo was a native of Mexico whose father, a merchant, had emigrated from Italy and whose mother boasted a French mother and British father. She had graduated from college in 1969 and started working in the Galería de Arte Misrachi, where Johnson exhibited with Tamayo, Orozco, Cuevas, and others. Theirs was a marriage made in heaven. Both were citizens of the world, steeped in arts and letters and profoundly committed to social welfare. In 1972 they headed to New Mexico, then a year later settled in Houston.

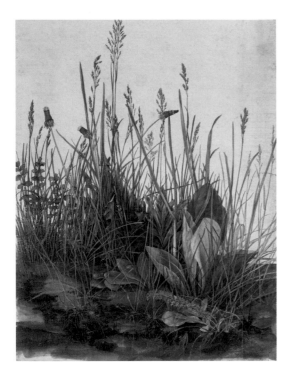

fig. 8 Albrecht Dürer, *Das grosse Rasenstück [The Large Piece of Turf]*, 1503, watercolor, tempera, and ink heightened with white on paper mounted on cardboard, 15⅞ x 12¼ inches. Graphische Sammlung Albertina, Vienna.

In Houston Patty Johnson founded Covo de Iongh Gallery to show the work of her countrymen, including her husband. Johnson returned to his studio to continue his search for the elusive mysteries of life, which he now found more in the environment of the New World than in the rituals and ceremonies of his adopted Mexico. Landscape and nature in the broadest sense began to assert themselves, and the figure slowly receded, replaced by the cohabitation of nature with the man-made. Fish and plants of all types and origins appear in this work, which also expresses his growing interest in volcanoes as symbols of the conflict in nature between life and death, as well as beauty and destruction, light and darkness, heat and cold.

A highlight of his first years in Houston were two exhibitions held simultaneously at the new Moody Gallery and at Covo de Iongh. "Louisiana Paintings" at the former and "New Mexico Paintings" at the latter featured works that intermixed themes exploring landscape and the artist's newfound desire to put aside carefully drawn composition to work more directly with paint. As critics noted, the paintings betrayed Johnson's debt to Surrealism, which the artist acknowledged: "It's surrealism by juxtaposition of human forms or places out of context, not by putting groups of symbols together."[1] Johnson affirmed in these exhibitions his conviction that figuration, not abstraction, provided the best means of engaging the viewer and transporting him or her to a world of higher meaning. A review in a local paper concluded, "Few artists infuse their works with the possibility of human tragedy as does Johnson. . . . Even the landscape is fraught with pregnant possibilities for wonder or alienation."[2]

The dual exhibitions cemented Johnson's reputation as one of the most promising younger artists in Houston. While the Moody exhibition documented his continued interest in ceremony and ritual, manifested in the carnival atmosphere of the Louisiana State Fair and in personalities like the religious folk figure Marie Laveaux, the Covo de Iongh show introduced a more mellow mood through the New Mexico landscapes, their broad expanses bathed in atmospheric washes and populated by richly clad phantom people. These newer works possess a degree of mysticism, a magical quality of idyllic peace reigning over the natural and the man-made both.

This lyrical side of Johnson's personality blossomed in the ensuing decade when, happily settled in Houston with his wife now writing art criticism for the *Houston Chronicle*, he explored the wonders of botany and marine biology as well as the exotic charms of the vast Texas landscape. He continued to show regularly with Moody Gallery and had a successful show at the Serpentine Gallery in London that was exclusively devoted to his masterful drawings of fish, the *Gulf Coast Estuary Series* (1987–1988, pp. 109, 112–114)—drawings that investigate and recreate the character of each specific species rather than merely record their appearance as scientific specimens. He extended such painstaking labors to drawings of plants, flowers, and other forms of vegetation. Johnson's passion for plant and animal life points to the artist's innate pantheism—a quality he shared with the great inventor-artist of the Renaissance, Leonardo da Vinci, and to a lesser degree with Dürer (fig. 8). His drawings of the seventies and eighties contain the seeds of the great still-lifes that Johnson would create in his final years.

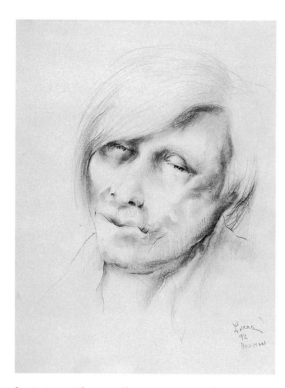

fig. 9 Lucas Johnson, *Self-Portrait*, 1992, pencil on paper, 12 x 9 inches. Patricia Covo Johnson, Houston.

Although Johnson lived in Houston, he took advantage of its proximity to Mexico to make regular excursions to Oaxaca and the heartland of his adopted home. The landscape of Mexico began to play a bigger role in his art in the eighties than it had when he actually lived there in the sixties; as he professed in a 1982 interview, "I never paint where I live.... I painted more of Mexico after I left than I ever did when I lived there."[3] What Johnson sought in his work was to capture those moments in nature when certain images seize your attention and refuse to leave your imagination.

One of these images was the volcano, which defines the topography of central Mexico. In the *Volcano Series* (1990–1996), Johnson drew specific inspiration from the startling eruption of Paricutín in the fields of Michoacán in 1947 (see p. 73). As noted by Alison de Lima Greene, "In *Volcano Series No. 3* of 1991 [p. 69], fiery streams of lava bear down on fragile stone walls. The image can be understood as an allegory for the forces of nature that inevitably overwhelm the constraints of civilization."[4] Johnson also identified the volcano paintings as "veiled self-portraits."[5] His identification with their power, as both a symbol and a gift of God, led him to investigate volcanoes under all climatic conditions, at all times of day, and in various states of eruption. He made of the volcano a *memento mori* and infused into its form all the characteristics of a living being: tranquility and repose on the one hand, violence and passion on the other.

While his interest in volcanoes as a subject was reaching its height in the early nineties, he undertook a suite of actual self-portraits. These drawings are anything but flattering. In an untitled self-portrait of 1996 executed on scratchboard (p. 143), his features become a mask of brute strength. In a pencil study of 1992, his visage expresses frailty and decrepitude (fig. 9). From neither of these drawings, nor from a drypoint etching of 1993 (fig. 1), do we appreciate the handsome features of the artist, not to mention the quiet charm and natural warmth of his personality. These are investigations of expression, not unlike the grotesque heads of Leonardo. They are at best a caricature, similar to the openmouthed obese figure in the drawing entitled *Gourmand, After Leonora* (1990, p. 118). The same psychology pervades his Untitled (c. 1995, p. 139) or his *Crossdresser* (1996, p. 140), both of which, however, bring to mind the unsettling photographs of Diane Arbus more than the scientific rendering of physiognomy by the Renaissance master.

Nowhere do the remarkable gifts of Johnson as an artist reveal themselves more fully than in his series *Drawings from the Underworld*, which he undertook in the summer of 1993 (pp. 127–131). Somewhat analogous to Joan Miró's *Constellations* (1940–1941) —a series of gouaches and watercolors that explores the darkest recesses of the artist's response to the cataclysmic events leading to the hostilities of the Second World War—Johnson's drawings are meditations upon the inevitability of death, the destruction of the environment in which we live, the threat of total annihilation, and even the deterioration of the human condition in general. The context of the pristine and remote natural setting in which the artist undertook the works may have contributed to their solemnity. The artist made the drawings in Hope, Idaho, where he had gone to work as a guest of Edward and Nancy Reddin Kienholz.

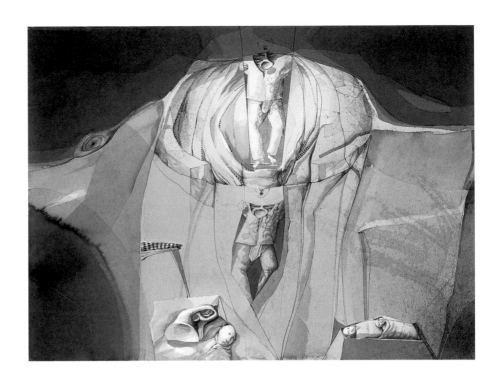

fig. 10 Lucas Johnson, *Last Musician (Drawings from the Underworld)*, 1993, ink and ink wash on paper, 22 1/2 x 30 1/8 inches. Private collection, Arizona.

Each of the large sheets of paper, meticulously developed in pen and ink, and richly elaborated in layers upon layers of wash to create the most profound range of nocturnal values, maps some unfathomable place in the artist's imagined underworld (fig. 10). The body of the landscape, the architectural details, and the narrative vignettes collide and overlap in a dreamscape of unfathomable meaning and heightened melancholy. In these works Johnson's powers of evocation are on a par with William Blake's illustrations or those nocturnal landscapes with all forms of creatures by the French Symbolist Odilon Redon.

If the *Drawings from the Underworld* constitute an ode to mortality, it is plausible to see them as the prelude to the capstone of his career —the long series of plant still-life paintings that he began in the nineties and that engaged his energies until his untimely death in 2002. These paintings sprang from a lifelong interest in plant forms, especially a passion for orchids (pp. 81–89). But they are not descriptions of the fleeting beauty of a blossom or the ephemeral charm of ripe fruit. Instead they document, even celebrate, the full cycle of plant life, from bud to blossom to withered stem, and do so by aggregating the plants on man-made surfaces, such as tables, to create a platform for their struggling elements. In these paintings, upon which the artist was working when he suffered a fatal heart attack, one appreciates that he had fathomed the full meaning of the mystery of life, at once vibrant and beautiful, but bearing the seeds of its own demise.

NOTES

1. Mimi Crossley, "The Direct Route: Lucas Johnson's Surrealism Depicts Humanism," *The Houston Post*, March 21, 1976.

2. Ibid.

3. Manuel Pellicer, "Celebrating the Mexican Revolution—Lucas Johnson," video, 1982.

4. Alison de Lima Greene, *Texas: 150 Works from the Museum of Fine Arts, Houston* (Houston: Museum of Fine Arts, Houston, 2000), 83–84.

5. Ibid.

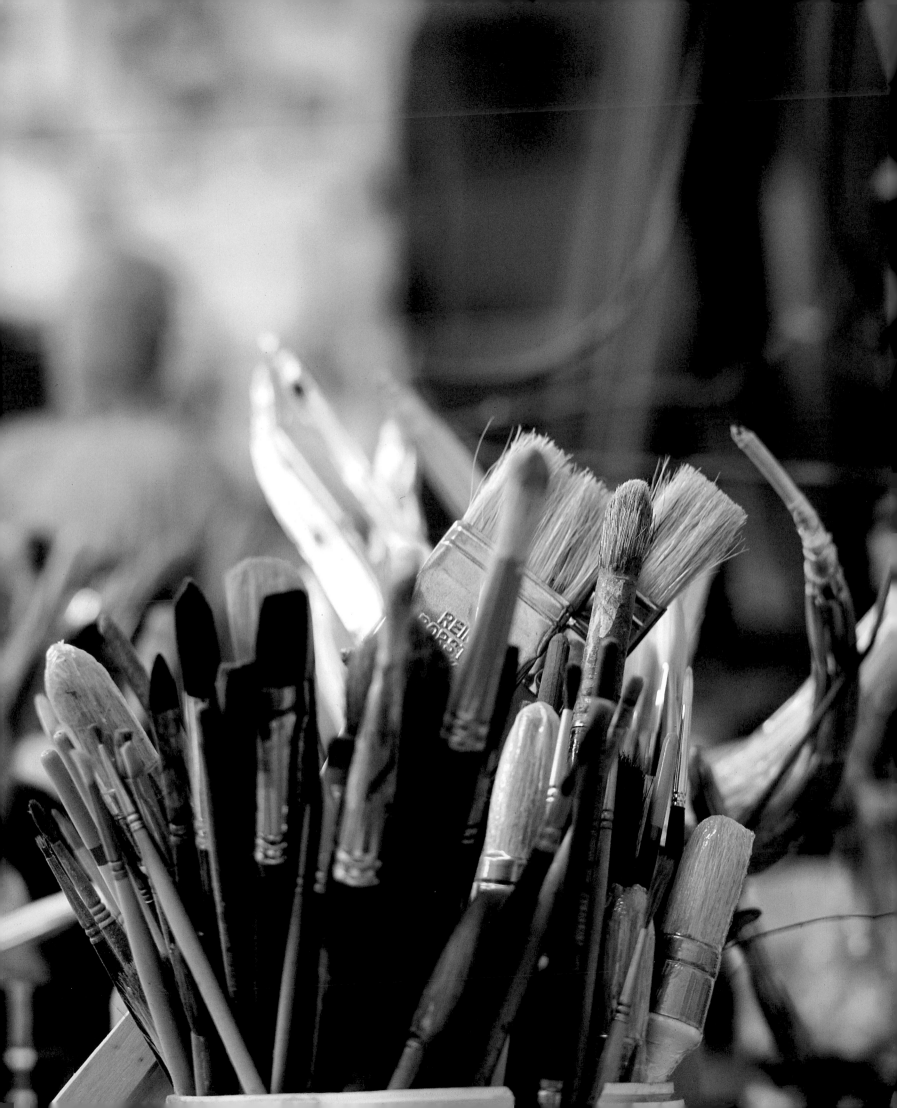

Paintings
1967–2001

All change is a miracle to contemplate;
but it is a miracle which is taking place every instant.
—*Henry David Thoreau*

Brushes on Johnson's painting table, Columbia
Street studio, Houston, 2002.

Niños de la guerra [Children of War], 1967
Oil on Masonite
33 1/2 x 48 5/8 inches
Dick and Janie DeGuerin, Houston

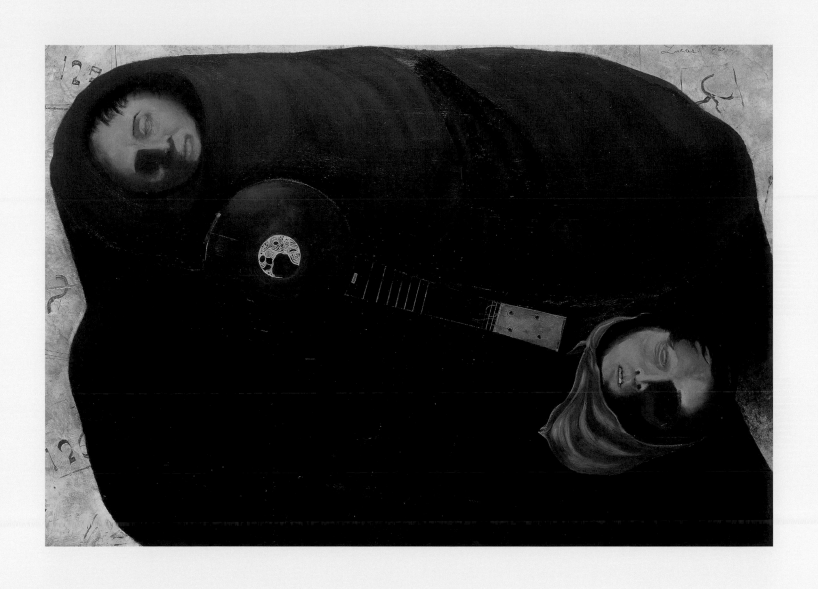

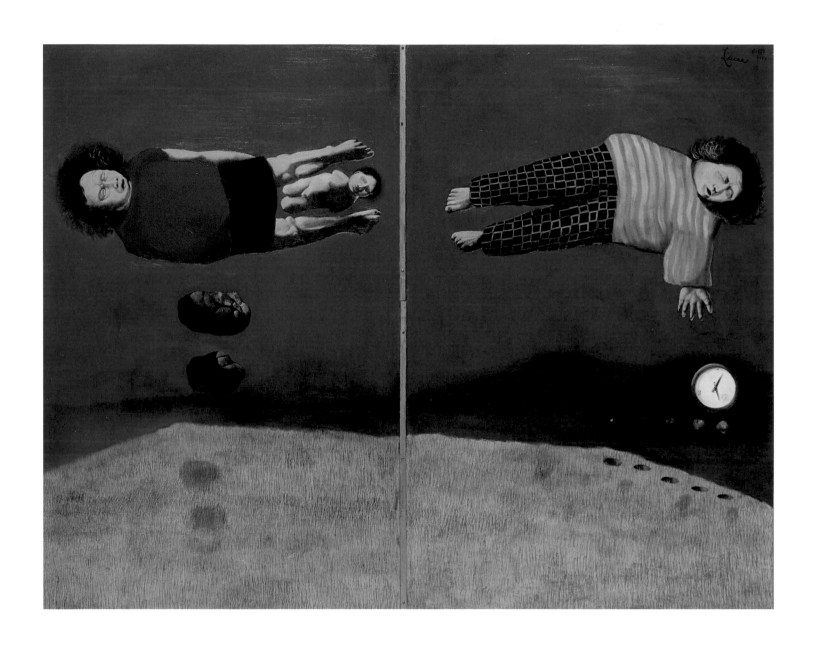

Untitled, 1968
Acrylic on Masonite
35 1/2 x 45 5/8 inches
Joan Wich, Houston

Carnaval [Carnival], 1968
Oil on Masonite
48 1/4 x 48 1/4 inches
Patricia Welder Robinson

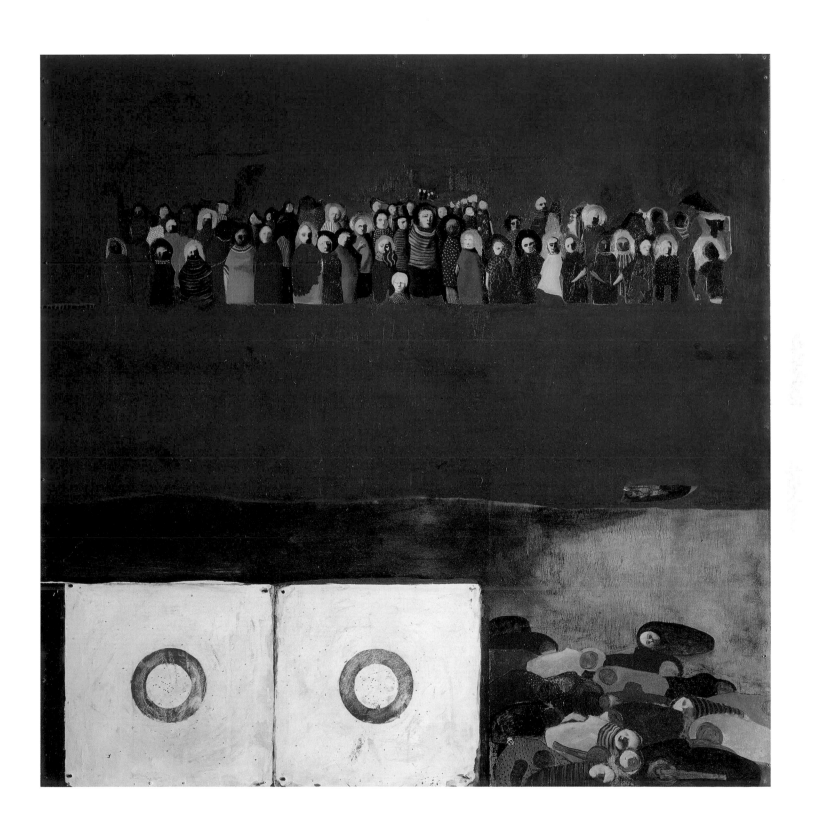

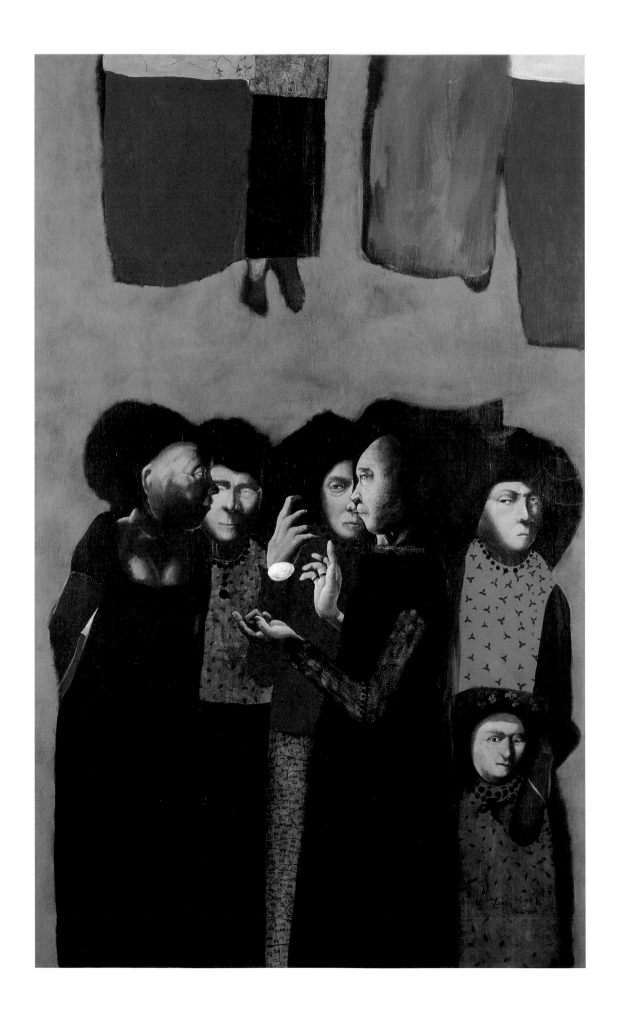

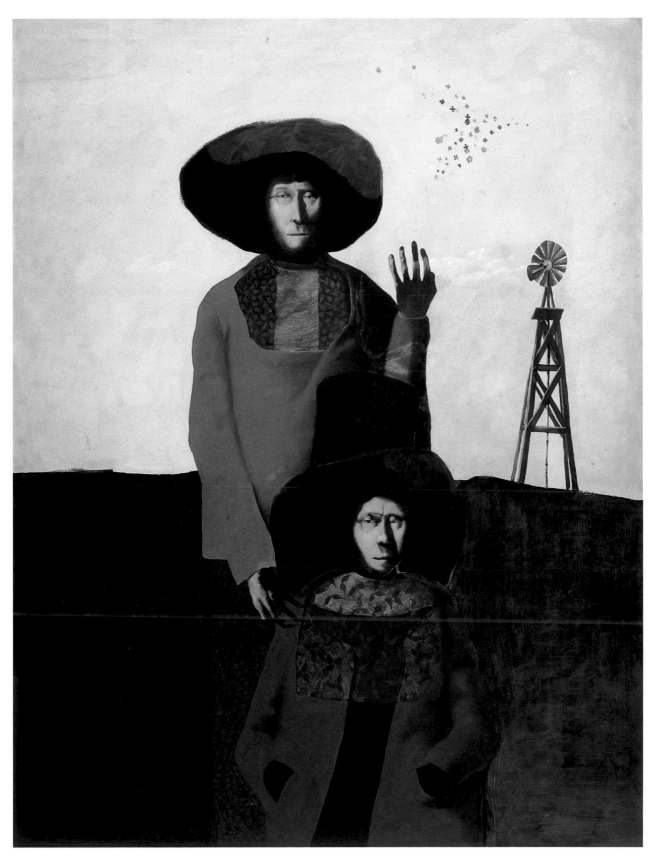

MARIE LAVEAUX, 1968–1969
Oil on linen
67 3/8 x 47 1/4 inches
Dick and Janie DeGuerin, Houston

MAGICIAN AND HIS SON OR AMERICAN GOTHIC, 1968–1969
Oil and acrylic on Masonite
63 3/4 x 47 5/8 inches
Dick and Janie DeGuerin, Houston

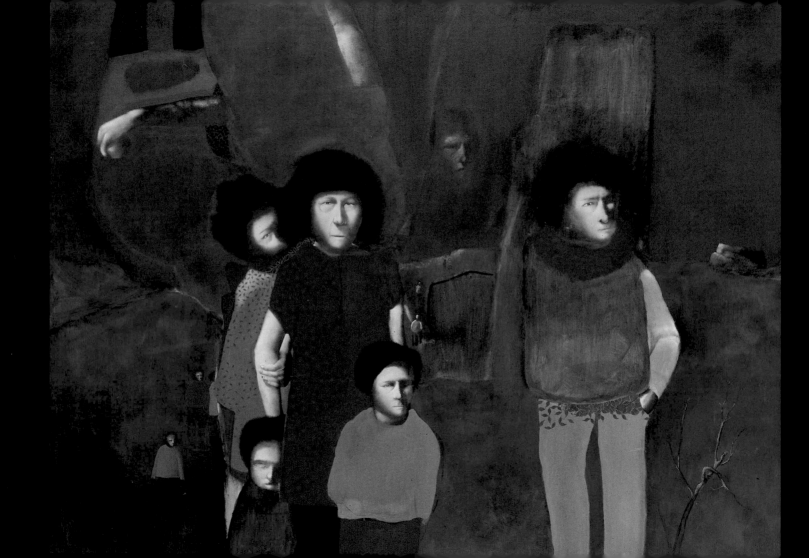

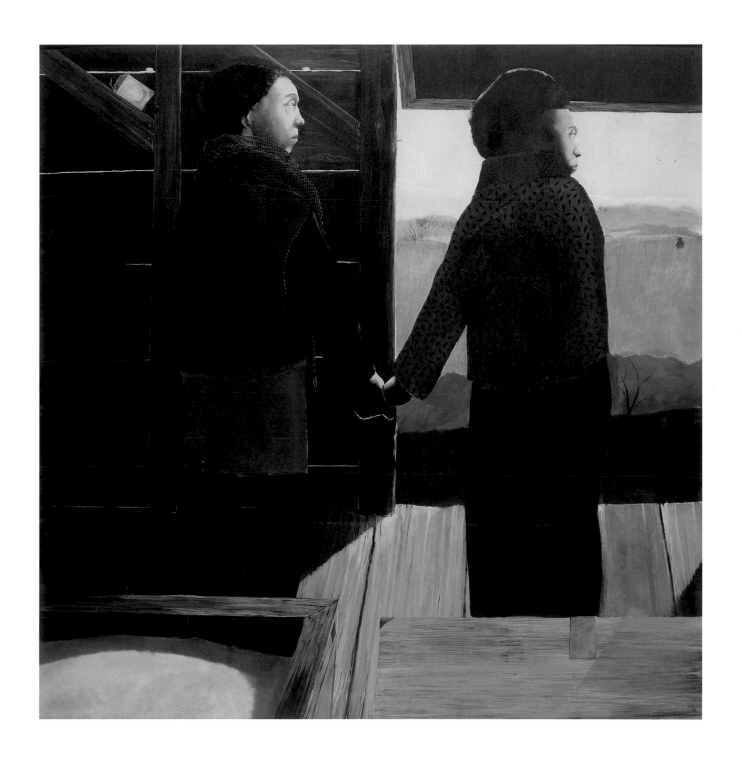

Los abandonados [The Abandoned Ones], 1970
Acrylic on Masonite
48 x 63 inches
Dick and Janie DeGuerin, Houston

Two Women in a Boxcar, 1970
Oil on canvas
48 1/4 x 48 inches
Herman and Mimi Detering, Houston

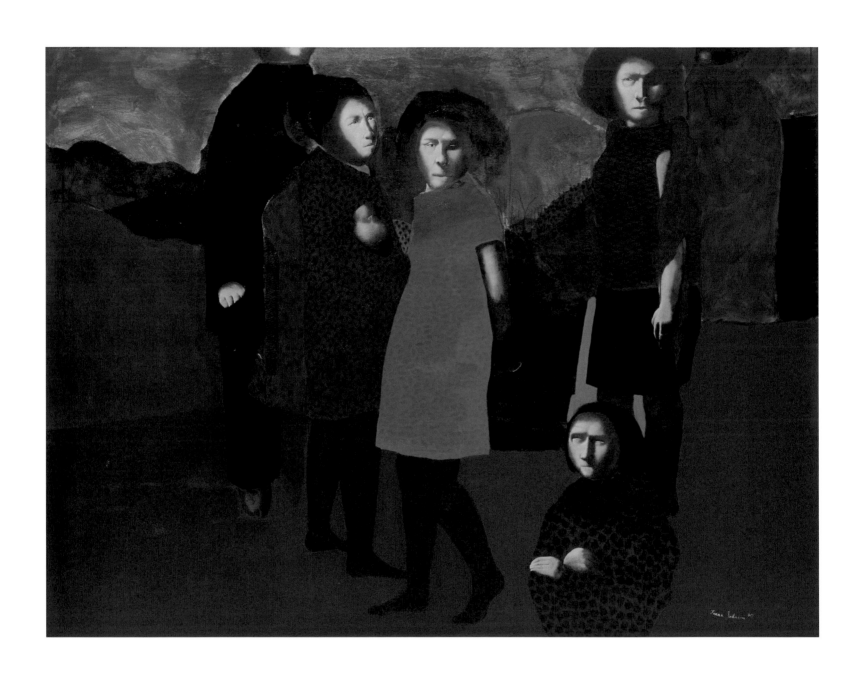

La junta, 1972
Oil on wood panel
48 1/4 x 63 1/8 inches
William M. Peña, Houston

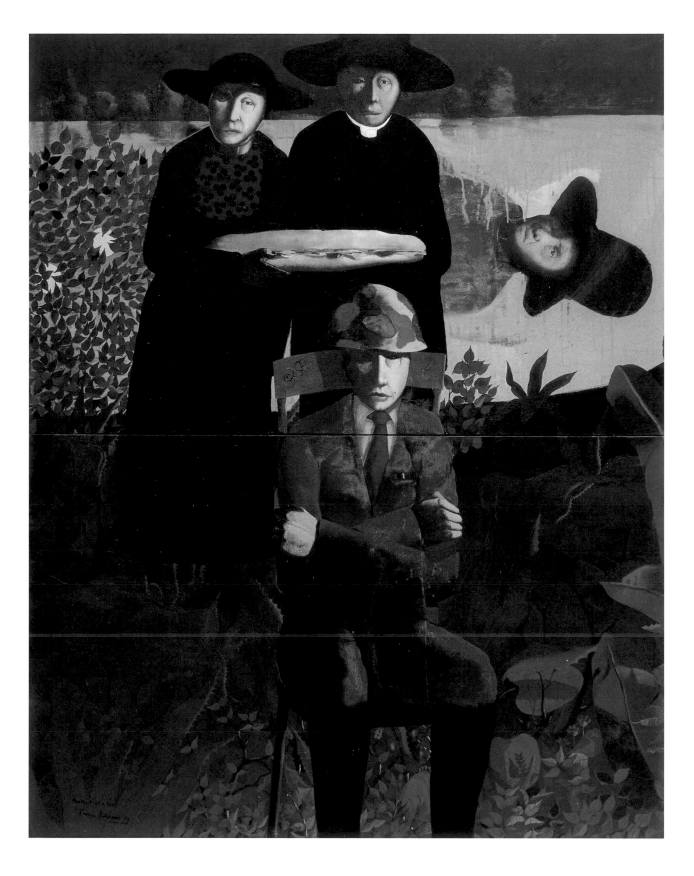

PORTRAIT OF A HERO, 1973
Oil on canvas
59 5/8 x 47 1/2 inches
Laura Jackson, Houston

Sus oídos ya no escucharán mi canto
[She Will No Longer Hear My Song], 1974
Acrylic on canvas
59 1/2 x 39 5/8 inches
Eva Wolski and Marc Grossberg, Houston

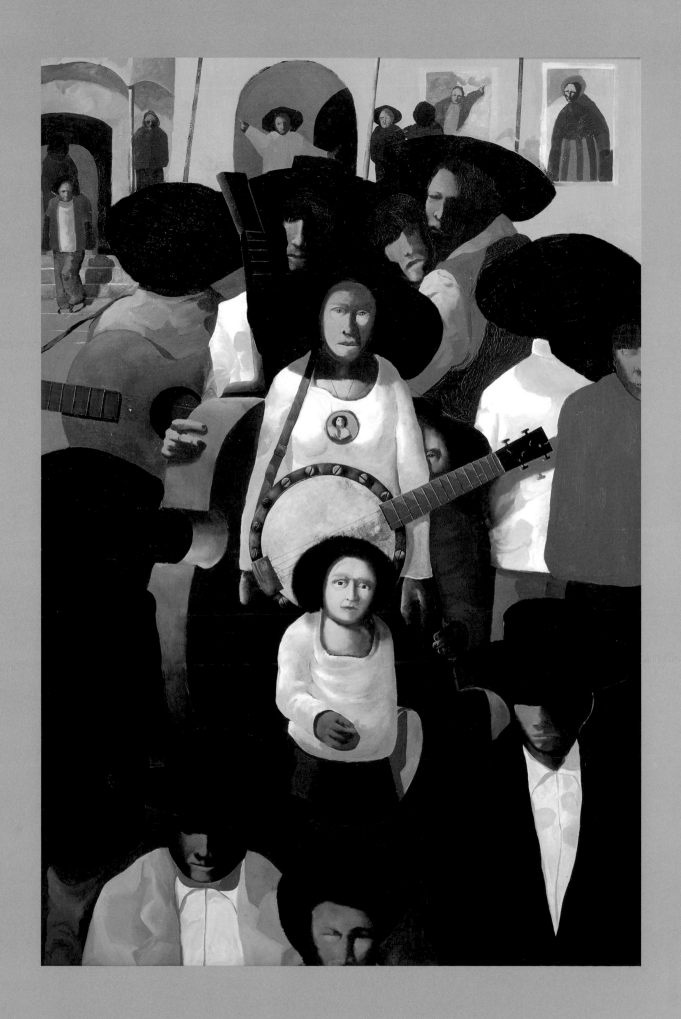

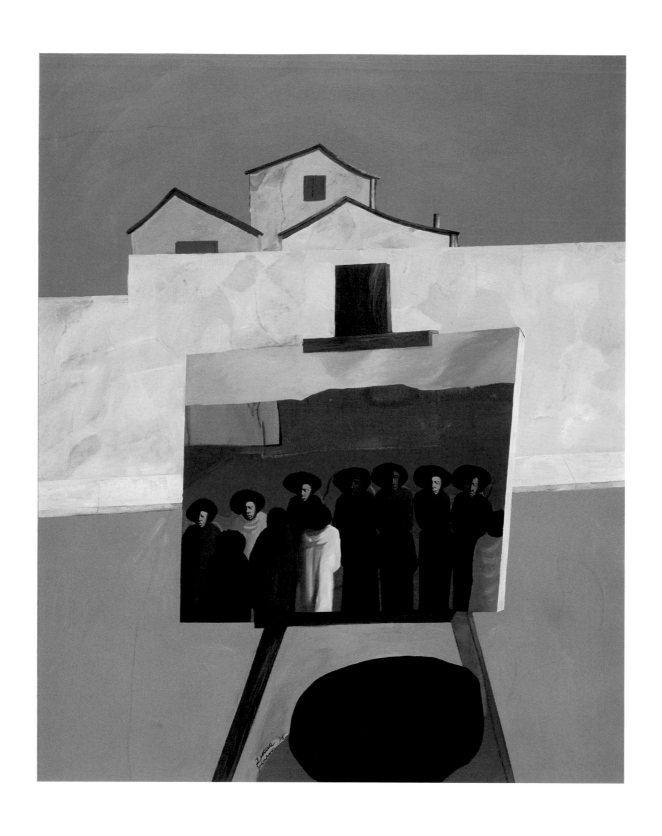

New Orleans, 1963, 1976
Acrylic on Masonite
49 ¼ x 39 ½ inches
Joan and Stanford Alexander, Houston

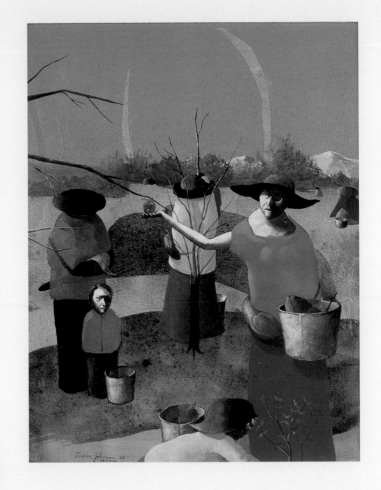

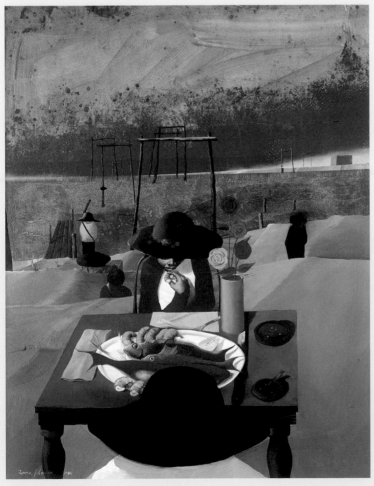

Arcoiris [Rainbow], 1980
Oil on canvas
18 x 14 inches
Elizabeth and Jack Weingarten, Houston

The Gulf, 1980
Oil on canvas
30 x 24 inches
Elizabeth and Jack Weingarten, Houston

ICARUS FALLING, 1975
Oil on canvas
65 3/4 x 79 3/4 inches
Patricia Welder Robinson

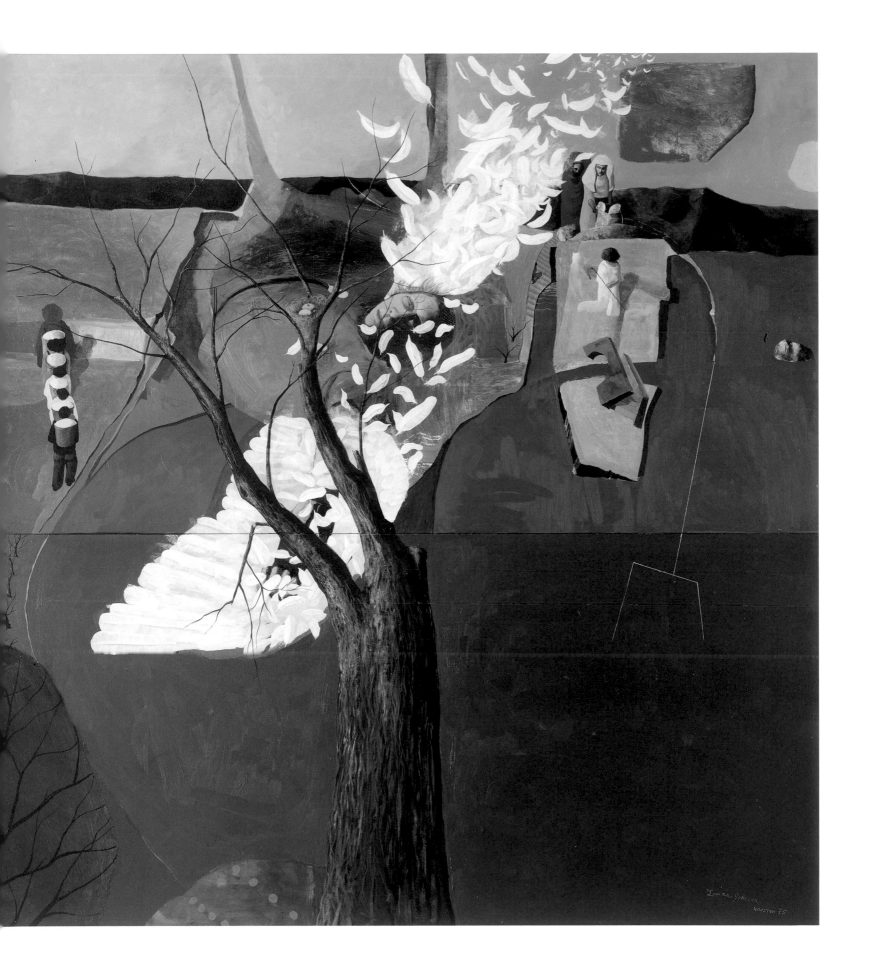

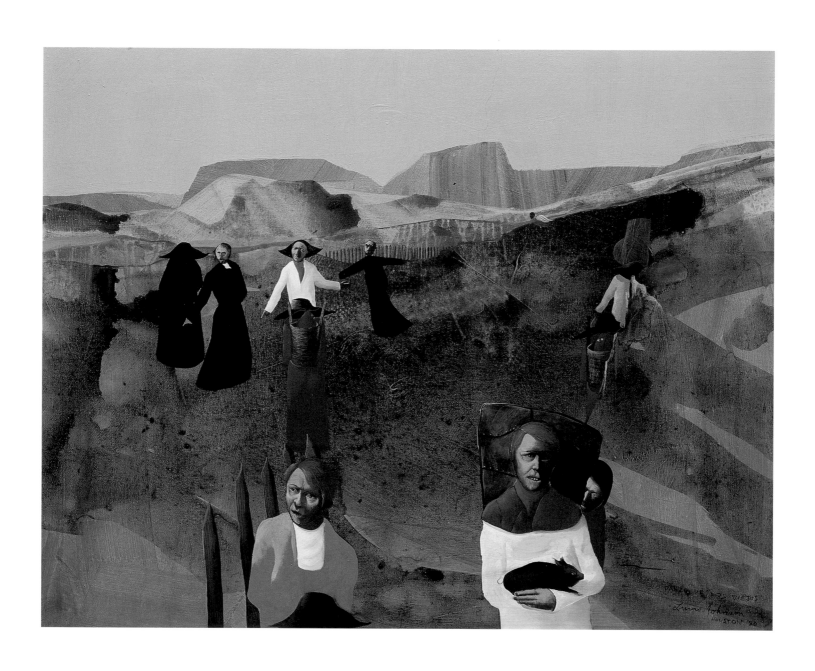

Danza de los viejos [Dance of the Old Men], 1980
Acrylic and oil on linen
24 x 30 inches
Jack and Jan Cato, Houston

La aparición [The Apparition], 1981
Acrylic and oil on panel
72 x 48 inches
Jack and Jan Cato, Houston

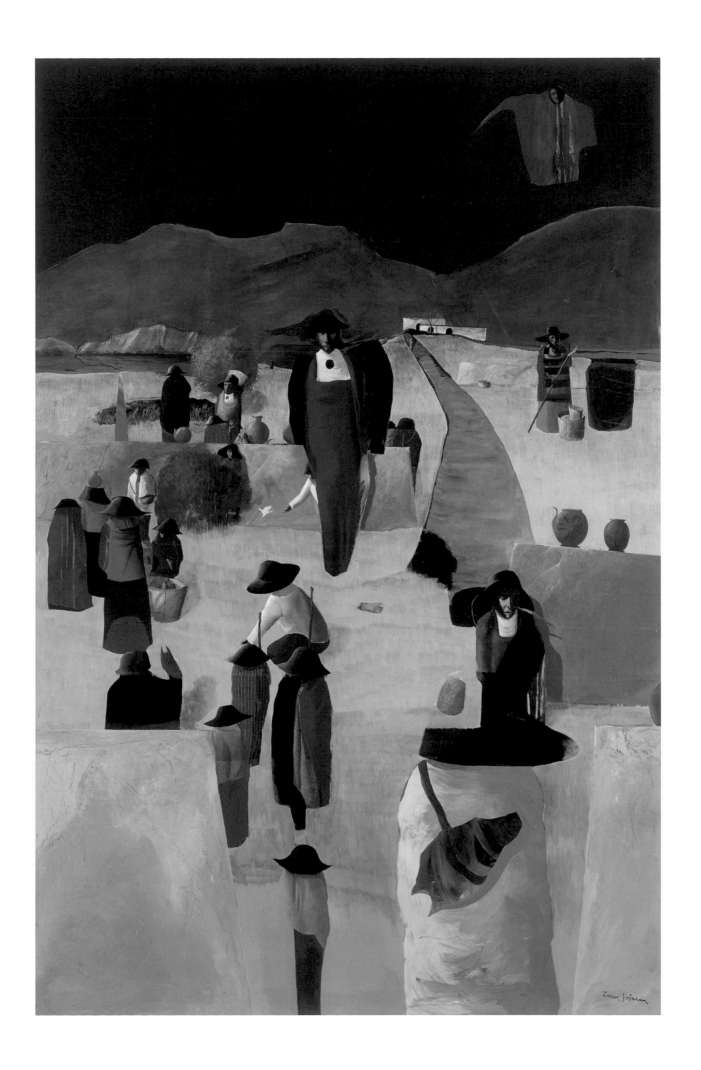

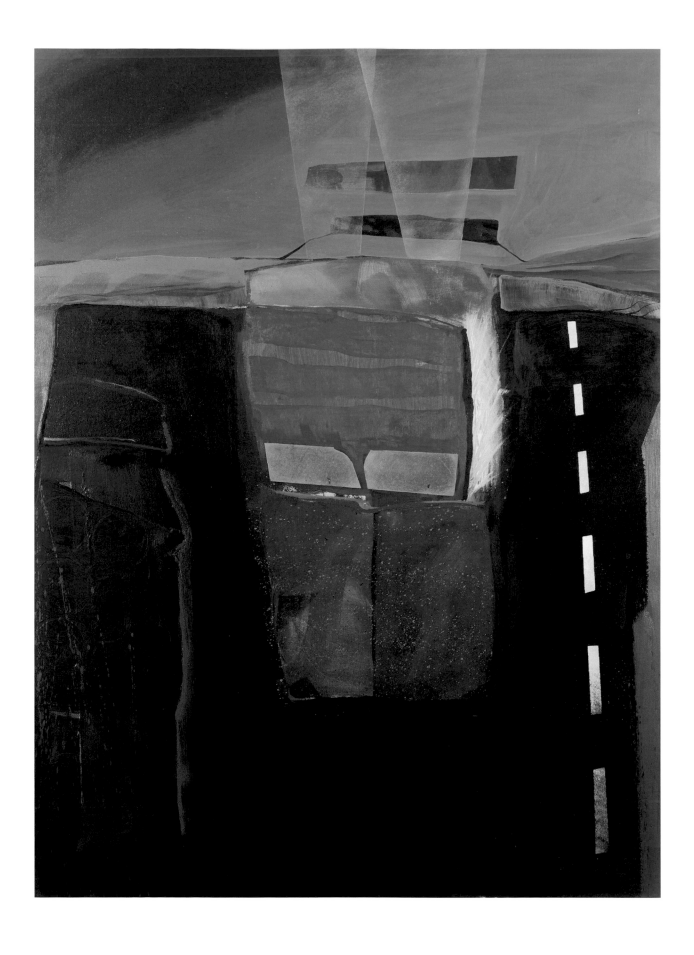

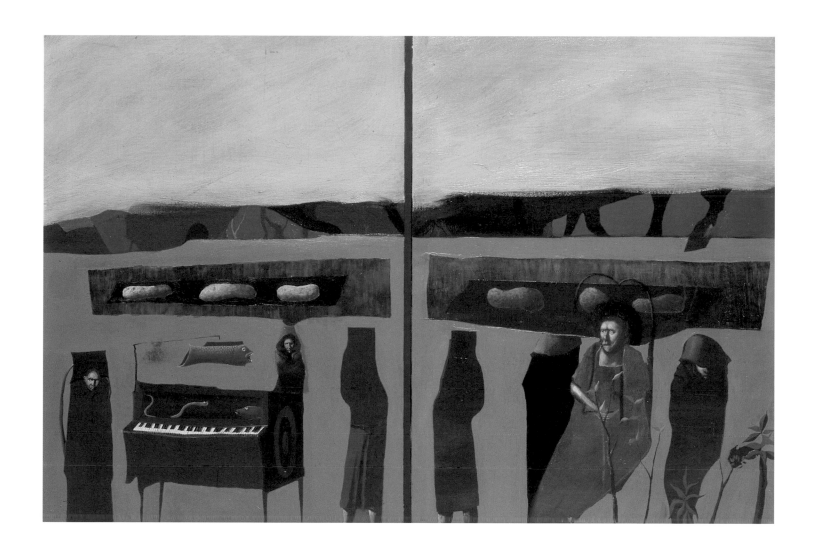

STARLITE DRIVE-IN SERIES, c. 1980
Acrylic on canvas
48 x 36 inches
Patricia Covo Johnson, Houston

PONTCHARTRAIN, 1989
Oil glaze over acrylic on canvas
28 ¼ x 44 ½ inches
Edward Stanton and Diane Baker, Houston

KERMESSE, 1989
Oil glaze over acrylic on canvas
62 7/8 x 99 3/8 inches
Nancy Reddin Kienholz, Hope, Idaho

EVENING RAINBOW, 1994
Acrylic and oil on canvas
110 x 146 inches
Jack and Jan Cato, Houston

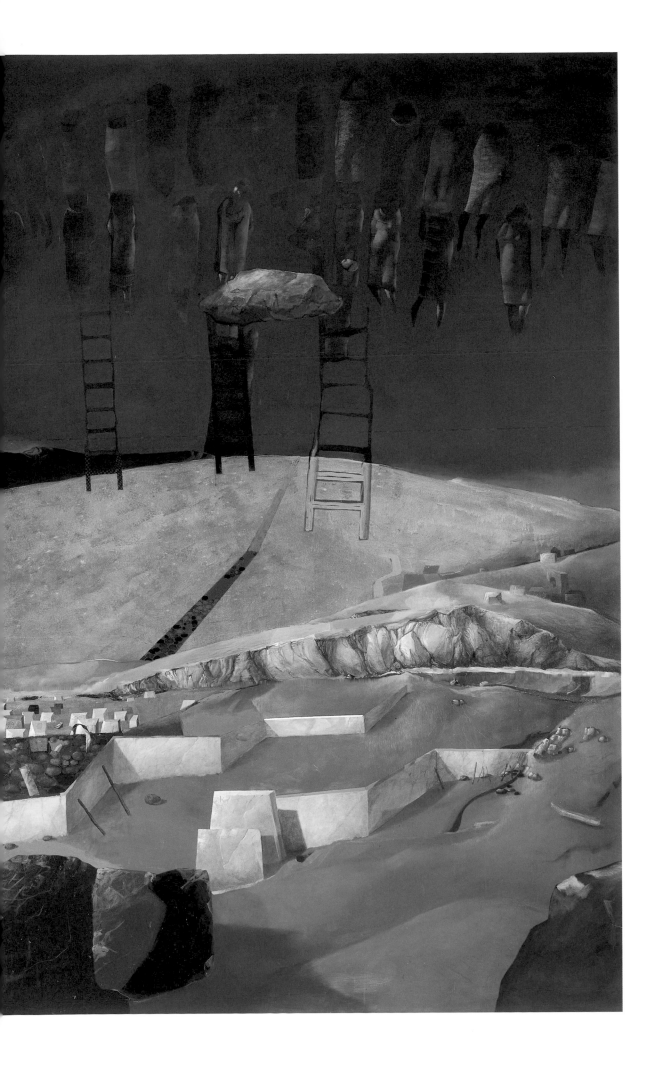

BLACK MESA, 1985
Acrylic and watercolor on panel
30 x 40 inches
Patricia Covo Johnson, Houston

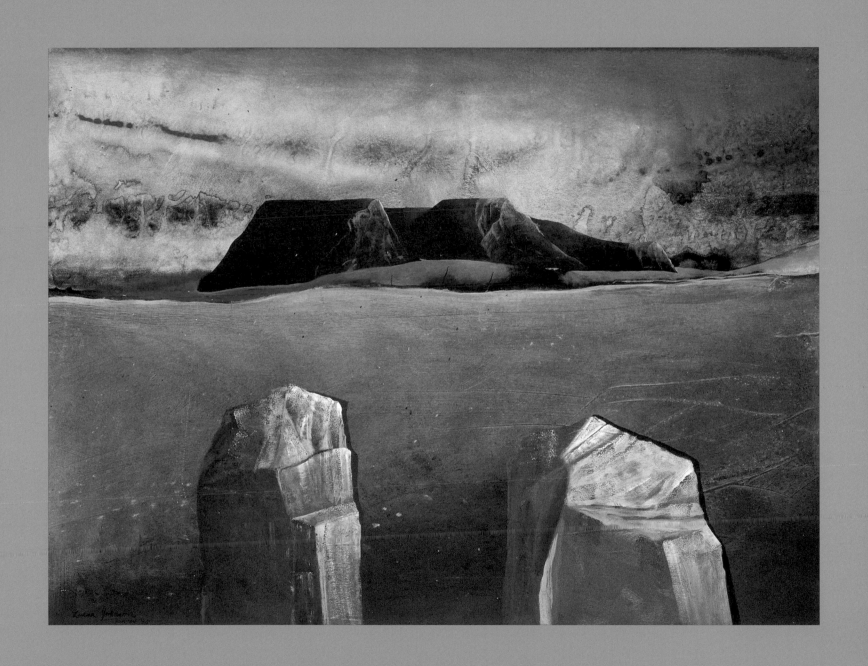

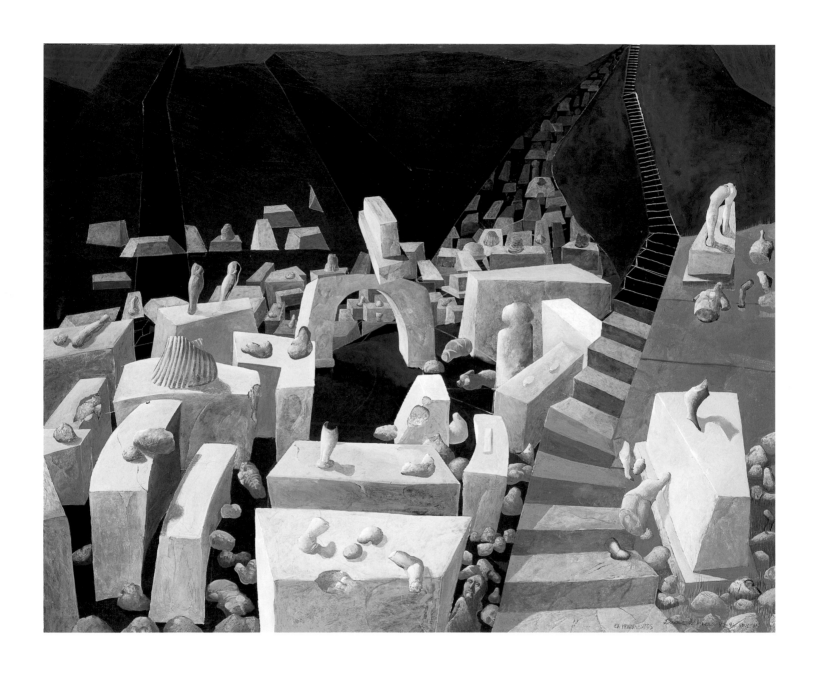

Ex-monumento [Ex-monument], 1990–1991
Acrylic on canvas mounted on panel
24 x 30 inches
Michael A. Modelski, Houston

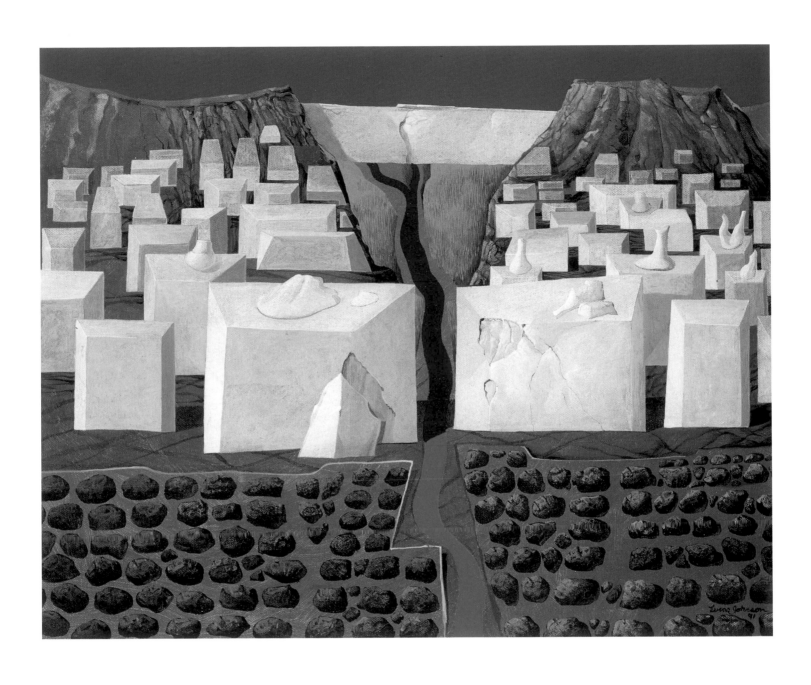

Valle de monumentos [Valley of Monuments], 1990–1991
Acrylic on canvas
16 x 20 inches
Karen Bryant, Houston

VALLEY OF MONUMENTS, 1990
Acrylic on canvas
24 x 30 inches
The Barrett Collection, Dallas

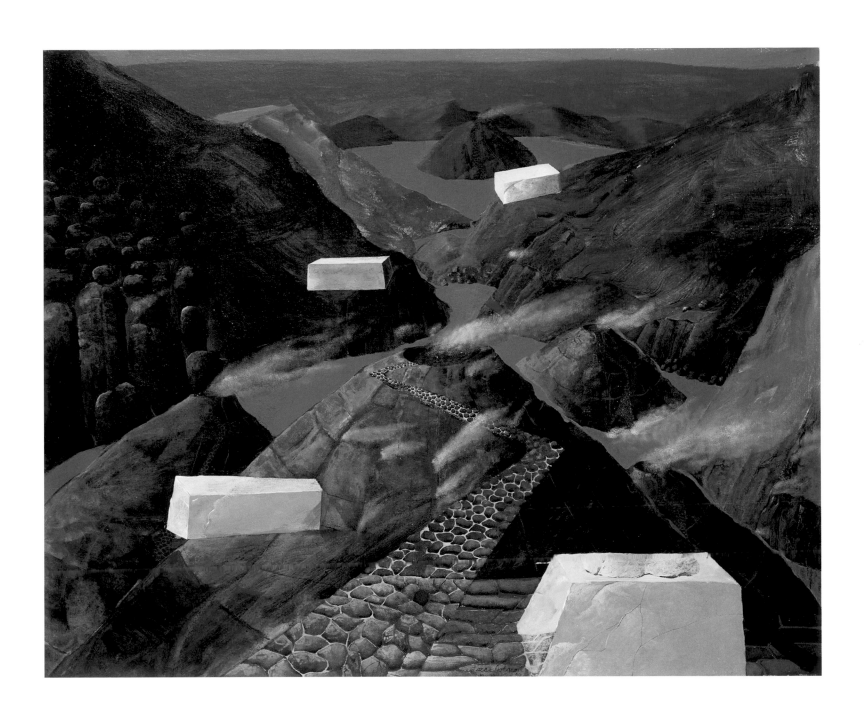

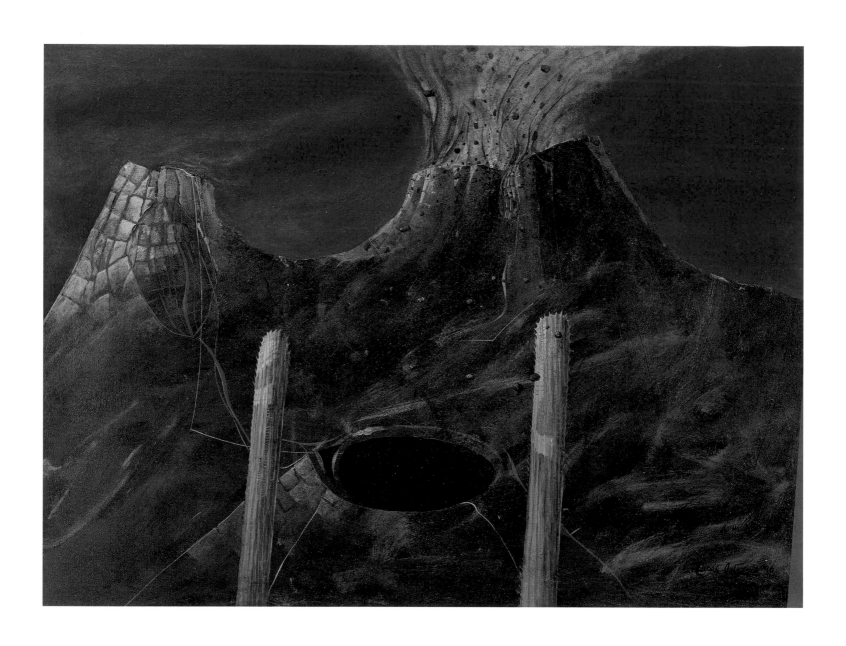

TWIN PEAKS ERUPTING, 1990–1991
Acrylic on canvas
22 x 30 inches
John and Laura Fain, Houston

Untitled, 1990
Oil on canvas
60 x 48 inches
San Antonio Museum of Art, purchased
with funds from the McFarlin Fund

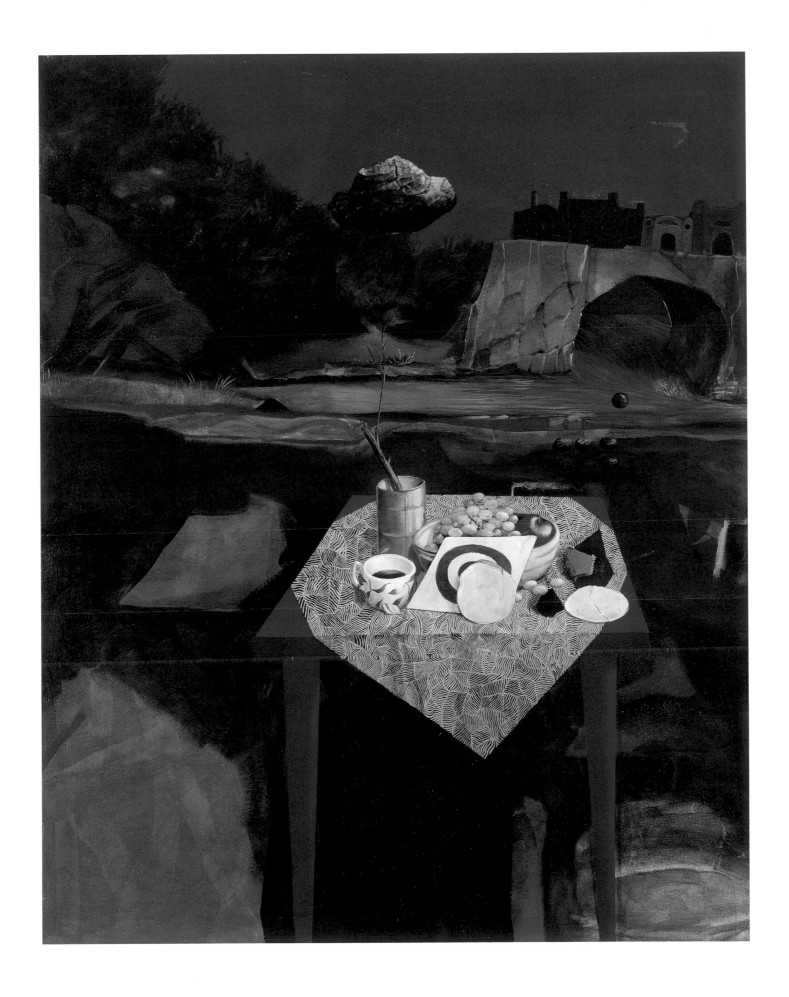

Lava Field #3, 1990–1991
Acrylic on canvas
22 1/4 x 30 1/8 inches
The Menil Collection, Houston,
gift of William Hill

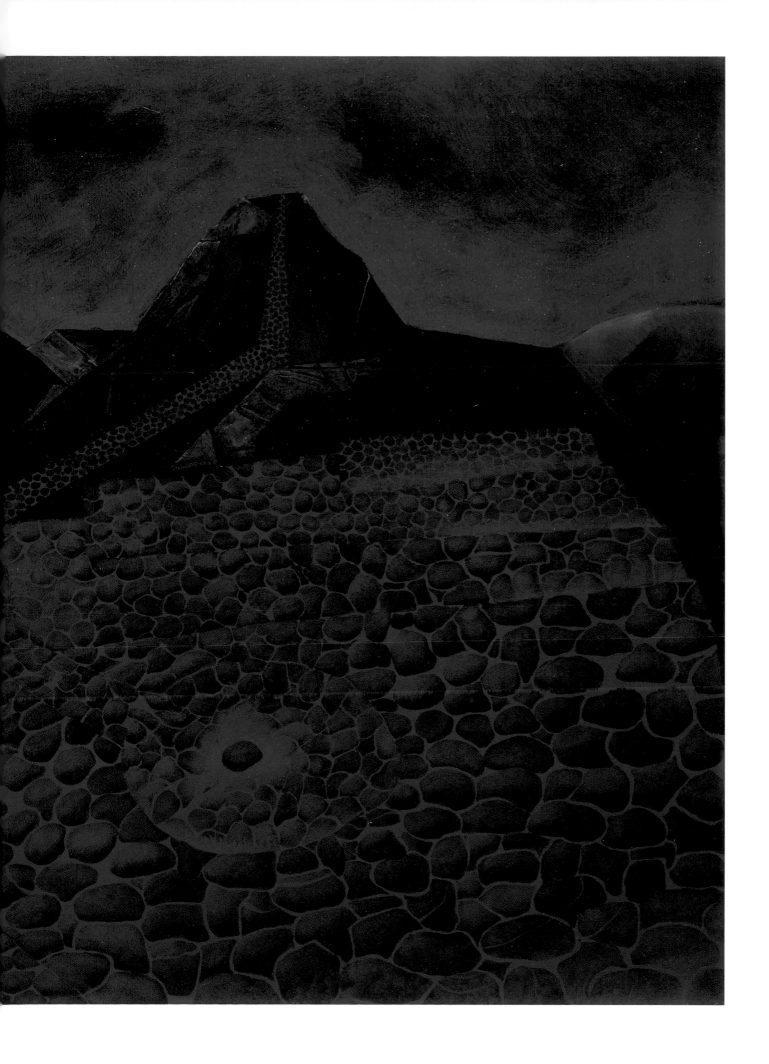

Temblor, 1991
Acrylic on canvas
Diptych: 14 x 36 inches
Jack and Jan Cato, Houston

Montaña negra [Black Mountain], 1991
Acrylic on canvas
48 x 36 inches
Jack and Jan Cato, Houston

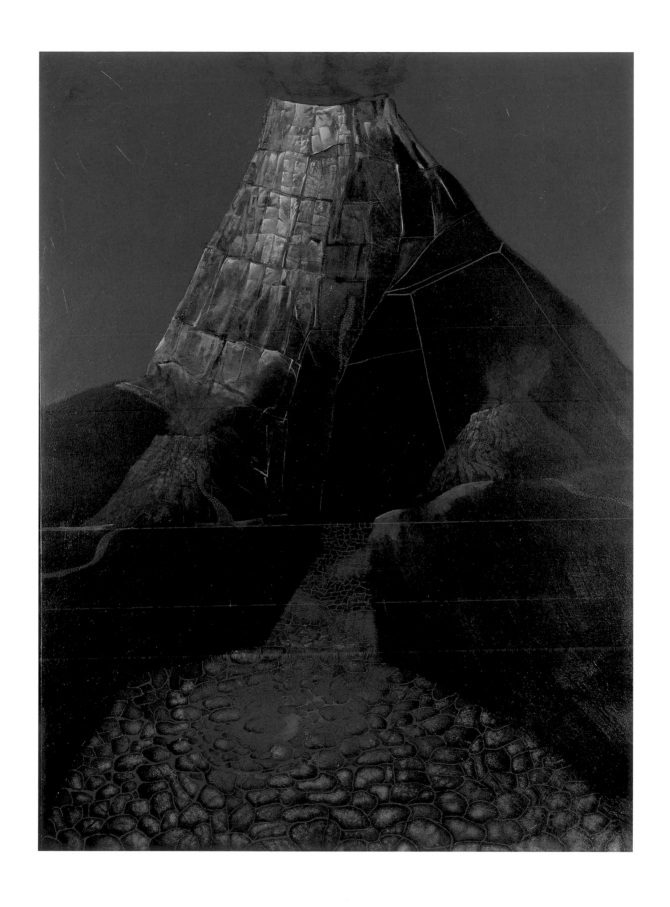

LAVA FIELD SERIES, 1990
Acrylic on canvas
Triptych: 15 3/4 x 39 3/8 inches overall
Private collection, Mexico City

VOLCANO SERIES TRIPTYCH, 1991
Acrylic on canvas
Triptych: 15 1/2 x 39 1/2 inches overall
Gayle and Mike DeGeurin, Houston

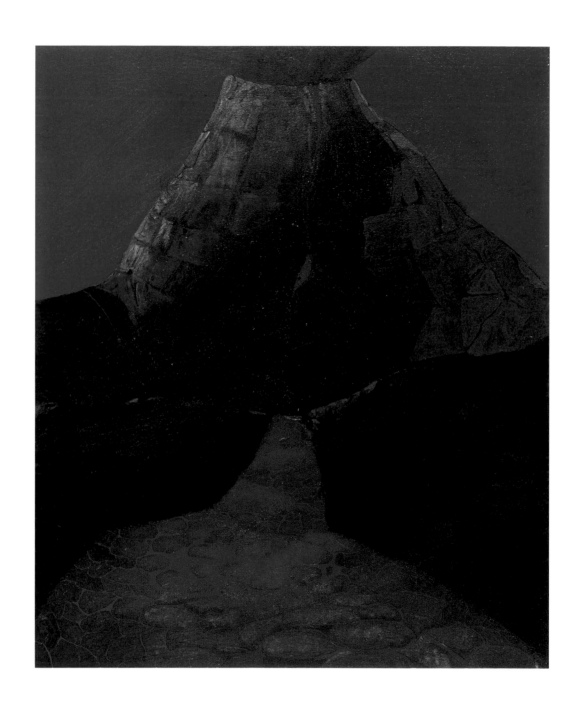

VOLCANO SERIES, 1991
Acrylic on canvas
24 x 20 inches
Leslie and Bradley Bucher, Houston

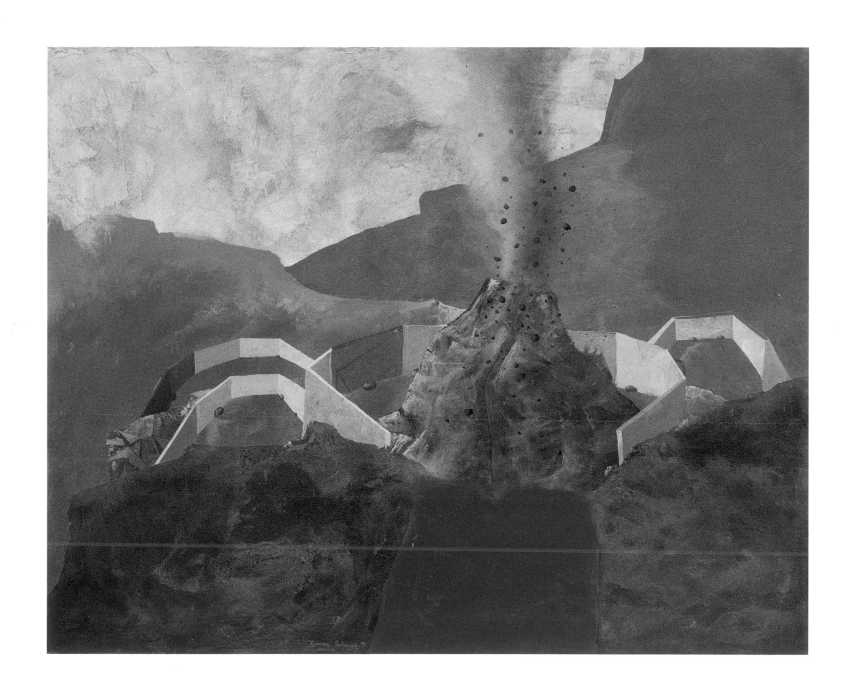

Untitled (VOLCANO SERIES), 1991
Acrylic on canvas
48 x 60 inches
Lynn Goode and Tim Crowley, Marfa, Texas

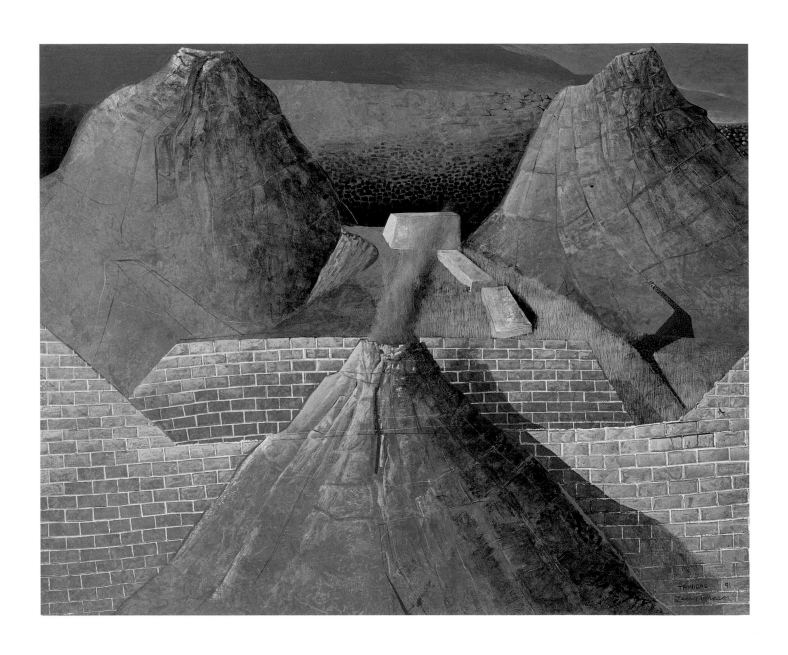

TRINIDAD [TRINITY] (VOLCANO SERIES), 1991
Acrylic on canvas
16 x 20 inches
Lynn Goode and Tim Crowley, Marfa, Texas

VOLCANO SERIES NO. 3, 1991
Acrylic on canvas
59 7/8 x 47 1/4 inches
Museum of Fine Arts, Houston. Museum purchase with funds provided by
Crowley, Marks, and Douglas; and Pablo Alvarado in memory of Diana Faz

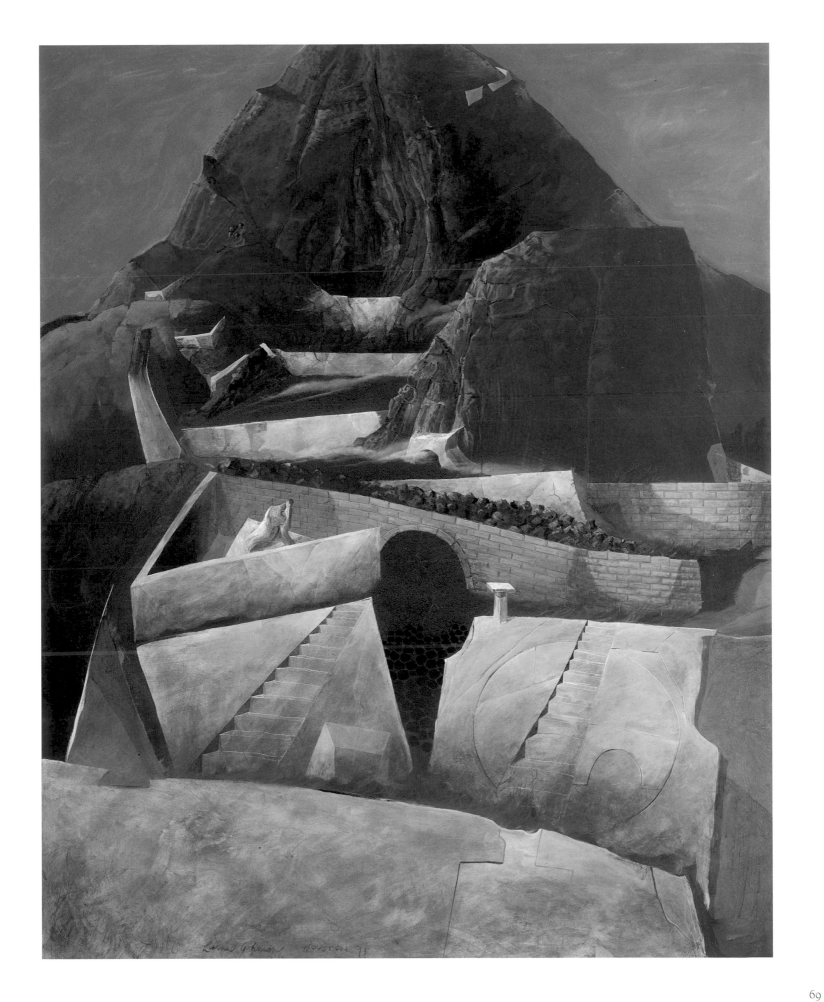

69

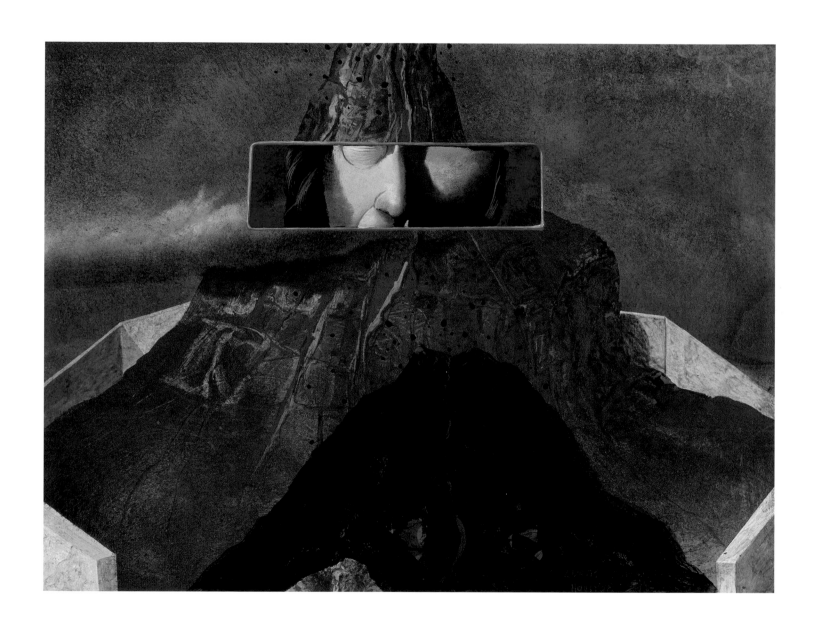

MOTORING SOUTH #2, 1992
Acrylic on canvas mounted on wood
12 x 16 inches
Private collection, Houston

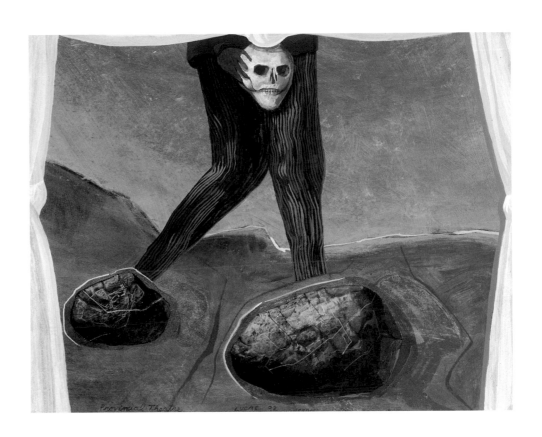

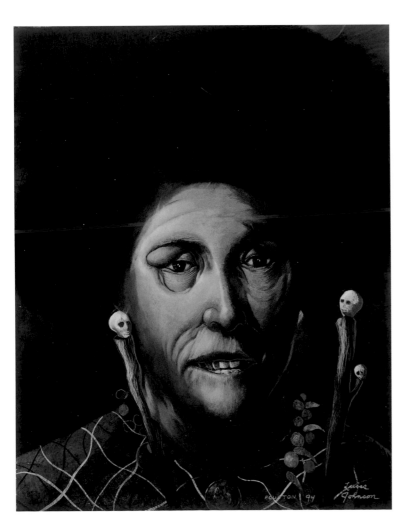

PROVINCIAL THEATER, 1993
Acrylic on paper mounted on canvas
11 x 13¾ inches
Patricia Covo Johnson, Houston

MARIE LAVEAUX, 1994
Oil on panel
14 x 11 inches
Donald R. Mullins Jr., Austin

Paricutín, 1994
Acrylic and oil on canvas
72 x 96 inches
William and Alice Cook, Houston

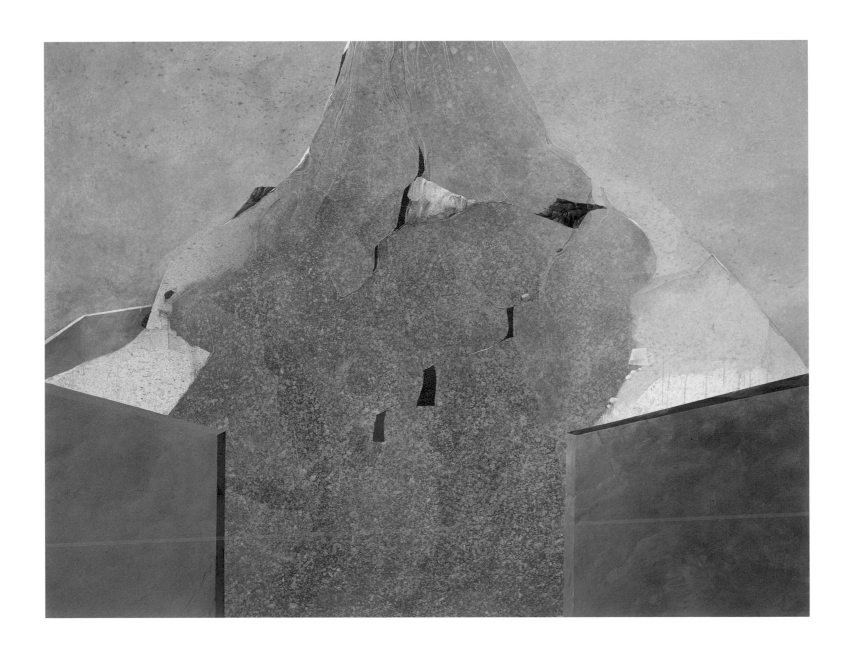

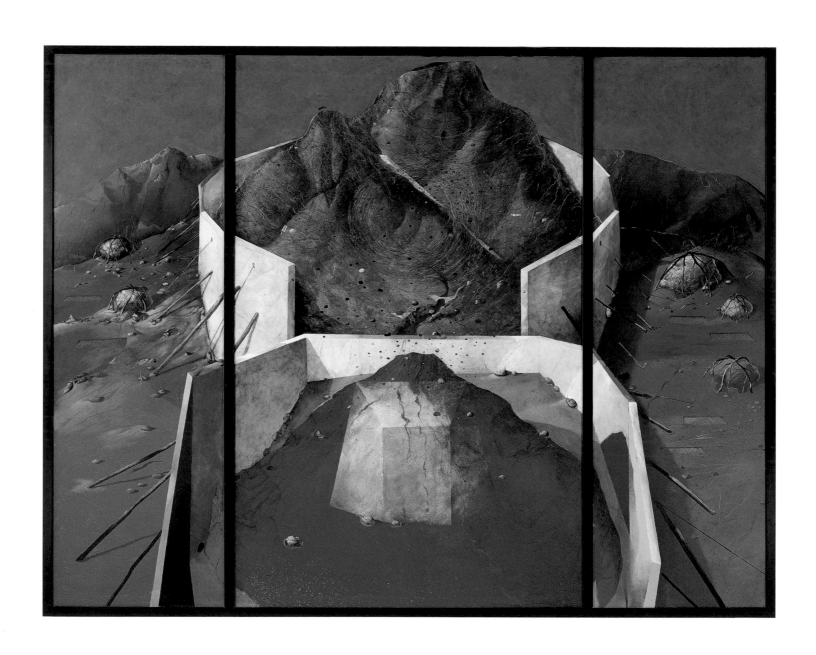

POLITICAL PRISONER (VOLCANO SERIES), 1994
Oil on canvas
Triptych: 74 ½ x 96 ½ inches overall
Jack and Jan Cato, Houston

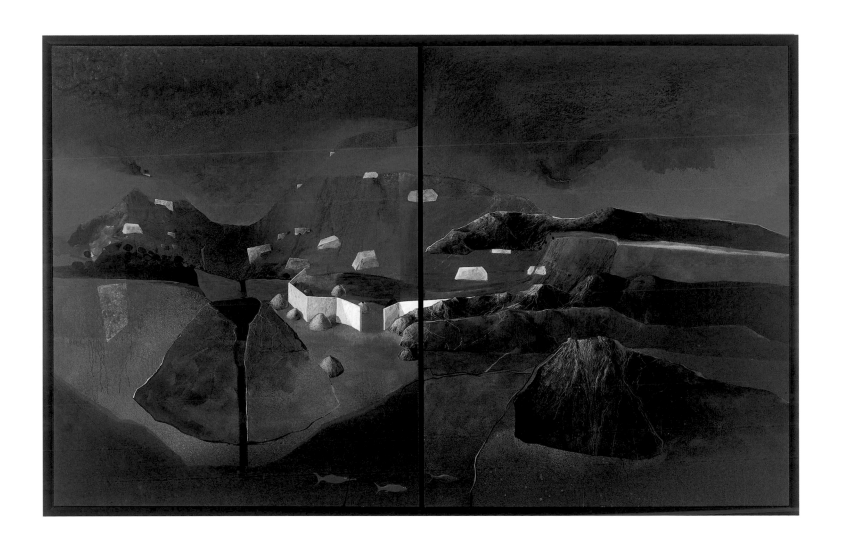

Untitled (MONUMENT SERIES), 1996
Oil glaze over acrylic on canvas
Diptych: 62 7/8 x 99 3/8 inches overall
Michelle Judson and Barry Hembree, Houston

WHISPER, 1996
Acrylic on canvas
60 x 48 inches
Jody Blazek, Houston

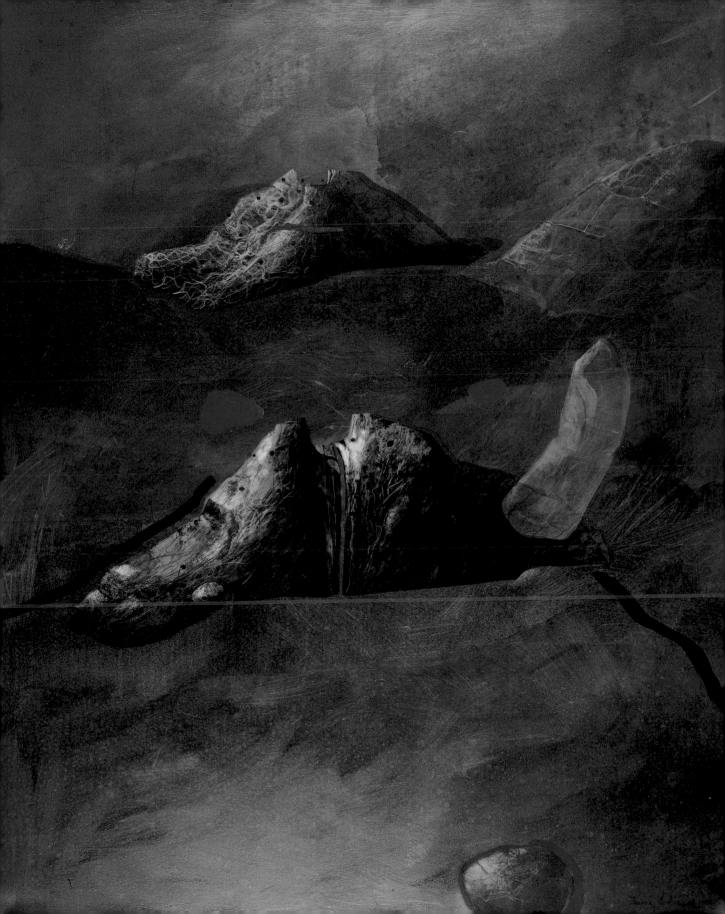

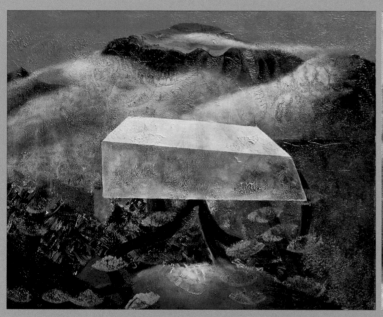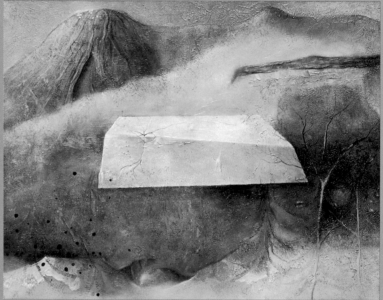

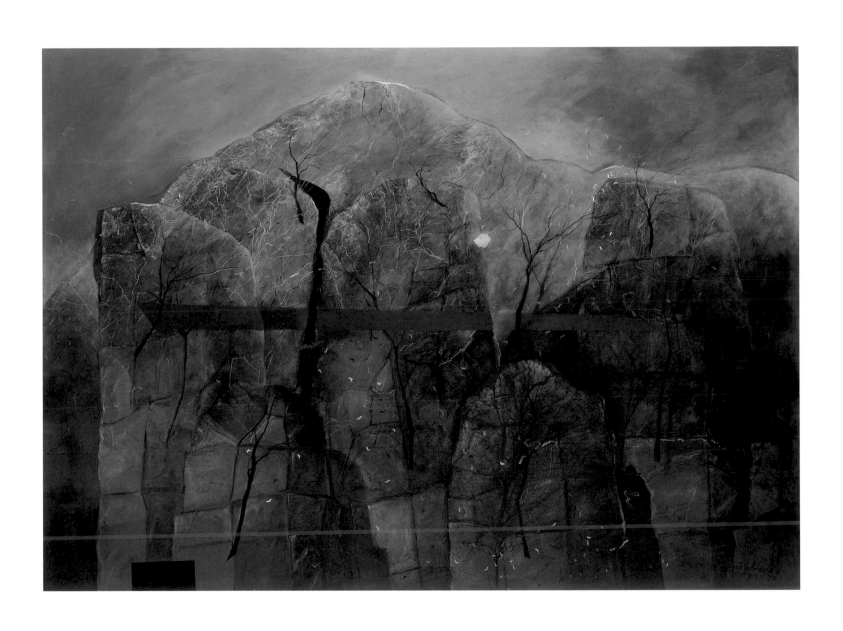

CLOUD FOREST, TAMAULIPAS, 1999
Oil on canvas
Diptych: 15 7/8 x 40 1/2 inches overall
Linda Katz and Ross Harrison, Houston

FRONTERA [BOUNDARY], 1997
Oil glaze over acrylic on canvas
60 x 84 inches
Edward Stanton and Diane Baker, Houston

Untitled, 1994
Acrylic on canvas
24 x 30 inches
South Texas Institute for the Arts, Corpus Christi.
Purchase funded by the Corpus Christi Art Foundation

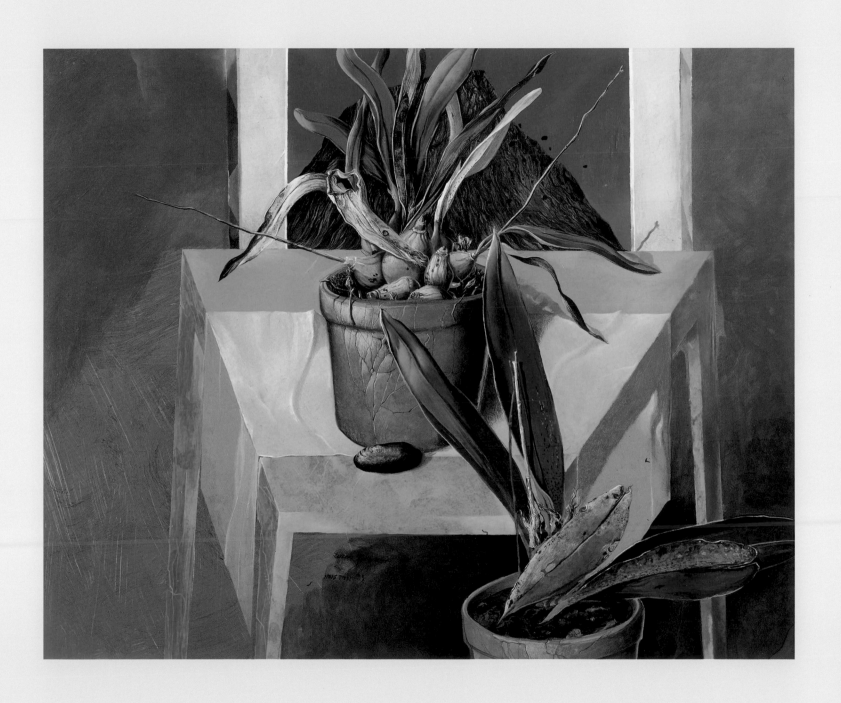

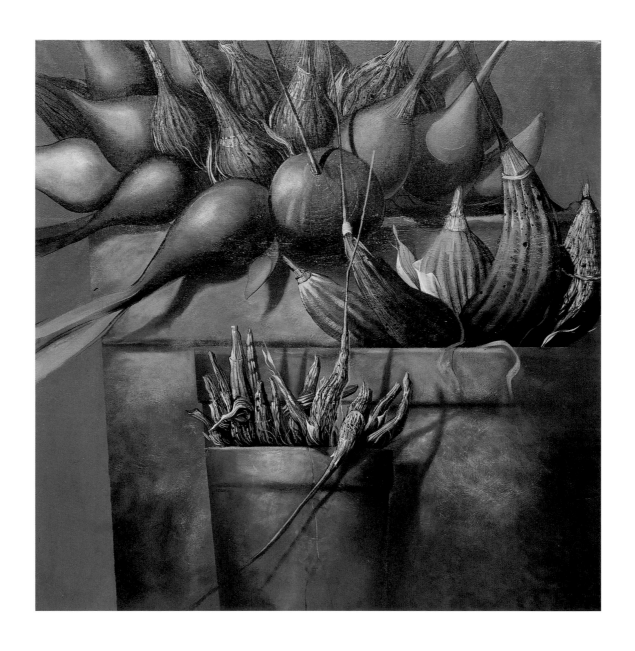

Trinity, 1999
Oil glaze over acrylic on canvas
24 x 24 inches
Kathy Poeppel and Dick Moiel, MD, Houston

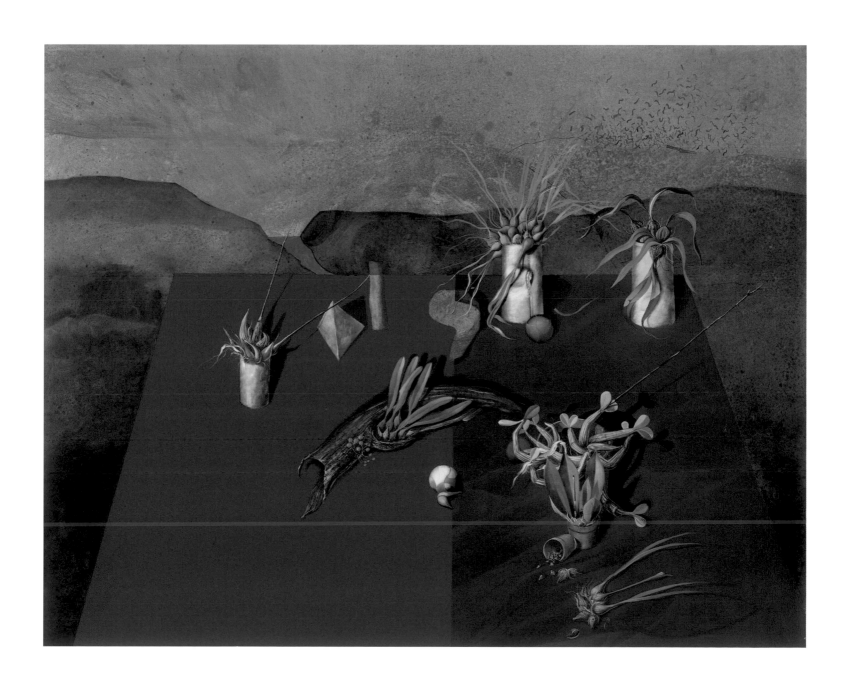

RED TABLE, 1999
Oil on canvas
63 ¼ x 80 inches
Irina Lanhans, Houston

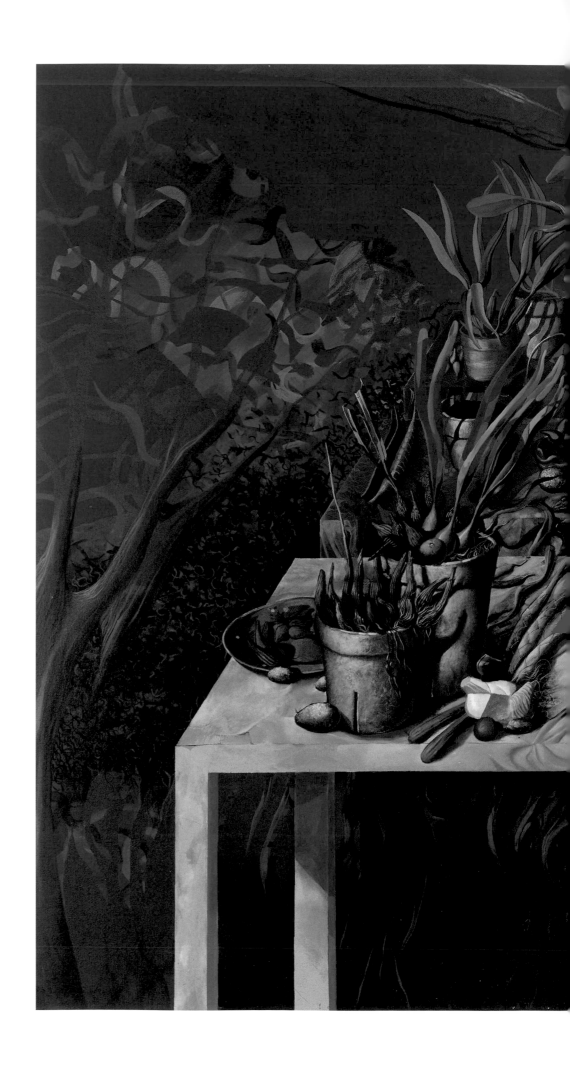

TRES MESAS [THREE TABLES], 1999
Oil on canvas
60 3/8 x 84 1/8 inches
Dana Roy Harper, Houston

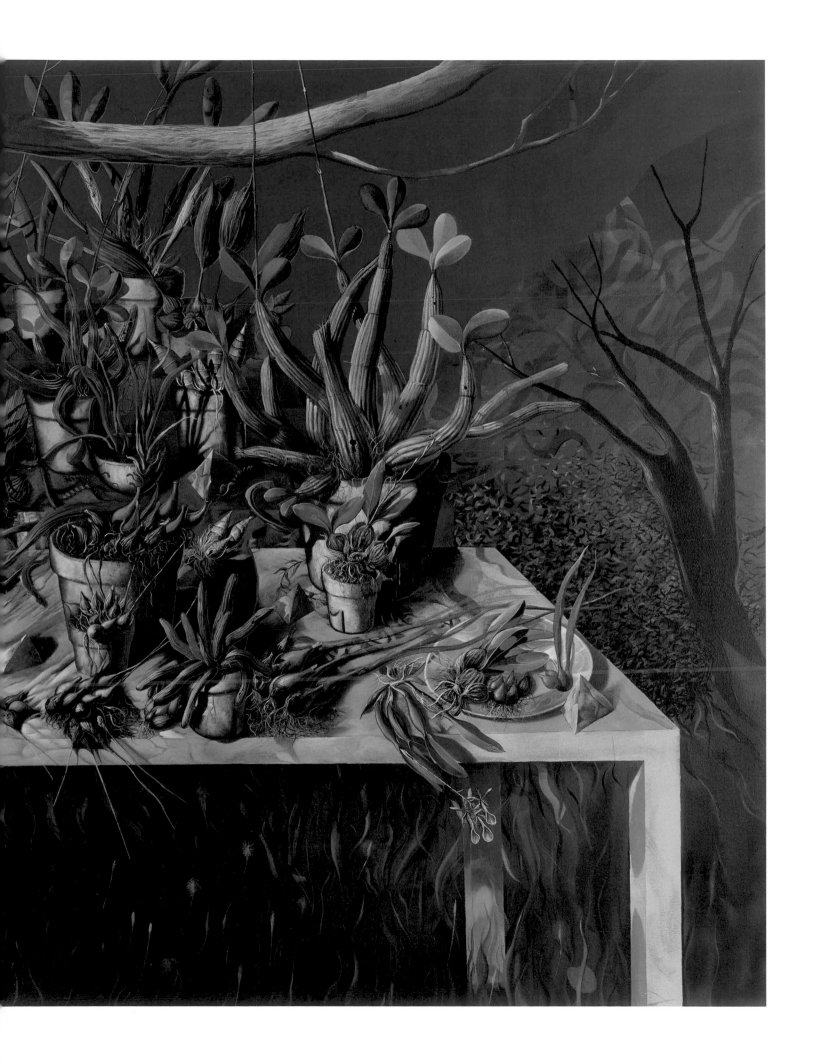

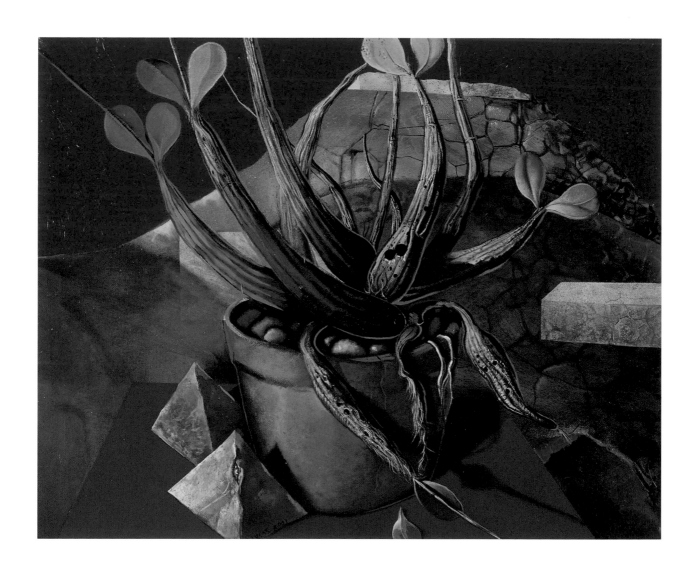

Untitled, 2001
Oil glaze over acrylic on canvas
16 x 19⅞ inches
Lil Nelms and Robert L. Ingram Jr., Houston

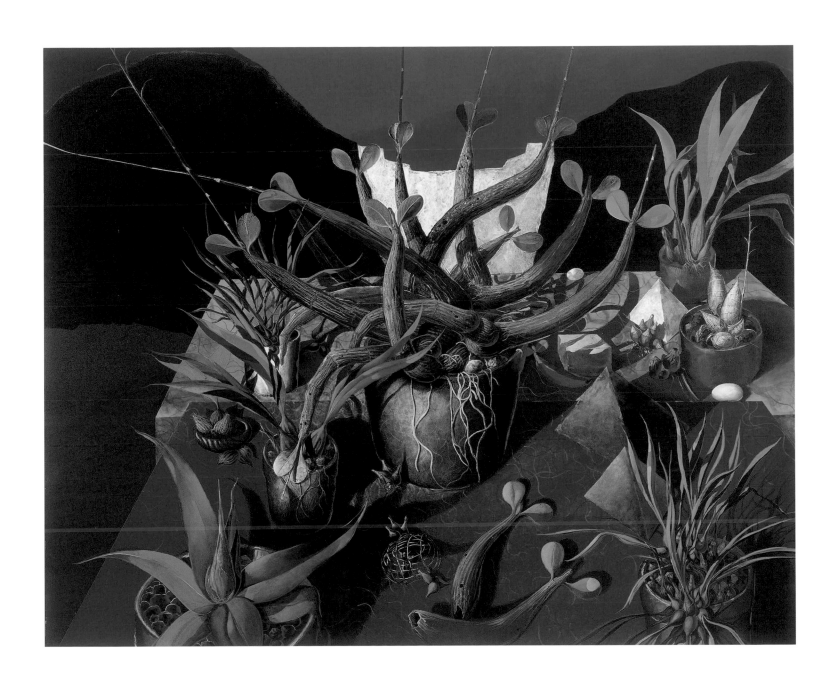

Still Life with Schomburgkia, 2001
Oil glaze over acrylic on canvas
48 x 60 inches
Patricia Covo Johnson, Houston

TWO TABLES, 2001
Acrylic on canvas
47 7/8 x 60 inches
Patricia Covo Johnson, Houston

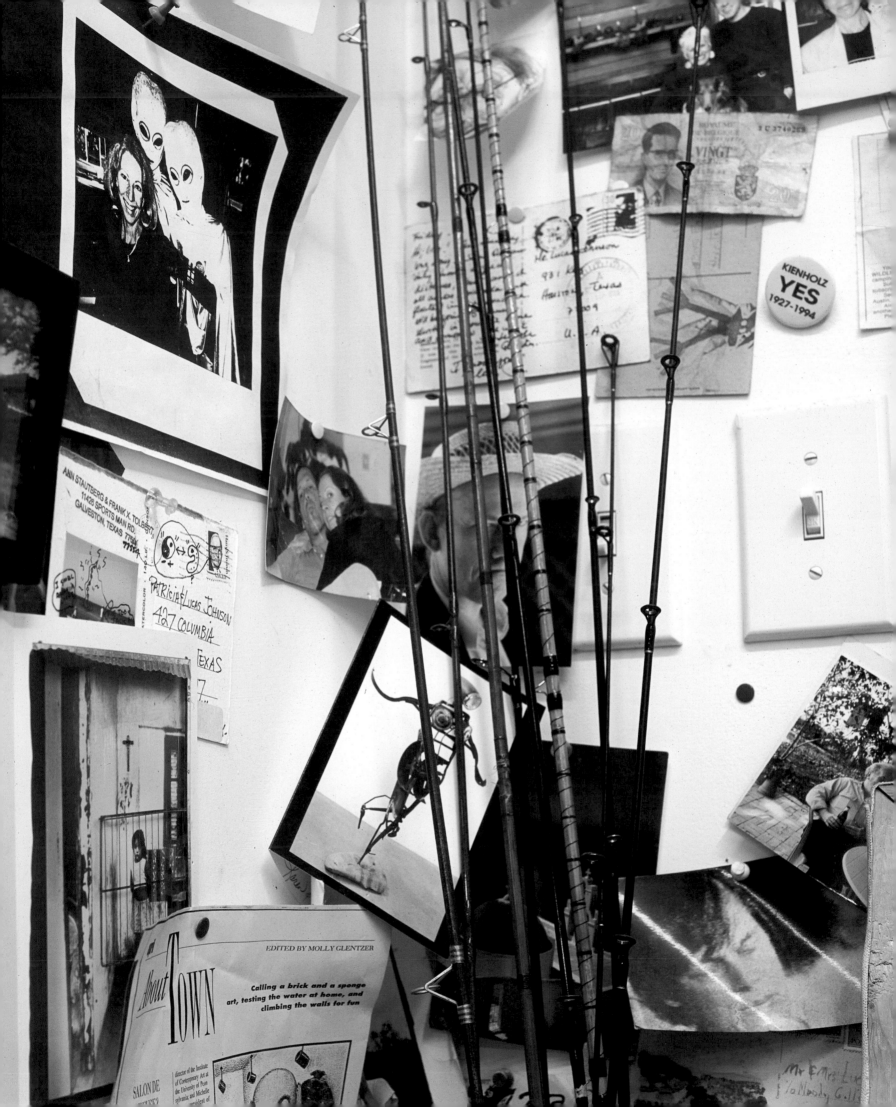

Works on Paper

1965–1996

Note: For editions, specific collections are omitted.

page 90: Johnson's ephemera and fishing rods, Columbia
Street studio, Houston, 2002.

Pobre [Poor One], 1966
Ink and ink wash on paper
8 1/8 x 11 1/8 inches
Bill Steffy, Houston

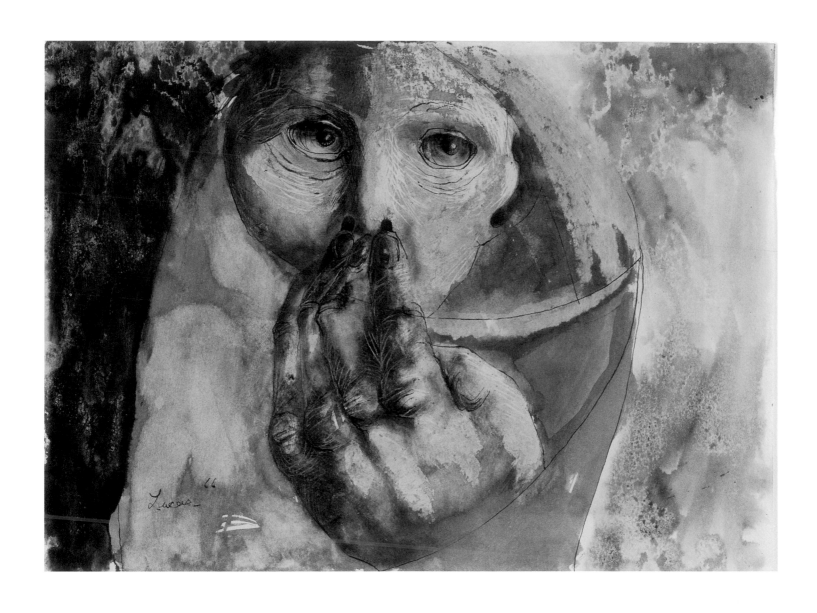

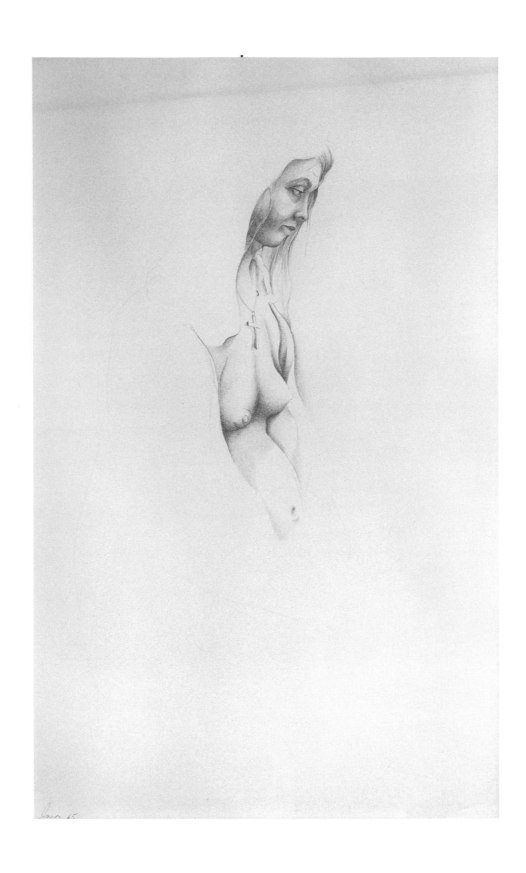

Untitled, 1965
Pencil on paper
25 1/8 x 19 1/8 inches
Private collection, Mexico City

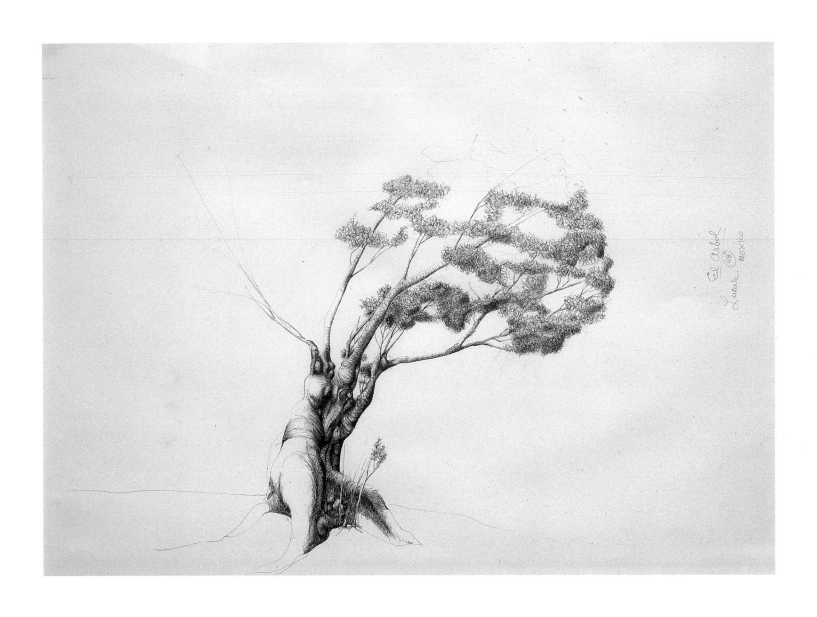

EL ÁRBOL [THE TREE], 1968
Ink on paper
21 x 28 1/2 inches
John and Laura Fain, Houston

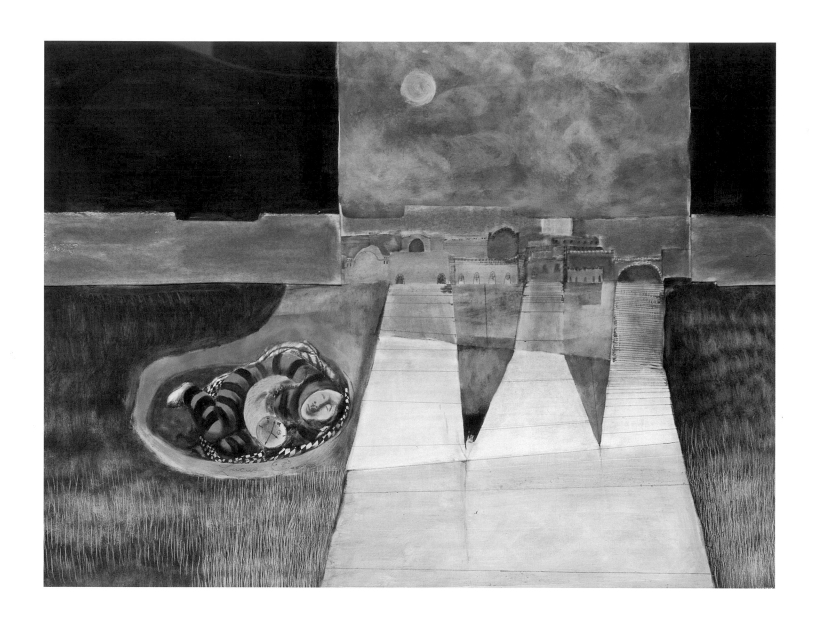

Untitled, 1967
Watercolor, ink, and collage on paper
21 1/2 x 28 3/4 inches
Laura Jackson, Houston

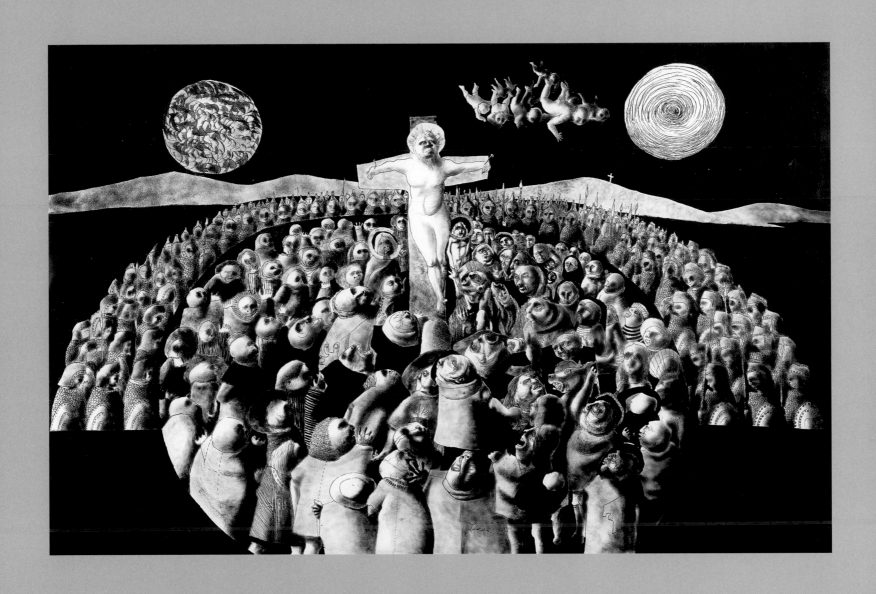

CRUCIFIXION, 1967
Ink and ink wash on paper
22 ¾ x 35 inches
Private collection, Mexico City

Carnaval [Carnival], 1970
Pen and ink and ink drawing collage on paper
14 7/8 x 11 3/8 inches
Patricia Covo Johnson, Houston

Untitled, 1969
Ink and collage on paper
13 1/2 x 10 1/2 inches
Elizabeth and Jack Weingarten, Houston

Círculo [Circle], 1969
Ink and paper collage on paper
13 5/8 x 10 3/4 inches
Carol Taylor, Dallas

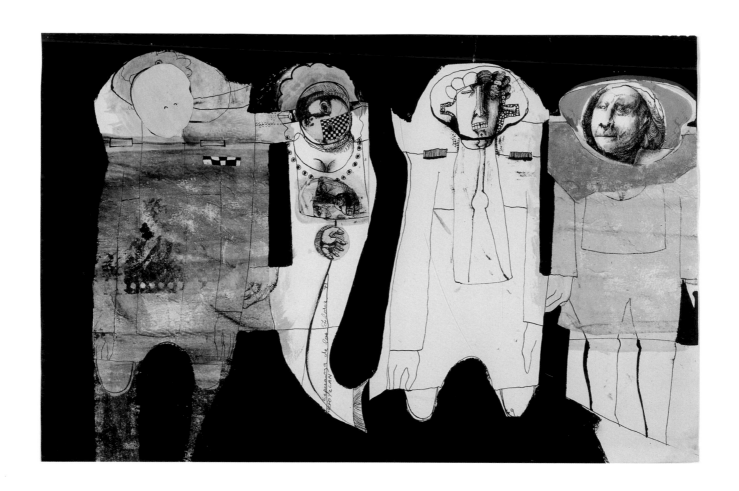

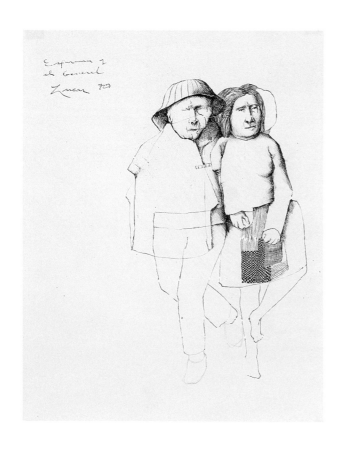

Esperanza de las Flores, 1971
[Esperanza of the Flowers], 1971
Pen and ink and ink drawing collage on paper
11 5/8 x 17 3/4 inches
Patricia Covo Johnson, Houston

Esperanza y el general
[Esperanza and the General], 1970
Pen and ink on paper
11 1/2 x 8 3/4 inches
Carol Taylor, Dallas

opposite:
Familia [Family], 1970
Acrylic on paper
30 x 21 1/2 inches
Patricia Covo Johnson, Houston

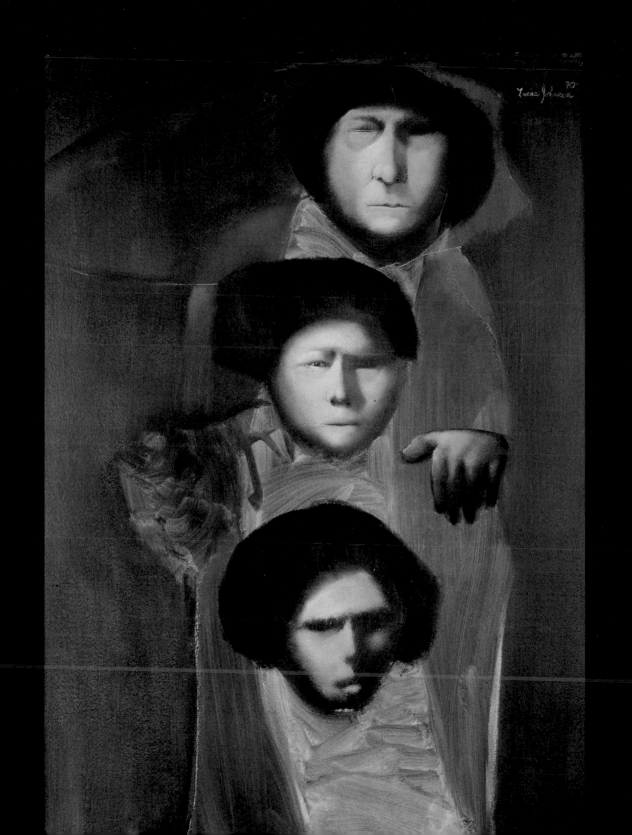

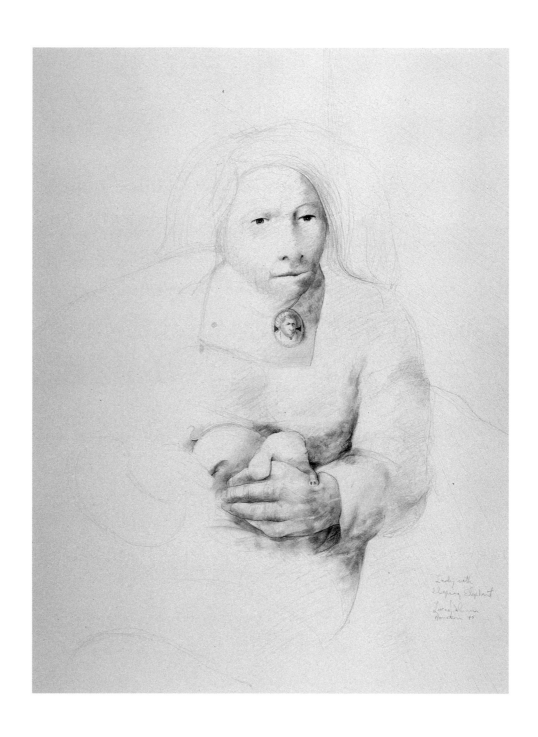

LADY WITH SLEEPING ELEPHANT, 1975
Graphite on paper
30 x 22 ¼ inches
Private collection, Houston

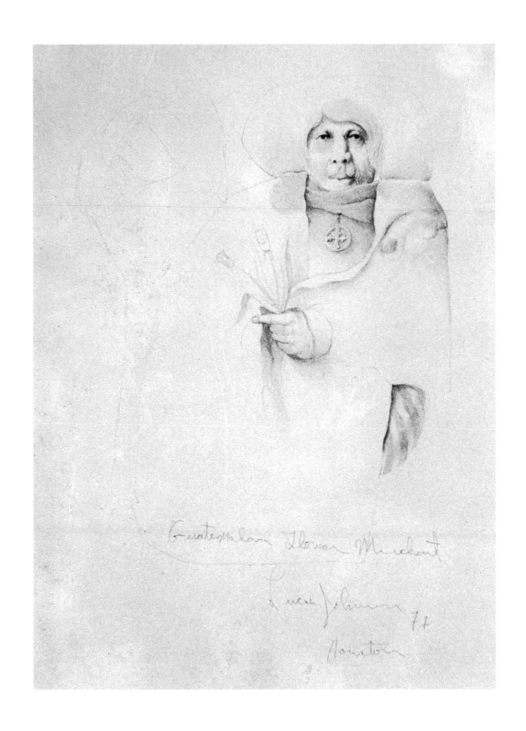

GUATEMALAN FLOWER MERCHANT, 1977
Graphite on paper
11 x 8 inches
Private collection, Houston

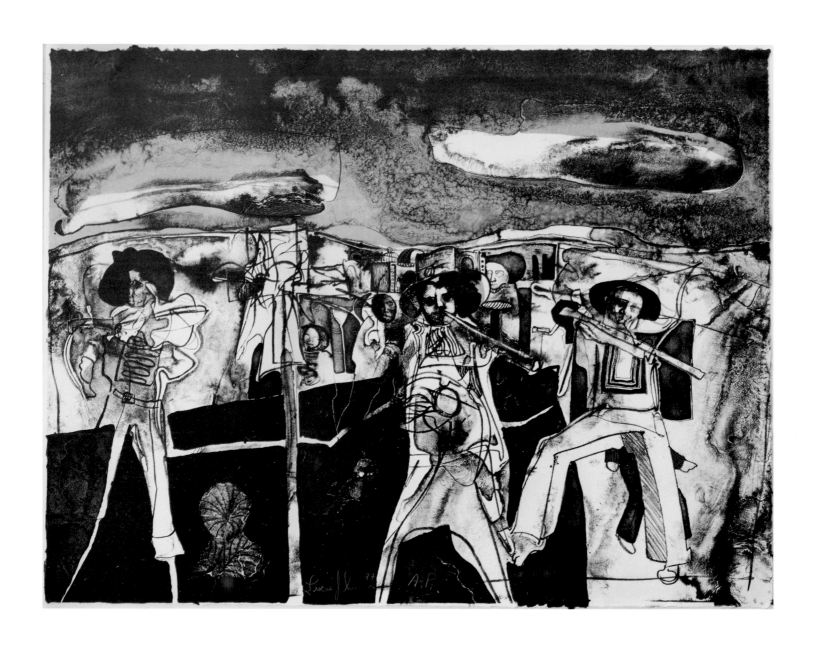

Los músicos [Musicians], 1977
Lithograph, edition of 30
19 1/2 x 25 3/4 inches

Untitled, 1980
Gouache on paper
17 ½ x 24 inches
Ursula Brinkerhoff, Houston

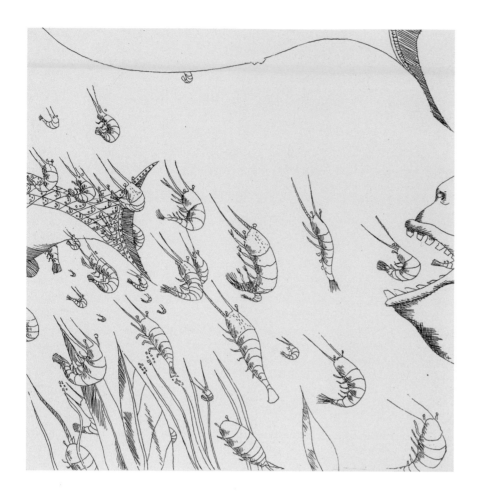

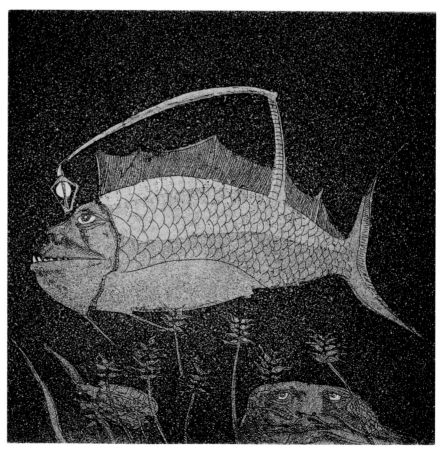

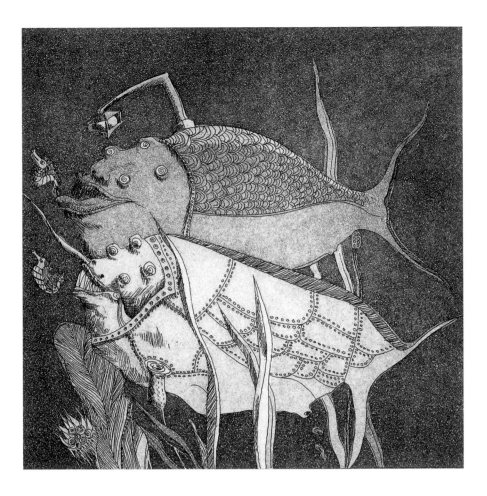

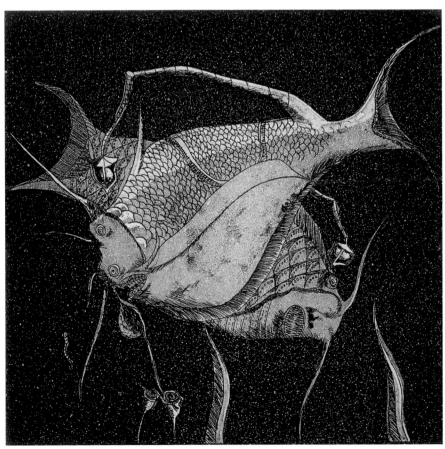

Bottom Feeders 1, 2, 3 & 4, 1980–1981
Etching and aquatint, edition of 20
5 x 5 inches, image, each

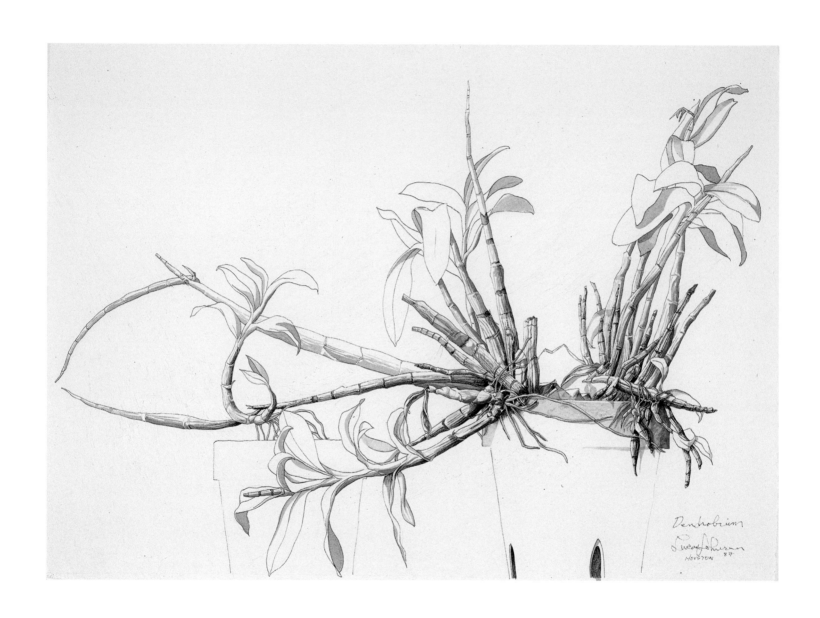

DENDROBIUM, 1987
Ink and ink wash on paper
23 x 30 1/2 inches
Meredith and Cornelia Long, Houston

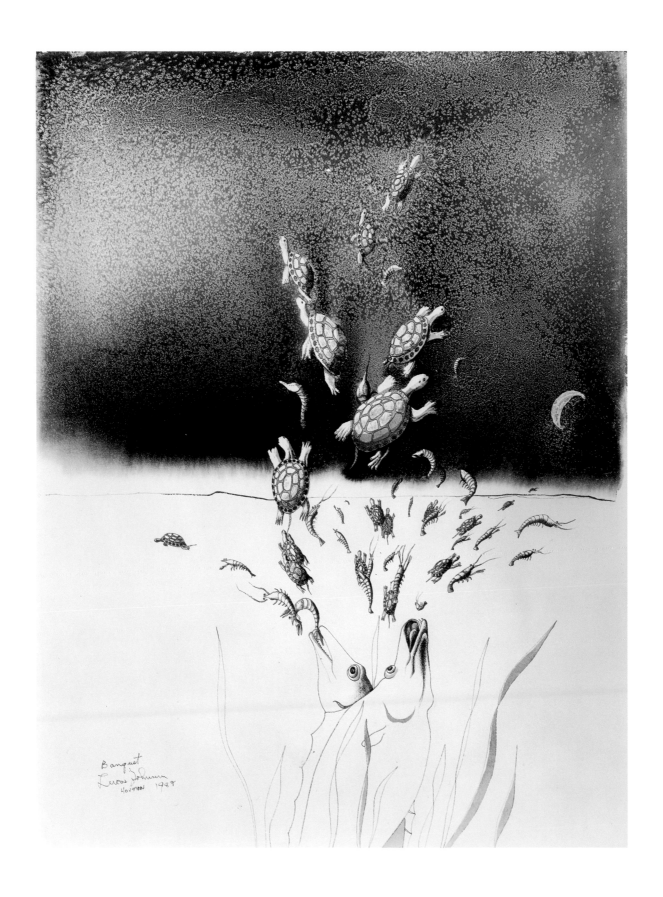

THE BANQUET (GULF COAST ESTUARY SERIES), 1987
Pen and ink and salt wash on paper
30 1/2 x 23 inches
Mario Covo, New York

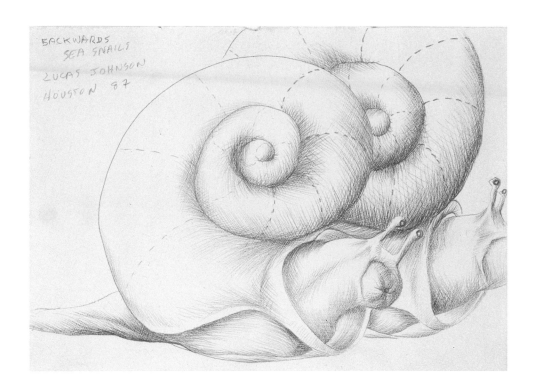

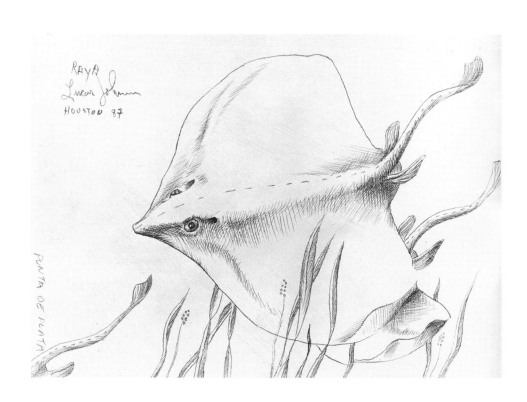

Backward Sea Snails, 1987
Silverpoint on gessoed paper
5 ¼ x 7 ⅜ inches
Walter Hopps and Caroline Huber, Houston

Raya [Ray], 1987
Silverpoint on gessoed paper
5 ¼ x 7 ¼ inches
Dorrie and Arthur Melvin, Houston

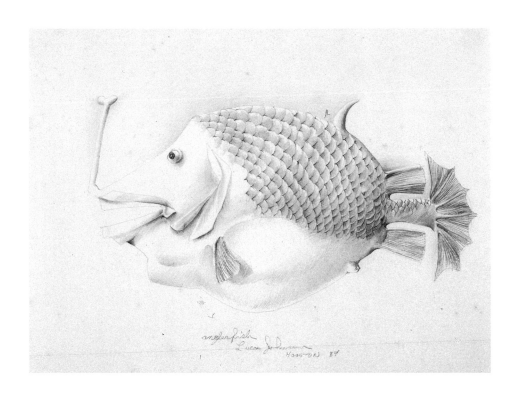

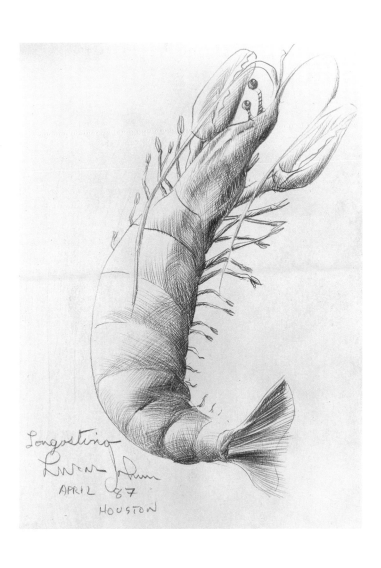

ANGLERFISH, 1987
Pencil on paper
9 x 12 inches
Ursula Brinkerhoff, Houston

LANGOSTINO, 1987
Silverpoint on gessoed paper
7 1/4 x 5 1/4 inches
Bill Sadler, Houston

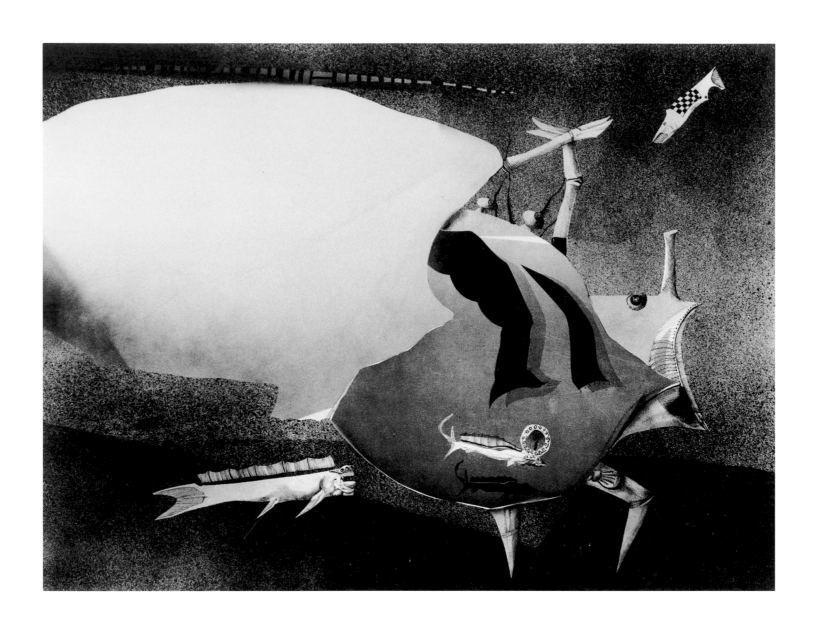

Untitled (Gulf Coast Estuary Series), 1987
Ink, ink wash, and spray acrylic on paper
22 1/2 x 30 inches
Private collection, Houston

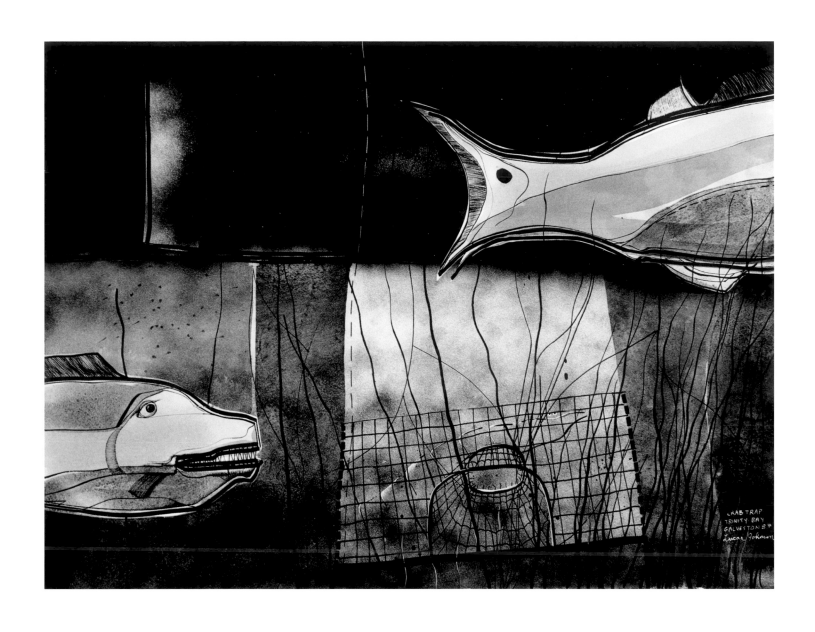

CRAB TRAP, TRINITY BAY (GULF COAST ESTUARY SERIES), 1987
Ink and ink wash on paper
22 1/2 x 30 1/4 inches
Private collection, Houston

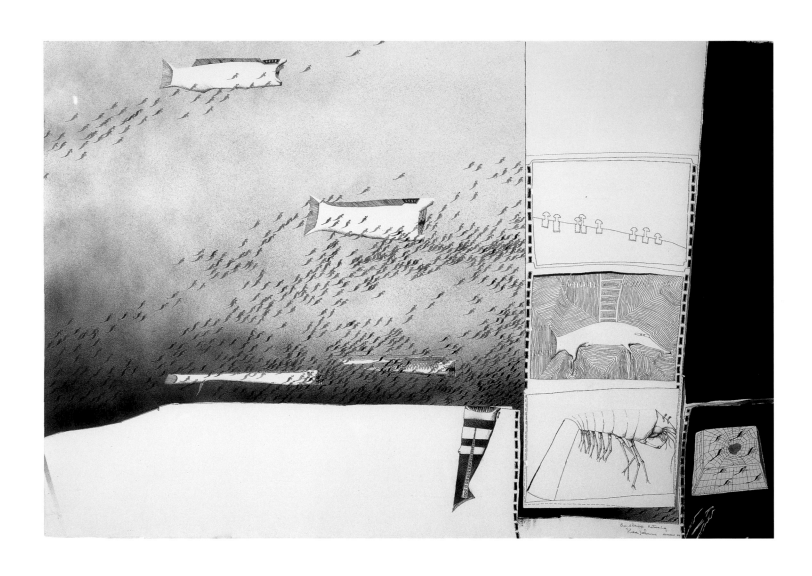

BAY SHRIMP RETURNING (GULF COAST ESTUARY SERIES), 1988
Ink and ink wash on paper
59 1/2 x 40 1/4 inches
Martha MacDonald, Houston

AQUARIUM IN ALVARADO, 1988
Pen and ink and ink wash on paper
31 1/2 x 47 1/2 inches
Private collection, Dallas

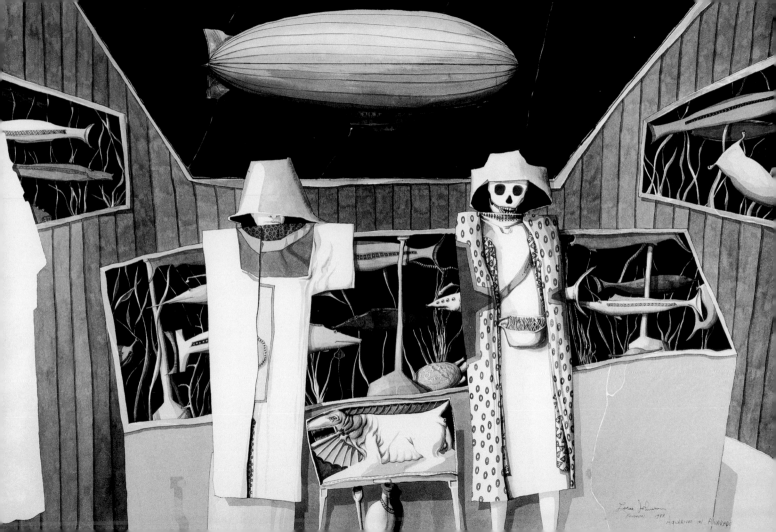

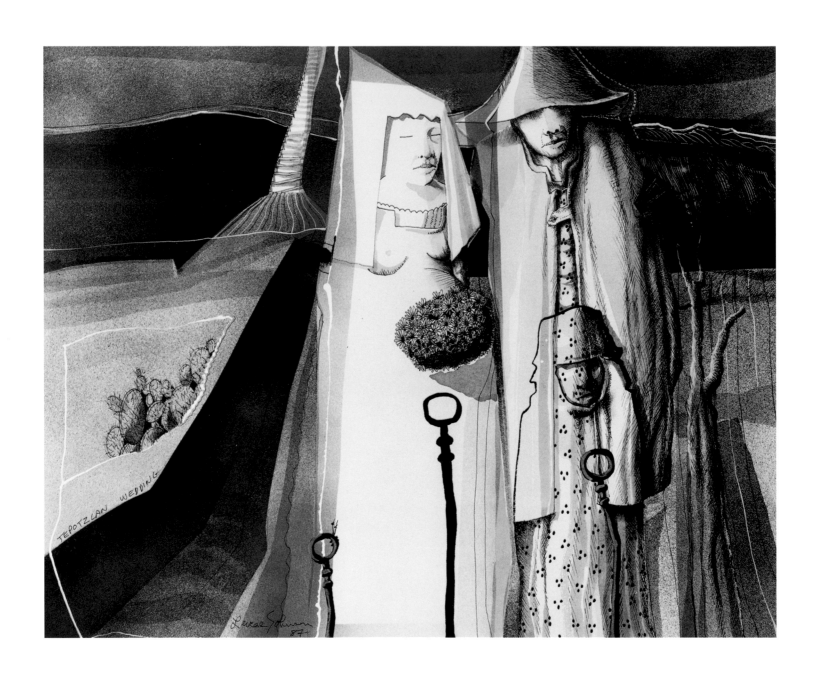

Tepotztlán Wedding, 1987
Ink and latex on paper
15 x 18 1/4 inches
Judy M. Youens, Santa Fe

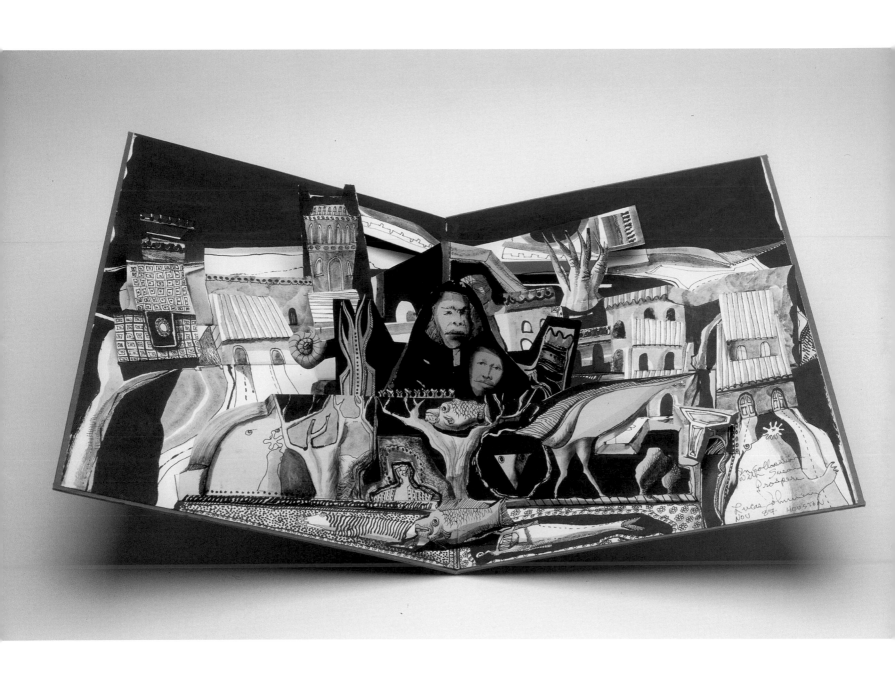

The Wide World, 1987
Pen and ink on pop-up format paper in portfolio boards
13 x 19 x 10 inches
Susan Prospere, Houston

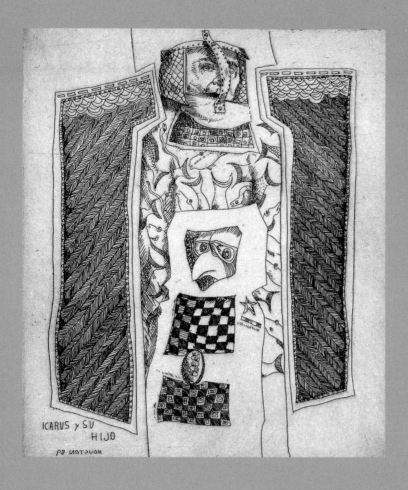

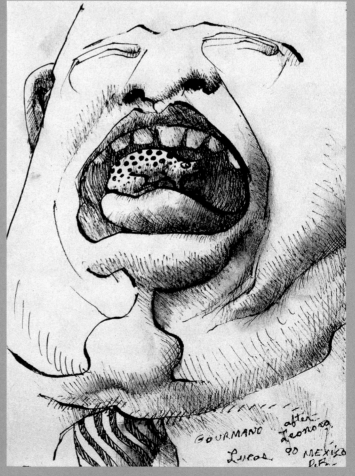

Icarus y su hijo [Icarus and His Son], 1989
Etching, edition of 50
6 1/2 x 5 1/4 inches, image

Gourmand, After Leonora, 1990
Ink and ink wash on paper
7 1/4 x 5 1/4 inches
Private collection, Houston

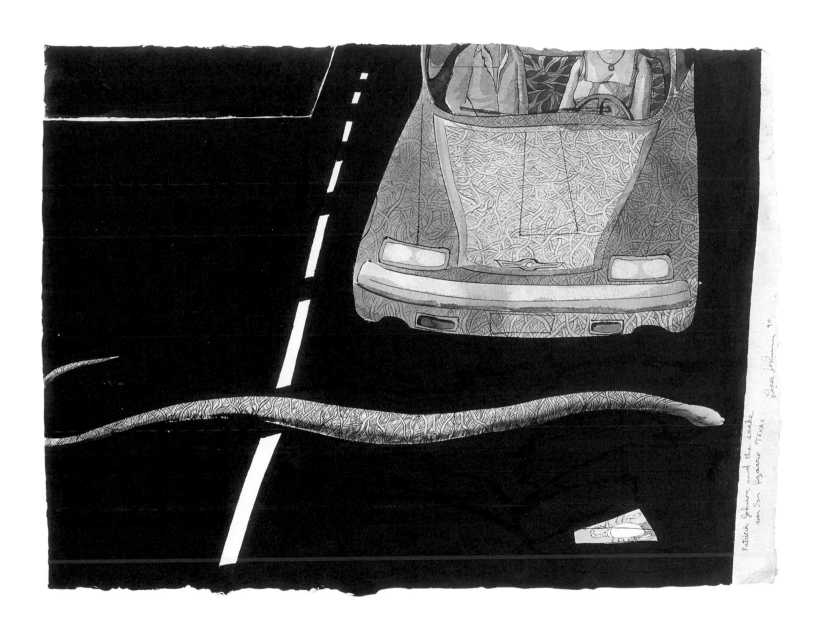

PATRICIA JOHNSON AND THE SNAKE, 1990
Ink and ink wash on paper
30 x 38 inches
Patricia Covo Johnson, Houston

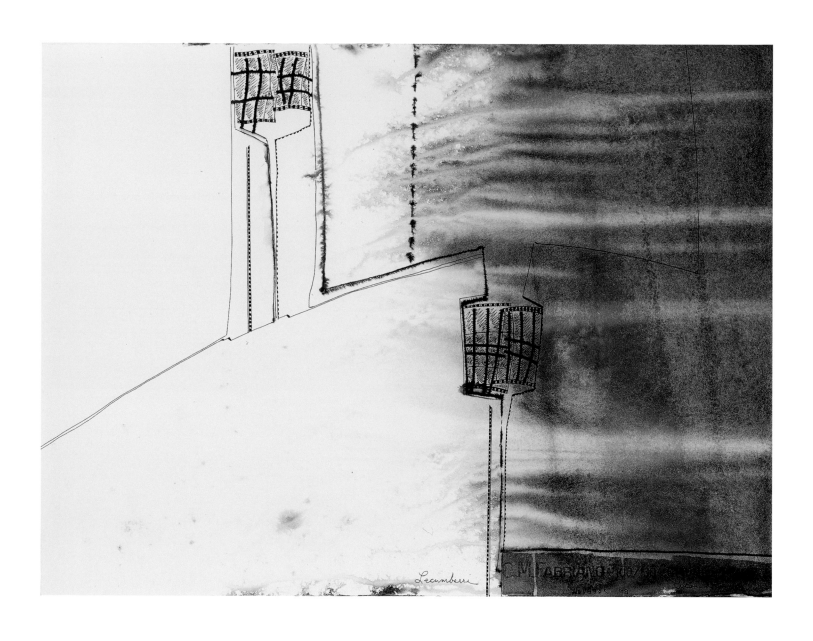

LECUMBERRI, 1989
Ink and ink wash on paper
22 1/4 x 29 3/4 inches
Patricia Covo Johnson, Houston

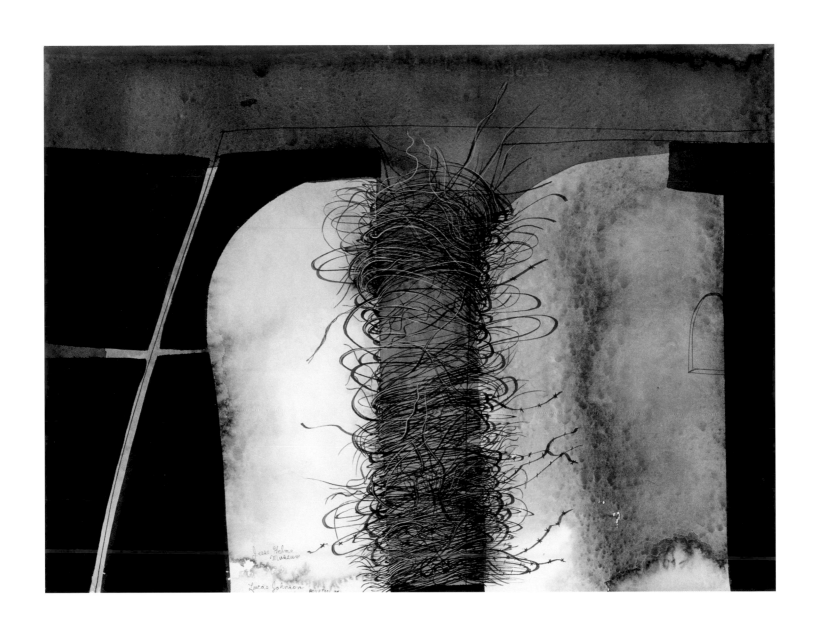

JESSE HELMS MUSEUM, 1990
Ink and ink wash on paper
22 1/4 x 29 3/4 inches
Patricia Covo Johnson, Houston

AFTERMATH, 1989
Ink and ink wash on paper
40 x 60 inches
Private collection, Mexico City

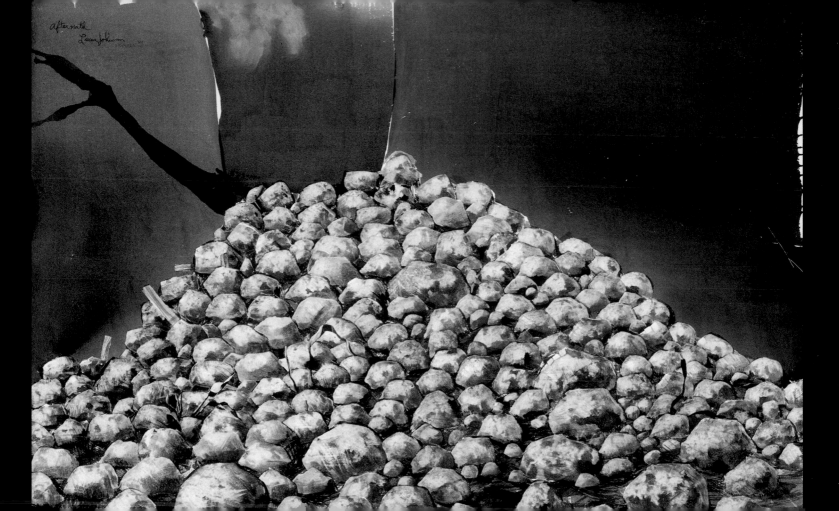

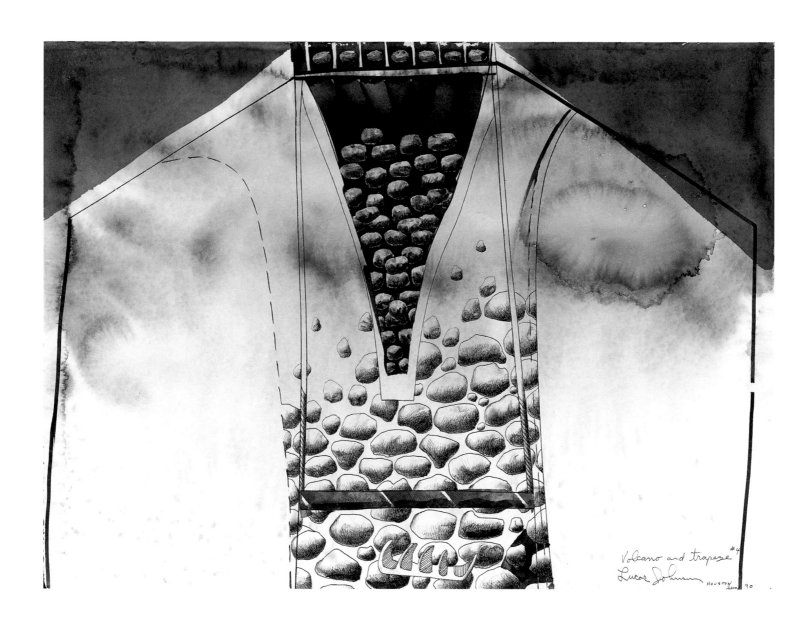

VOLCANO AND TRAPEZE #4, 1990
Ink and ink wash on paper
22 3/4 x 30 1/2 inches
Private collection, Houston

VOLCANO AND TRAPEZE #2, 1990
Ink and ink wash on paper
80 1/2 x 60 inches
Private collection, Houston

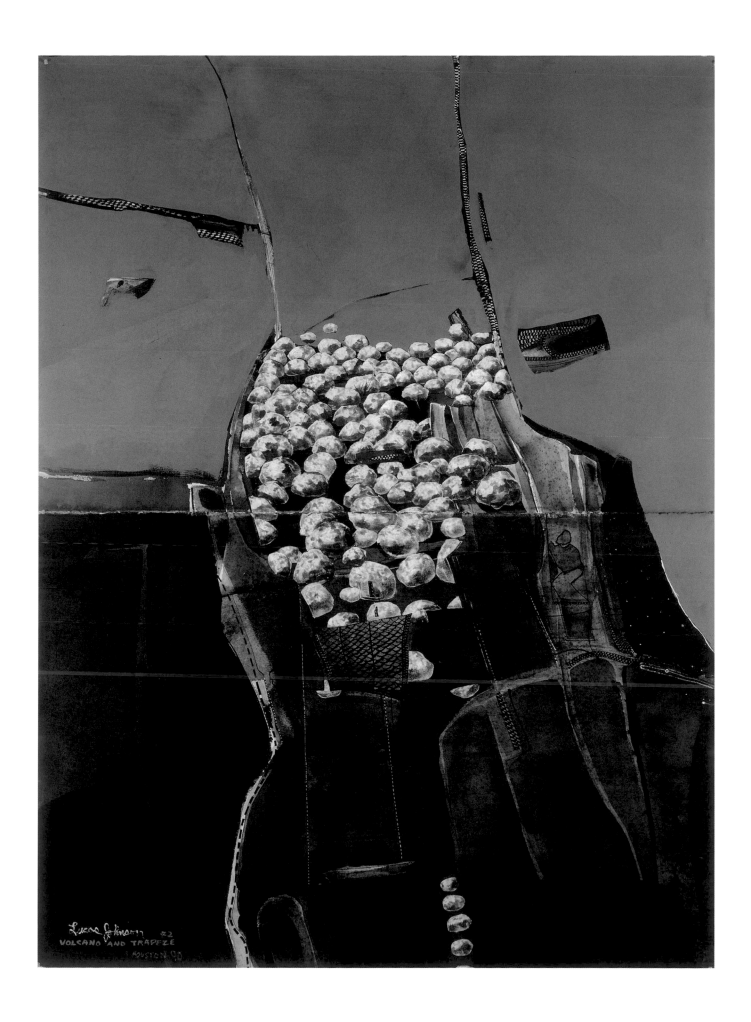

FLOWER GARDEN (DRAWINGS FROM THE UNDERWORLD), 1993
Ink and ink wash on paper
22¼ x 30⅛ inches
William Hill Land and Cattle Co., Houston

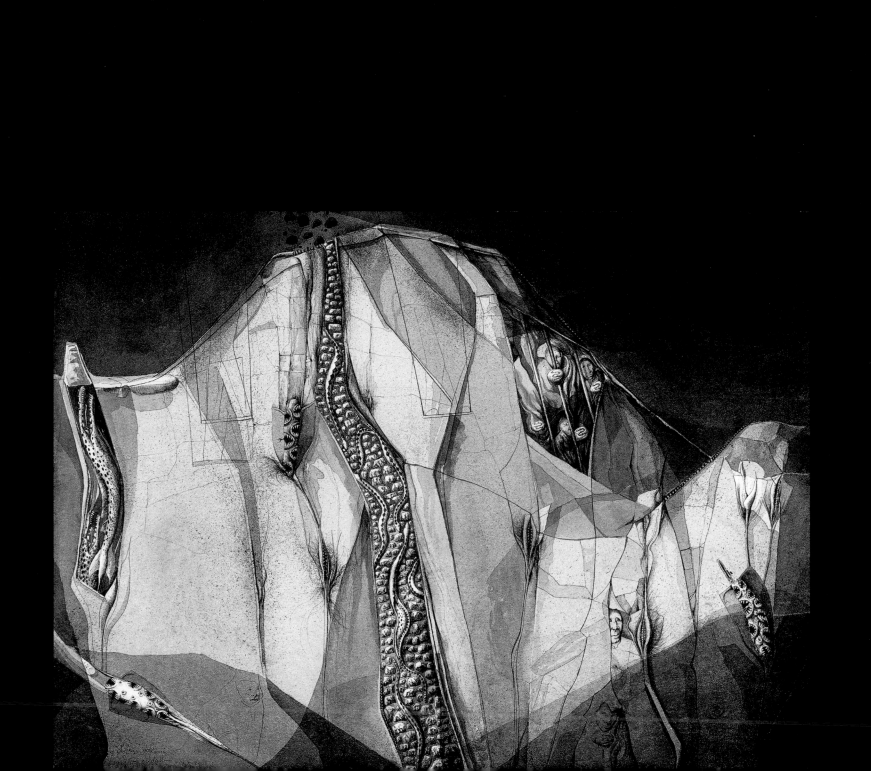

Untitled (DRAWINGS FROM THE UNDERWORLD), 1993
Ink and ink wash on paper
22¼ x 30¼ inches
Patricia Covo Johnson, Houston

Tres Marías [Three Marías] (Drawings from the Underworld), 1993
Ink and ink wash on paper
22 ¼ x 30 ¼ inches
The Barrett Collection, Dallas

La iglesia y los ciegos [The Church and the Blind]
(Drawings from the Underworld), 1994
Ink and ink wash on paper
22½ x 30 inches
Marilyn Oshman, Houston

Untitled (DRAWINGS FROM THE UNDERWORLD), 1994
Ink and ink wash on paper
16 x 14 1/4 inches
Private collection, Houston

LLAMADA [THE CALL], 1994
Ink and ink wash on paper
12 1/4 x 9 1/2 inches
Betty Moody and Bill Steffy, Houston

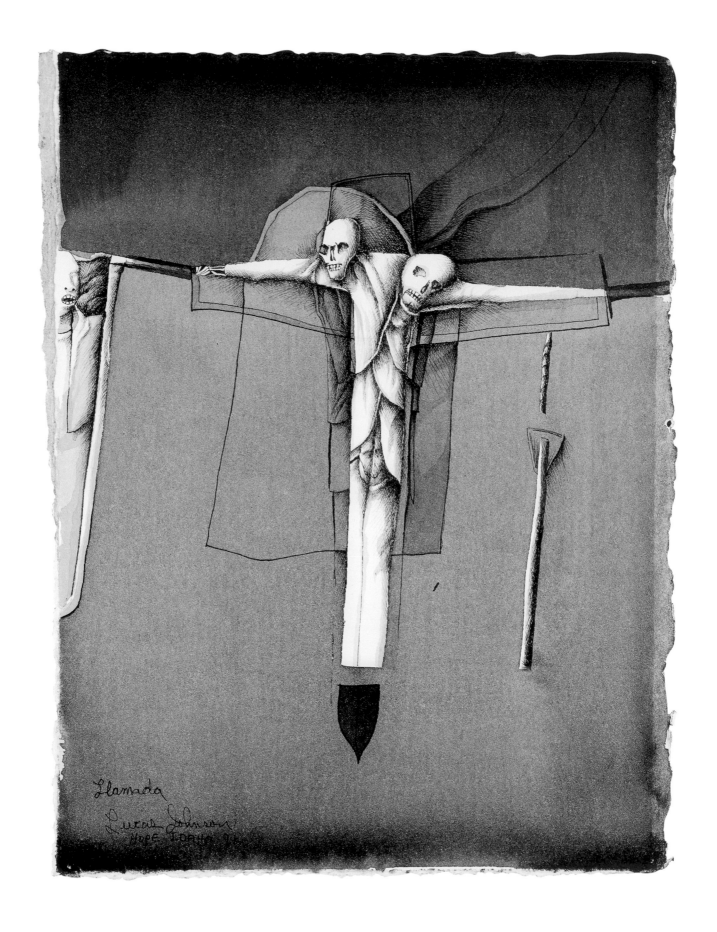

Llamada
Lucas Johnson
HOPE FORUM

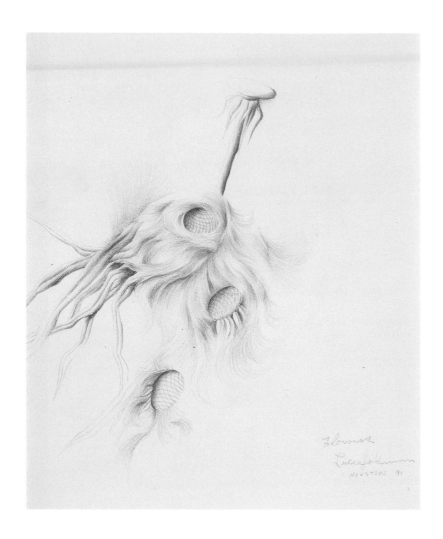

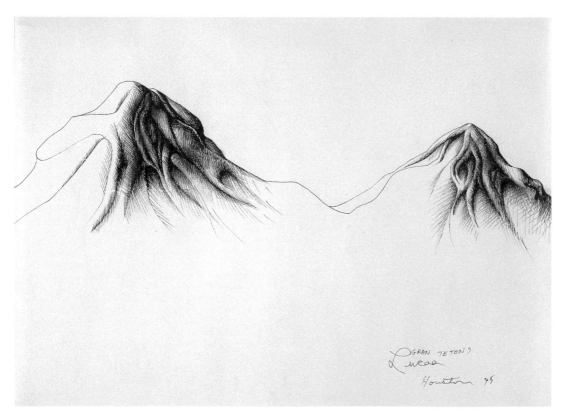

FLOWERS, 1995
Silverpoint on gessoed paper
12 x 9 inches
Patricia Covo Johnson, Houston

GRAND TETONS, 1996
Ink on paper
9 x 11 3/4 inches
Private collection, Houston

HIVE, 1995
Ink and ink wash on paper
30 x 40 inches
Patricia Covo Johnson, Houston

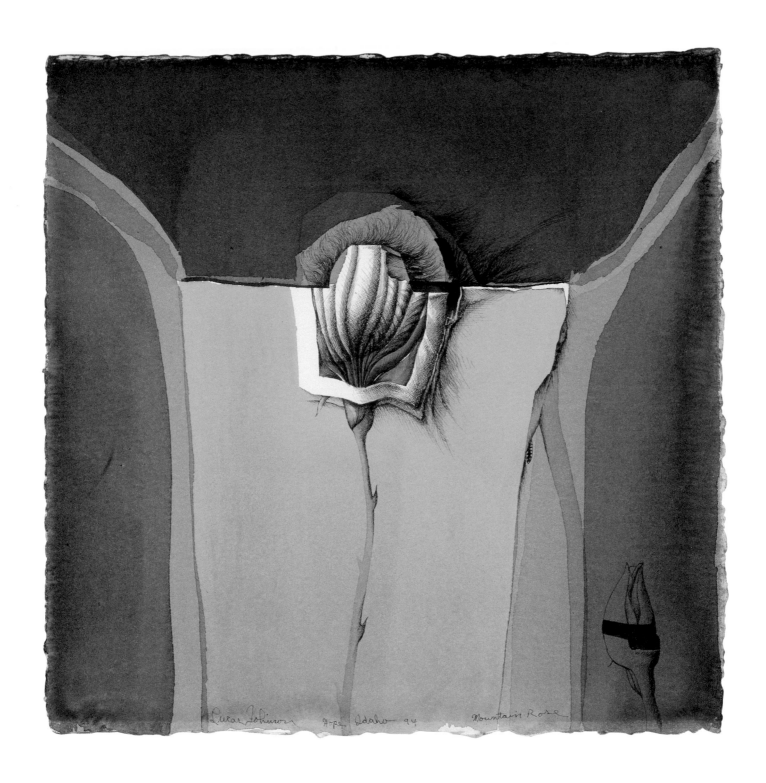

MOUNTAIN ROSE, 1994
Ink and ink wash on paper
12¼ x 12¼ inches
Patricia Covo Johnson, Houston

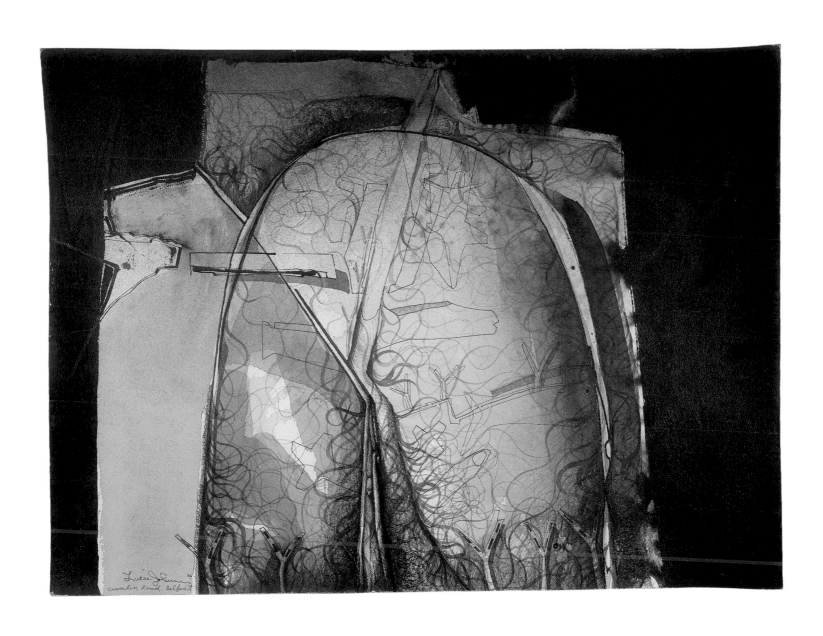

CRUMLIN ROAD, BELFAST, 1996
Ink and ink wash on paper
22⅛ x 30 inches
Private collection, Houston

Untitled, c. 1995
Ink and ink wash on paper
9 x 6 1/4 inches
Private collection, Houston

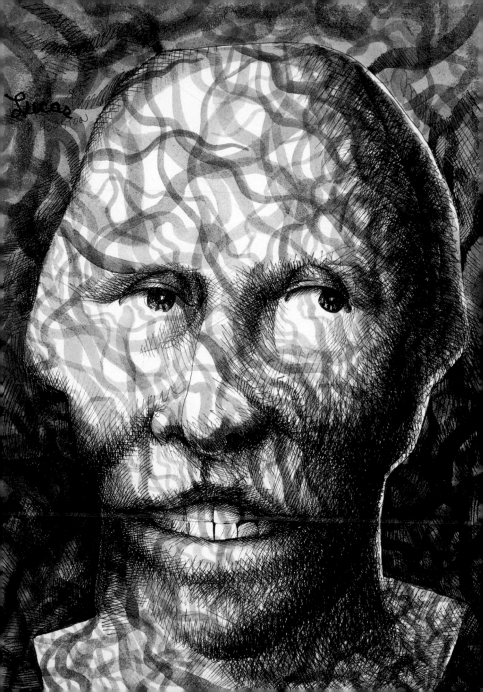

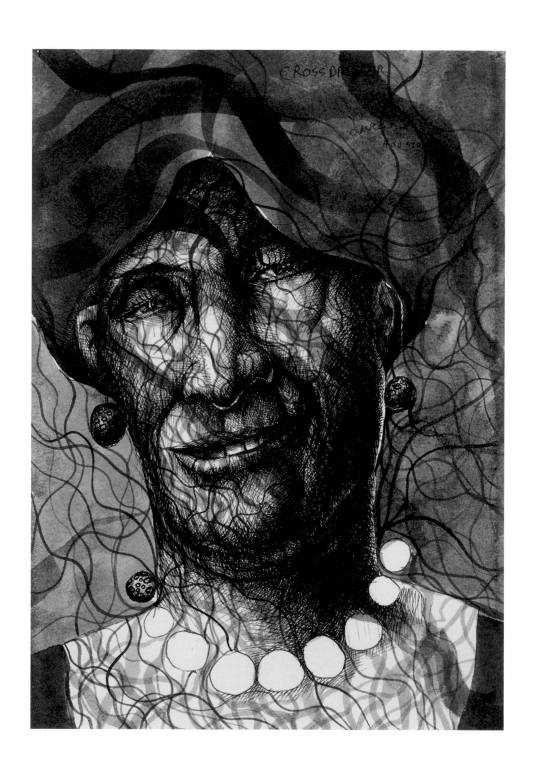

CROSSDRESSER, 1996
Ink and ink wash on paper
9 x 5¼ inches
Private collection, Houston

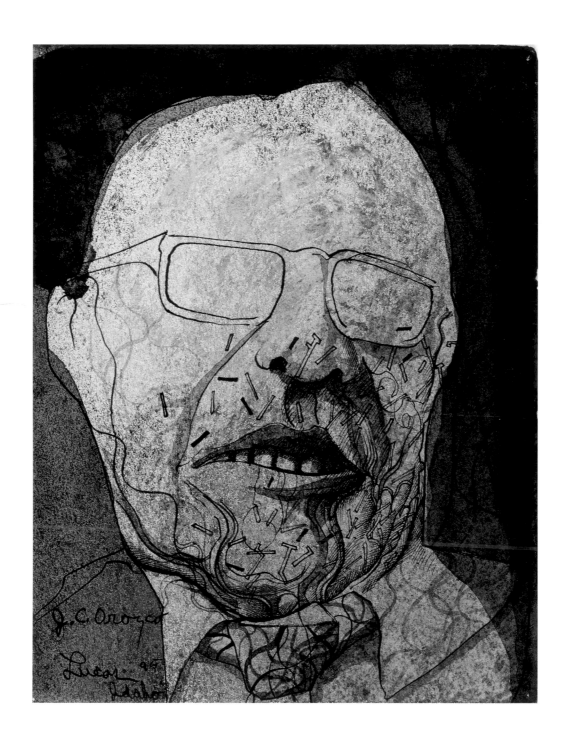

J. C. Orozco, 1995
Ink and ink wash on paper
9 x 7 inches
Patricia Covo Johnson, Houston

SELF-PORTRAIT, 1996
Scratchboard
7 x 5 inches
Vicky Trammel and Ben Russell, Houston

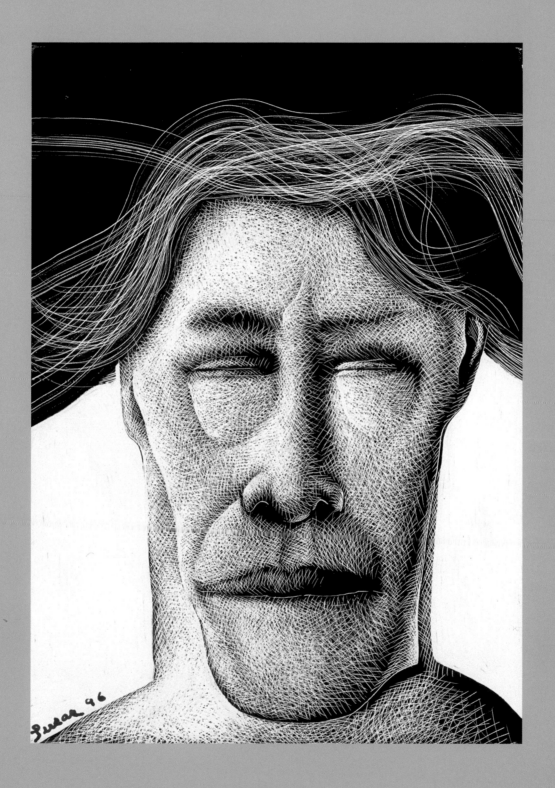

Chronology, Exhibition History,
and Selected Bibliography

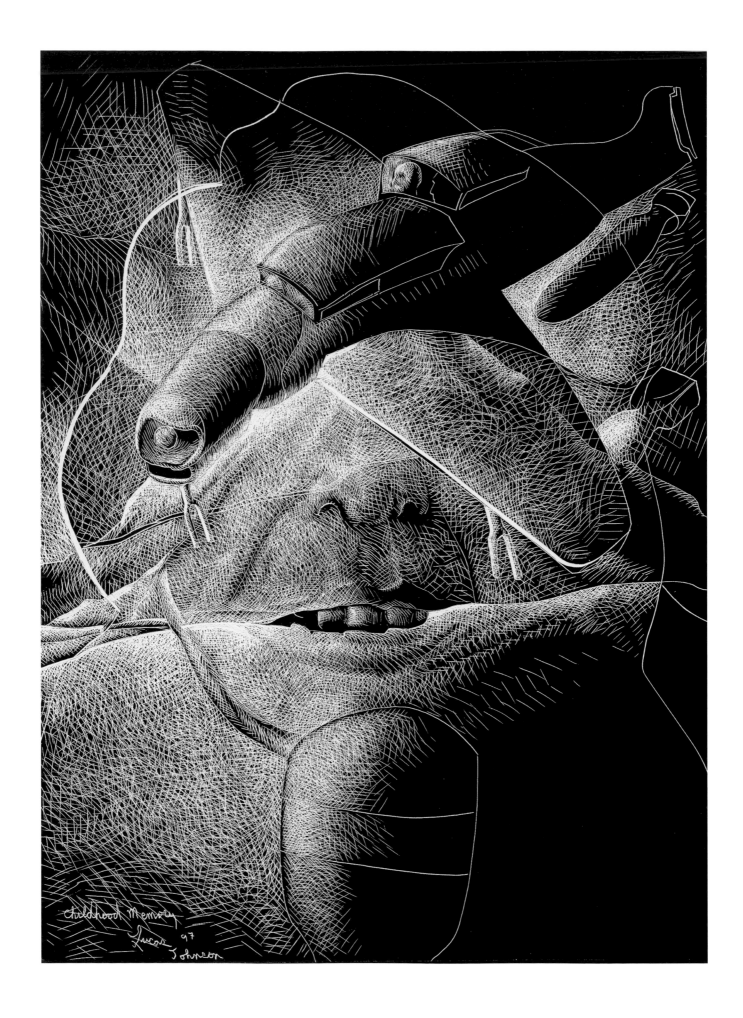

Chronology: The Art and Life of Lucas Johnson

PATRICIA COVO JOHNSON

I called Lucas the Yankee with a Latin soul. Raised in Protestant New England, Lutheran and stoic, he opened his heart and passion to the people and the language of Mexico. The landscape and mysticism of the country, with its rich and multifaceted culture, became a cornerstone of his art.

In his early drawings and paintings, the subjects were personages tied to the humanist impulses of artists in the 1960s that re-introduced humankind—its shape, myths, hopes, triumphs, tragedies—as the center of the work.

After he moved to Texas, his imagery grew more abstract, more symbolic, but humanity is always present. It is explicit in the figures of the early work, where the young artist responded to the life around him, informed by myth and natural beauty, in conditions that were devastatingly poor yet powerfully spiritual. His compassion did not abate in later years, but deepened as he witnessed the ignorance, intolerance, and sheer stupidity of hate groups and government policies that forget that people just want to live. Humanity became implicit in those later works—in the walls that surround his volcanoes, in the still-life tables crowded with an artist's tools, and in the potted orchids of his last paintings.

There was humor, too, wry and astute, sometimes ribald in image and wordplay. It surfaced in conversations about art and politics, and entered his graphic work in punning images.

"I never paint where I am," he often said. Lucas took his time in order to "distill and pick out the unnecessary detail, so just the strong images stay," he said, "magic moments that you have, certain images that strike you."

He took the time, too, to indulge his bottomless curiosity about just about everything—politics, literature, the who and why of people's lives, the qualities of different art materials and techniques, how fish respond to certain lures, how to do plumbing and fine woodworking. His sharp eye could see a bird in a tree before others saw the tree.

Lucas "didn't rush," Nancy Reddin Kienholz recalls. "There was always time for digression to observe birds or orchids, Texas longhorns or salt grass flats. Lucas taught me to see the beauty of flatlands. Secondary roads were Lucas's way. I loved traveling those roads with him. Always having time to stop for a cup of coffee or a bird on a wire."

Funny how life unwinds in twists and turns you don't see coming. Lucas followed wherever his heart led, hungry to experience whatever life offered. He turned one of those corners one day, and lucky for me, I was there waiting for him.

Files are lost; people die. This chronological narrative is based on available records covering nearly four decades of Lucas Johnson's work. Newspaper and magazine articles have been crucial in constructing the chronology and providing descriptions. Lucas rarely spoke about his art, and his innate shyness made him a difficult, though compelling subject for interviews. But he did answer questions, and those video and print exchanges have supplied an invaluable record of his thoughts.

"People are always asking me about the symbols in my work, but I'm superstitious about talking about my painting. It's like giving away the magic. When I do talk, I don't work for weeks."[1]

Lucas was never good at remembering dates, and he didn't keep a calendar, but he could recall specific activities and events, both personal and professional, with detailed accuracy. Those recollections became familiar, making this re-creation of Lucas's story a voyage across memories, mine and those of many others who shared them with me in conversations and letters.

page 144: View of Columbia Street studio, Houston, 2002.

fig. 11 Lucas Johnson, *Childhood Memory*, 1997, scratchboard, 12 x 9 inches. Private collection, Houston.

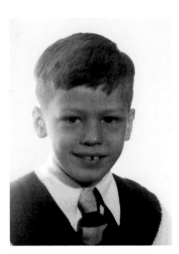

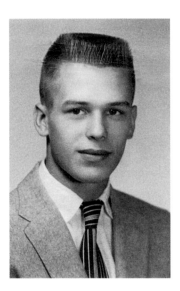

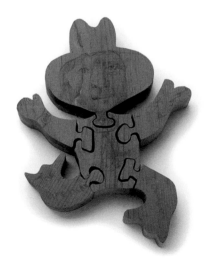

1940–1962

Leonard Lucas Johnson Jr., born October 24, 1940, in Hartford,
Connecticut, was the second child of Leonard Lucas Johnson and
Dorothy Gustafson, and brother to Suzanne.

Leonard Sr., born in Havana to Swedish parents, was a manager
at the Pratt & Whitney plant in Hartford. He was a brilliant man
with a fluent command of languages and dreams of becoming an
interpreter. He was also an alcoholic who would go on binges that
left the family in continuous poverty. His drinking and repercus-
sions from his support of labor organizing led to his dismissal from
one job after another. When Lucas was seven, the family moved to
San Gabriel, California, near Los Angeles. Leonard Sr. hoped times
would be better. They weren't, but the family survived.

Lucas, then called Leonard, daydreamed in class, staring out
the window and doodling in notebooks. On a class field trip to the
Huntington Library sometime during elementary school, he saw
Thomas Gainsborough's famous *Blue Boy*. He remembered the visit
clearly. "When I was a child, I was taken to a museum as part of a
class [trip]. Most of the kids ran around looking at everything.
I just saw one painting that I just thought—I couldn't believe some-
body could do it. I spent the whole time we were there looking at
the painting, trying to figure out how to do it. I was inspired.
I thought it was magic. I found out later that it is. I've really been
trying to get that good ever since."[2] For Christmas that year, he
asked for an artist's pencil.

When he graduated from high school, he enrolled at the
University of California–Los Angeles, intending to get a degree in
marine biology. He quit before his junior year. It wasn't what he
wanted to do—he had always known he wanted to be an artist.

By that time his father's alcoholism had driven him out of his
parents' home. After one of many violent arguments, Lucas finally
left. "When Leonard left, Dad was angry," Lucas's sister, Suzanne
Green, recalls. "He said Leonard was wasting his life, that he
could've done something with his life."

Lucas had also earlier married Sharon Johnston, his high school
girlfriend. They lived in California for a while, and then in Hawaii,
but divorced about a year later.

Lucas began to wander.

He remained out of touch with his family until 1975, when his
mother was finally able to track him to Houston. She told him his
father had died nine years before. "We had tried to find him, through
Social Security and the draft board, places like that, when Dad was
still around," Suzanne says. "Dad didn't know we were looking.
Mom and I finally got word back of Leonard's whereabouts through
the American Embassy in Mexico, but Dad had died by then."

Lucas vividly recalled working his way cross-country after leaving California. He taught skiing in Alta, Utah; rode fence on a cattle ranch in Jackson Hole, Wyoming; shucked oysters on the East Coast; worked in the galley of a cargo ship bound for Australia. Eventually, around 1960, he landed in New Orleans where he taught himself basic art techniques by studying Ralph Mayer's *The Artist's Handbook of Materials and Techniques* (1940). A friendship with American figurative artist George Tooker encouraged him to experiment with delicate media like egg tempera, Tooker's métier. Lucas practiced his developing craft by drawing picturesque scenes and portraits for the tourists in Jackson Square, signing them "Henry Fatbitch."

"I did all of the scenes everyone else was doing," he told a reporter.[3] "That's how I learned to draw." He signed his serious work "Leonard Johnson" until he discovered a mediocre watercolorist with the same name, after which he added "Lucas" to his signature. He also learned of the legend of Marie Laveaux, the famous and powerful eighteenth-century voodoo queen, who would make an appearance occasionally in his later work.

To pay the bills, Lucas worked part-time in a frame shop. There was a lot of drinking, too, in the low-down bars of the French Quarter.

Then Lucas left New Orleans and went to New York. Dead broke, he lived in a walk-up on Avenue D and survived on "soup" made from ketchup and hot water at one of the Horn & Hardart Automats. Always an avid reader, he frequented bookstores and befriended writers. Poet Joel Cohen was among them. When the wheelchair-bound Cohen decided to make a visit to Mexico, he asked Lucas to accompany him. The moment he landed in Mexico City, Lucas felt at home. "I was like a man on fire," he said. Later, instead of joining Cohen on their flight back to New York, Lucas saw his friend off and cashed in his own return ticket. What was intended as a brief sojourn became his life for the next decade and changed his heart forever.

Several factors were at play in his decision to stay in Mexico. The sense of ease Lucas discovered in Mexico was crucial, but his opposition to the Vietnam War was also compelling. He had registered as a conscientious objector. In a 1970 interview, with the war still raging, he told KPFT radio in Houston, "I'm a hundred percent against the war, particularly on moral grounds, but I can't picture myself on a bandstand telling people what they should do or believe."[4]

Lucas had also grown increasingly disillusioned with what he perceived as American artists' failure to engage in political dialogue. In Mexico he discovered a welcoming haven where art, society, and politics coexisted in a heady mixture. He was soon part of an ever-widening bohemian circle of writers, actors, musicians, and artists, both Mexicans and expatriates like poet Margaret Randall, composer Conlon Nancarrow, and Surrealist artist Leonora Carrington.

1962–1972

The art community in Mexico City was energized. The generation of artists who followed the "Big Three" of the mural movement—Diego Rivera, José Clemente Orozco, and David Alfaro Siqueiros—sought fresh avenues that engaged Mexico's unique history and simultaneously addressed the contemporary world. In 1966 art historian and critic Justino Fernández wrote in his introduction to Alfonso de Neuvillate's *Pintura Actual 1966* [*Contemporary Painting 1966*]: "It is natural that new generations should rebel against their predecessors. But if they deny them, they are lost."[5]

The rebels, among them José Luis Cuevas and Gunther Gerzso, "had taken new paths and were preoccupied with what was happening in the rest of the world, knew how to widen their horizons with lessons learned from European and American painters," de Neuvillate wrote. "Those young men of the recent past and of today neither attempted nor attempt to copy or keep up with the latest fashion. In their creations, these artists obey the need to mold personal worlds, each of them different—with respect to forms, themes, and even ways of resolving problems with which they are confronted at the moment of conception."

By August 1962 Lucas was exhibiting in various galleries and at the Instituto Mexicano-Norteamericano de Relaciones Culturales in Mexico City, variously signing the work L. Lucas Johnson and eventually just Lucas Johnson. He exhibited in group shows with artists whose focus on figuration and humanist concerns were like his own, among them Francisco Corzas and Leonel Góngora.

He met Helen Bickham, an artist and émigré from the United States, who had settled in Mexico in 1962 with her two young sons,

fig. 16 Poster for the opening of a group exhibition, Galería Sagitario, Mexico City, June 23, 1967.

fig. 17 Lucas Johnson and Jürgen Fisher, Pratt Institute print studio, Brooklyn, New York, 1966.

fig. 18 Newspaper clipping showing a group of artists (José Luis Cuevas, Arnaldo Coen, Francisco Corzas, and Lucas Johnson) preparing for the exhibition, from "Salón de Independientes," *The News*, August 24, 1968.

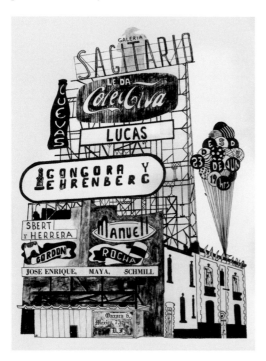

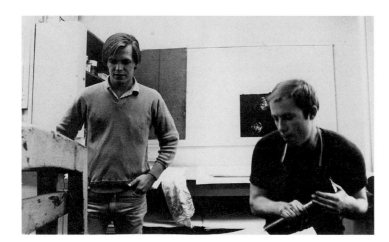

Geoffrey, age four, and Brett, age two. Brett remembers living in the village of Cuajimalpa, northeast of Mexico City, and being dirt poor. Eventually the Bickhams moved to Mexico City, where Helen taught English at the Instituto Politécnico Nacional. Lucas and Helen married in 1964.

Lucas shared a studio with a group of artists. Teodoro Maus, an aspiring artist with deep roots in the city, leased a building in 1964 in a bohemian neighborhood a few blocks from the famous Zona Rosa —so called because while in the daytime it was a place for high-end boutique shopping and extended meals at fine restaurants, at night-time it became the Red Zone. The artists shared the rent and most meals, which Teodoro describes as consisting of eggs and rice for breakfast, rice and eggs for lunch, and rice only for dinner ("*huevos con arroz para desayuno, arroz con huevos para la comida, arroz a huevo para cenar*"). When flush, the artists would sometimes hire a model.

Eventually Teodoro opened Galería Sagitario on the ground floor, where resident artists and others who were invited showed their work. Teodoro recalls:

> It was a moment of true bohemia, especially because none of us thought or conceived it as being such. The place was an old, crooked house we tried to level with car jacks. Artists came who had nowhere else to stay—because they'd fought with the wife or, like Lucas, needed a place to work. It was a place of enormous work and one of the most prolific eras for all of us. There was a sense of searching; there was debate and discovery. Lucas brought Bob Dylan's music.
>
> We turned the ground floor into a gallery. It was an immedi-ate success because all the important galleries in the Zona Rosa lent us art by their artists. We complemented exhibits with poetry readings, lectures, and music performances. The only activity that left cash was the framing "business" that Lucas and I set up.

The gallery opened to the public in June 1966. Writing in the English-language daily *The News*, art critic and historian Toby Joysmith had few nice words for the gallery's inaugural group show, but lauded Lucas: "With the exception of Cuevas, there is little here that any reputable foreign gallery would wish to exchange. The surprise of the show was a young draftsman, Lucas Johnson, who was not known to this critic before. His drawings are delightfully deceptive. Apparently casual, they show an acute intelligence at work. Johnson is a master at carefully contrived space."[6]

After Galería Sagitario closed in 1968, Lucas was asked to join Galería de Arte Misrachi. The gallery was a specialized arm of Central de Publicaciones, a bookstore/gallery established in the early twentieth century across from the Alameda. Its owners, Alberto Misrachi and Enrique Beraha, had focused on Mexico's "Old

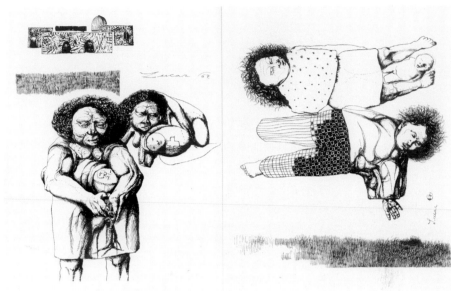

Masters"—Siqueiros, Orozco, Rivera. When the new gallery opened as an independent enterprise in the Zona Rosa, just a few blocks from the former Sagitario, it sought exclusive representation of younger artists. Sculptor Francisco Zúñiga and draftsman Cuevas were among its roster of artists when Lucas joined. The agreement with Misrachi included a monthly stipend that would be balanced against total sales at the end of the fiscal year. Although Lucas's work always sold well, sales were not guaranteed, and the monthly check offered a modicum of security. When Lucas and Helen were divorced years later, in 1971, he arranged for the gallery to pay the stipend directly to her as support for Geoffrey and Brett.

In the mid-1960s the David Gallery in Houston became a second home for Lucas. Owned by Dianne David, it had evolved from The Bookman, an enterprise that her brother, Dorman David, had opened in 1962 when he was twenty-five. Financed by the paterfamilias, Henry David, founder of Mudwhile Mud Sales Co., The Bookman was "stocked with old books and lots of Texana—and just for interest old prints and unusual artifacts [Dorman] stumbled across."[7] Dorman's interest was in buying for the store, not running its operation. By 1967 Dianne and her mother, Grace David, had taken over ownership of The Bookman , where author Larry McMurtry, then a graduate student at Rice University, worked part-time. It quickly became a center of contemporary art for a growing roster of regional artists.

Dorman had found his way to Mexico City looking for documents about Texas in the city's flea markets and national archives. When he met Lucas on one trip, Dorman recalls, "I told him he should visit my sister." Lucas's introduction to the gallery came in a group show in 1964 that led to regular solo exhibitions until Dianne closed the gallery in 1971.

Lucas's status as *inmigrado* (resident alien) in Mexico required that he leave the country for a period of time every year. He usually made the trip to Houston, driving the 1,100 miles, sometimes in a single day, in a van he had loaded with paintings and drawings for the gallery. His first solo exhibition in March 1966 featured his drawings. A reviewer wrote, "He knows his black and white media and achieves varieties of textures and force with India ink, lithographic crayon, touche and varying oil-thinned washes. [In his drawings] his social conscience is in the ascendancy. The eyes of his people are haunting and devastating."[8]

Later that year Lucas executed a series of lithographs at Pratt Institute in New York. The dense black-and-white images were published as a folio of eight prints titled *Man and War* (1966) and exhibited in Mexico. One critic wrote that Lucas "captured the death of human hope. His work is not an accident of the imagination, but a reflection of an artist's perception of what we of this generation all know and feel. He relinquishes nothing."[9]

While Lucas had established a reputation in drawing and graphics, his exhibition of paintings in 1967 at the Instituto Mexicano-Norteamericano de Relaciones Culturales was, according to critic Joysmith, "a pleasure and a surprise. A pleasure because Johnson's drawings are always worth looking at. A surprise because his paintings are an unexpected departure. These paintings underline that, if the message is urgent enough, technical considerations can take second place.... Johnson may be eclectic, but his synthesis is his own. He never fails to enlist the poetic imagination of his viewers."[10]

Painting, Lucas told an interviewer, "is a challenge. It is probably the most valid of the plastic arts. Real personal vision has been lost, but man, being basically a spiritual being, will return to art."[11]

In January 1968 Lucas exhibited his new paintings, drawings, and prints at Galería de Arte Misrachi. A magazine in Mexico City took the opportunity to publish one of the few full-length interviews that Lucas made during his career. His replies to probing questions revealed much about who he was as a person and an artist. It reads in part:

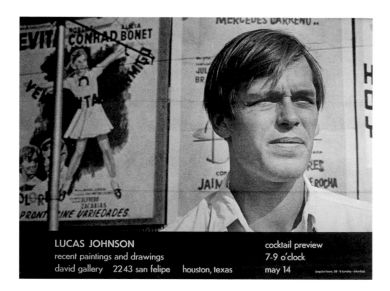

LUCAS JOHNSON
recent paintings and drawings
david gallery 2243 san felipe houston, texas

cocktail preview
7-9 o'clock
may 14

Question: Do you know what you want to do [accomplish] when you express yourself?

Answer: Yes. To show I have a social conscience. In every one of my works, you will always find my relationship with society, not in the personal sense, but my preoccupation with what is human or what reveals a lack of humanity. I mean, I try to express myself as a human being at the level of all men, and reject the lack of humanity towards our fellow man.[12] (See complete interview, pp. 167–169.)

As Mexico prepared for the 1968 Olympics, artistic activity and student protests, endemic around the Western world, rose to a fever pitch. Lucas was included in several group exhibitions during the first months of the year. One was the "Salón de Independientes" at the Universidad Nacional Autónoma de México. The show was a response to the "official" exhibitions of Mexican "Old Masters" that had flooded the city in anticipation of the Games. For the "Salón" Lucas made a mural with polymer paint and collaged images from newspapers and illustrations from Digest on the Diseases of Birds (1942) by Robert Stroud (the Bird Man of Alcatraz). Titled Dos vistas de Nueva Orleans (Two Views of New Orleans) (1968), it was a complex cityscape populated by numerous figures. Portions of the work were reproduced in Master of Knives, a collaboration with poet C. W. Truesdale.[13] They are the only record of the work, which disappeared, either stolen or destroyed. Lucas never knew what happened to it because political turmoil soon afterward forced him to leave the country.

The student demonstrations in Mexico are notable for the massacre of October 2, 1968, in Plaza Tlatelolco. Thousands of laborers, students, and sympathizers gathered that night at the pre-Columbian site in the heart of downtown Mexico City to protest the govern-ment's policies; the military was ordered to respond with tanks, bazookas, and snipers in "self-defense."

Official reports of the time placed blame on student "agitators" and downplayed the number of dead and wounded—estimated today at 200–300 dead and thousands wounded and arrested. Details of that night continue to be investigated by the committee established by the Mexican congress in October 1997. Luis Echeverría Alvarez, then the minister of the interior under president Gustavo Díaz Ordaz, and subsequently president of Mexico, admitted the students had been unarmed. (Involvement by the CIA has also come to light.)

Lucas's and Helen's support for the student movement was well-known and reportedly documented by government agencies. A friend in the administration strongly suggested that the family leave the country. They headed north.

Arriving in New Orleans, Lucas ran into Leonora Carrington, who had also been urged to leave Mexico. After a few days, Lucas, Helen, and the boys made their way to the East Coast and settled on a farm in Saugerties, New York. Brett writes:

We left after the Tlatelolco massacre. My Mom was on some sort of political blacklist at the Politécnico and [was] told that it was best that we leave right away. There were army tanks in the Zona Rosa. It was a memorable year—we drove to the U.S. [and] had to sneak our pet armadillo across the border in Mom's purse because rabies shots were required by Customs, but vets said you couldn't give an armadillo a rabies shot, so we gave it a sleeping pill instead. I remember we drove through Alabama and [saw] "Colored" water fountains and restrooms at gas stations, and how no one would stand in our line at the supermarket because Lucas had very long hair and Mom was wearing jeans instead of a skirt or dress. It was also the year I saw a lot of snow and well-below-zero temperatures for the first time—in New York State, the winter of '68. The Catskills had an unbelievably cold gray winter that year.

Lucas focused on keeping the family together and staying warm. He loved the farmhouse, which he described as an old Dutch structure with low ceilings and drafty walls that allowed winter to whistle through. He showed drawings in a small café in town. Mostly he remembered sitting in an easy chair by the fireplace reading, the armadillo sleeping on his feet.

In December 1968 the Fair Lawn (New Jersey) Public Library hosted "Manscape," featuring the collection of Selden Rodman. Though best-known as a writer with a passionate interest in Haitian art, Rodman was also an avid collector of work by humanist artists. He had met Lucas in Mexico during a trip that he wrote about in The Mexican Traveler (1969). Among the forty-one works he lent to the

fig. 21 Lucas Johnson, cover of *Pablo Neruda—The Early Poems*, (St. Paul, Minnesota: New Rivers Press, 1969).

fig. 22 Lucas Johnson, poster for exhibition of drawings from the book *Master of Knives*, poems by C. W. Truesdale, David Gallery, Houston, 1971.

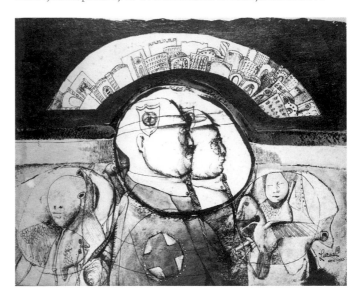

library were paintings by Lucas, Andrew Wyeth, and Ben Shahn, and drawings by Orozco, Cuevas, and Leonard Baskin.

The family returned to Mexico City in the fall of 1969. By then Lucas's exhibition schedule had become fairly regular, with annual solo shows at Misrachi and David galleries. Small solo and group exhibitions were scattered throughout a variety of venues in Mexico and the United States.

That summer I began working at Galería de Arte Misrachi. The gallery's director, Lotte Mendelsohn, talked about Lucas as she introduced me to the inventory and bragged on the roster of artists— "Old Masters," young ones, and aspiring newcomers. When I finally met Lucas, he was nothing like I'd imagined from the wise severity and spirituality in his work. He grinned with merriment when I told him I had pictured him as a very old man. I think he was flattered.

The catalogue of Lucas's exhibition at Misrachi in April 1970 lists sixteen paintings, eight mixed-media works on paper, and a group of twenty ink drawings collectively titled *New Orleans*. Ten of the drawings had been reproduced in *Pablo Neruda—The Early Poems*.[14]

Critic Carla Stellweg previewed the exhibition for Mexico City's dominant daily. "Faces dominate Johnson's work, faces that mirror, reveal and give visible shape to the lives lived. The melancholy is intense."[15]

A few weeks later, Joysmith saw a parallel between Lucas's paintings (especially *Familia* [1968] and *Magician and His Son* or *American Gothic* [1968–1969, p. 33]) and regionalist painting in the United States, as well as a "correspondence" between Lucas and Cuevas: "Both have a prodigious natural talent for drawing. Both have a predilection, amounting almost to an obsession, with the grotesque, the odd, the warped and the deformed. But Cuevas doesn't paint, Johnson does."[16]

In February 1971 David Gallery showed a group of the drawings that had been reproduced in Truesdale's *Master of Knives* the year before. That book was the largest collaboration between the artist and the poet, whose friendship went back to Lucas's early years in New York. Truesdale had often used Lucas's work as illustrations for publications by New Rivers Press and the *Minnesota Review* in St. Paul, which he edited. Daniel Halpern, editor of Antaeus Press in New York, also periodically reproduced Lucas's drawings in Antaeus publications.

About the same time, Houston-based architect Marvin Watson introduced Lucas's work to Andreas Brown, owner of the Gotham Book Mart and Gallery in New York. Established in 1920 by the dynamic Frances Steloff, the Gotham was a champion of modern literature and a mecca for authors. Brown, Steloff's handpicked successor, bought the business and the brownstone on West 47th Street that housed it. He continued the bookstore's traditions,

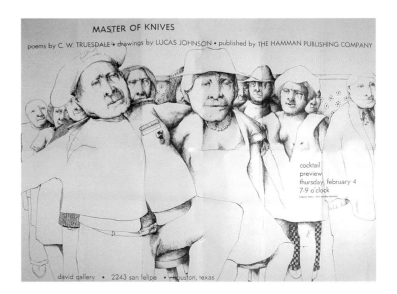

fig. 23 Installation view of exhibition "Lucas Johnson,"
Gotham Book Mart and Gallery, New York, April 1971.

fig. 24 Lucas Johnson at the entrance to the
Gotham Book Mart and Gallery, New York,
April 1971.

fig. 25 Lucas Johnson, cover for *Letters
from Siberia and Other Poems* by Roger
Mitchell (St. Paul, Minnesota: New
Rivers Press, 1971).

fig. 26 Lucas Johnson and Patricia
Covo, Garibaldi Square, Mexico City,
summer 1971.

and his own appetite for literature and the visual arts grew as
legendary as hers.

Brown exhibited a group of Lucas's paintings and drawings at
the Gotham in April 1971. The sale of ten works was cause for cele-
bration. It was also an opportunity for Lucas, an avid reader, to
spend a significant portion of his sales receipts on books. His library
grew with first editions and new literature that Brown selected for
him. Among them was W. G. Rogers's biography of Steloff—*Wise
Men Fish Here* (1964), named after the Gotham Book Mart's motto—
which she inscribed for Lucas.

Lucas's marriage to Helen had grown increasingly difficult, and
it became apparent that it could not continue. He filed for divorce,
and the friendship that he and I had developed within the boundaries
of the gallery became a love affair. (We talked about the potential
conflict of my working in the gallery that represented him, which
was not really an issue; we didn't imagine then the depth of the
conflict that would ensue years later when I accepted the post of art
critic for the *Houston Chronicle*.) My father, an old-fashioned European
patriarch, loved Lucas, but would not allow him in the house until
the divorce was final.

We were married on November 16, 1971, on the steps of the
courthouse in Algiers, across the Mississippi River from Lucas's old
haunt, New Orleans. The judge was leaving for the weekend and,
dispensing with all ceremony, declared us husband and wife in less
than a minute. My father, drafted on the spot as a witness along
with my step-mom and the judge's secretary, was stunned at the
informality of the proceedings and for years after wondered if the
marriage was really legal.

fig. 27 Newspaper clipping, review page showing works from exhibition "Lucas Johnson," Galería de Arte Misrachi, Mexico City, from "Lucas Johnson: La Pintura, Como Camino Hacia la Libertad," *Excelsior*, March 7, 1972.

Back in Mexico City, Lucas set up his studio in one of the bedrooms of our spacious apartment, but he ended up working on the dining room table anyway.

That winter he was given a prestigious commission by Fibracel de México for a print the company would give as Christmas gifts to its clients. Previously the commissions had gone to Cuevas and the sculptor Zuñiga. Given a choice of where to work, Lucas asked for the Imprimérie Clot Bramsen & Georges in Paris. The atelier's reputation had grown over the decades through its printing work for a wide range of international artists, including Roberto Matta and Mexico's Francisco Toledo. "Besides," Lucas said, "I've never been to Paris." The company arranged for Lucas to spend February 1972 working at the atelier, expenses paid. Located near the Bastille, it was an old-fashioned workshop where apprentices polished stones by hand in a cramped basement and the presses were hand-driven. Lucas produced a three-color lithograph of a juggler that did not entirely please him, but was wholly appreciated by Fibracel.

In the summer of 1972, we moved to La Canova, a tiny community near the town of Velarde, New Mexico, about halfway between Santa Fe and Taos. Lucas had scoped out the area and found a three-acre property with a small adobe house surrounded by apple orchards. Black Mesa lay in the near distance, and a narrow trickle of the Rio Grande served as one property line. It was a beautiful setting, but

Lucas Johnson

La Pintura, Como Camino Hacia la Libertad

the gritty adobe dwelling needed every kind of improvement, from walls to indoor plumbing, so Lucas did not make any art. Funds were quickly depleted.

Complicating everything was the palpable hostility we felt from all sides. The small apple-growing community was poor and angry. The locals—Chicano and Indians—hated one another, and both groups hated the Anglos. We abandoned the place thirteen months later, fearing that we would either kill or be killed—neither one a good option. Disillusioned and broke, we moved to Houston to raise travel funds. Mexican architect Mathias Goeritz had told Lucas he would arrange for a teaching post for him in Tel Aviv. Lucas just had to get himself there.

1973–1979

We drove into Houston on June 5, 1973. It was the day of art patron John de Menil's funeral, which was being broadcast on the radio. It was raining. It kept raining for days. Marvin Watson gave us his townhouse for the two weeks he would be on vacation. Later he lent us the house on Berthea Street that he was renovating into Watson/de Nagy Gallery. Eventually we found a little apartment in a fourplex on Peden Street that Dorman David was leaving. With the television turned nonstop to the Watergate hearings, the living room became Lucas's studio. And Houston, intended as a stop on the way to somewhere else, became home.

The austere beauty of the New Mexico landscape that had seduced Lucas made its way into a group of early 1970s lithographs titled *Velarde* and *La Canova* in which Black Mesa is a prominent feature. Black Mesa appeared again in other works including a series of symbolic landscape paintings collectively titled *Starlite Drive-In* (see p. 46) in the early 1980s.

With the sale of *Portrait of a Hero* (1973, p. 37), the first painting Lucas made in Houston, we took our Mustang on a six-week driving trip through Mexico, which Lucas knew well, and into Guatemala, where neither of us had been. It was the first of many road trips we would take over the years—to New York, across the south into North Carolina, to California and Idaho, and countless times into Mexico.

The first stop on the way to Guatemala was with friends and my family in Mexico City. The second was in San Gabriel de Etla, a farming community a few miles north of Oaxaca City. Friends Rex and Lollie Marcum had moved there after their retirement—he as director of the Instituto Mexicano-Norteamericano de Relaciones Culturales and she as professor of English at the Universidad de las

fig. 28 Exterior of El Molino, location of Lucas Johnson's studio, San Gabriel de Etla, Oaxaca, 1983.

fig. 29 Rex Marcum, San Gabriel de Etla, Oaxaca, c. 1983.

fig. 30 Newspaper clipping, review page of the exhibition at Galería de Arte Misrachi, Mexico City, from "Iconoclastic Painter: That's Lucas Johnson," *The News*, November 1, 1974.

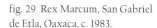

Américas. They'd bought a seventeenth-century mill snuggled in the hills and were transforming it into a bed-and-breakfast, catering especially to artists. El Molino (The Mill) became a haven for many, including Houston artists Earl Staley and Bob Camblin. For Lucas, it was a working refuge every summer for a decade, until the Marcums pulled up stakes once more to settle in Rex's native state of Wyoming.

Chichicastenango or maybe Guatemala City had been our original destination. By circumstance and luck, we landed in San Lucas Atitlán. The village sat on the edge of Lake Atitlán and in the shadow of its namesake volcano, which spewed smoke and ash continuously and glowed fiery red against the clear night skies. San Lucas was a center for the sale of coffee beans grown by families in the surrounding mountains. We stayed in a tiny boardinghouse frequented by coffee buyers and where electricity was available only a few hours a day. We slept on its straw mattresses until our visas expired (with the Mexican border still a day's drive away).

Back in Houston, Lucas settled down to paint. The volcanoes that had been part of his physical and psychological landscape in Hawaii, Mexico, and now Guatemala would appear in his work years later.

An exhibition at Galería de Arte Misrachi at the end of October 1974 included paintings and mixed-media collages. Writing that Lucas "scrupulously rendered faces with the finish of a Van Eyck in paint or an Ingres in pencil," Joysmith described the new work as departures, with "added maturity, a sureness and deftness of handling. He is both figurative and semi-abstract. But his slow working methods allow him to create an order which he then slowly disintegrates until the razor-edge of image or non-image is reached."[17]

Betty Moody in Houston had known Lucas's work through the David Gallery. In early 1975 she prepared to open her own gallery and asked him to join her stable of artists. Betty became a good friend as well as his dealer. Moody Gallery's inaugural exhibition on September 13, 1975, featured work by Arthur Turner, Stanley Lea, Fritz Scholder, Lamar Briggs, and Charles Pebworth, whom Betty knew from her years working at DuBose Gallery. It also featured one painting by Lucas, *Icarus Falling* (1975, pp. 42–43). A review noted, "Whether the fanciful, naive dramas painted by Johnson or the misty landscapes of Briggs, the subjects of all these artists are based on an expressive interpretation of external reality, [though] Johnson [focuses] more on human interaction and is most exploratory in [his] personal imagery."[18]

A few weeks later, on September 25, I opened Covo de Iongh Gallery with a group show titled "Master Drawings." The works

focused on humanist and Surrealist artists from Mexico and the
United States: José Luis Cuevas, Rufino Tamayo, Leonora Carrington,
and Lucas, with a complement consigned by Selden Rodman that
included drawings by Rico Lebrun, Seymour Leichman, and James
Kearns. The gallery occupied half of the ground floor of a duplex on
Sul Ross. The other half was Lucas's studio; our living quarters
were upstairs. Within a few months, the gallery resettled in a better
and bigger location on Montrose Boulevard.

On March 13, 1976, Moody Gallery and Covo de Iongh hosted
simultaneous solo exhibitions for Lucas. He had completed two
series of paintings: *The Louisiana Paintings*, which the Moody exhibited,
and *The New Mexico Paintings* at Covo de Iongh. Collectors waved to
one another as they crossed Montrose and West Gray, headed from
one gallery to the other. Both galleries sold everything. The exhibi-
tions included "30 paintings, five drawings and three lithographs, all
executed in the past year. There's not a bummer in the bunch."[19]
Another review said, "The two exhibitions are explorations into
landscapes and Johnson's desire to put aside carefully drawn com-
position for a while to draw more directly with paint."[20]

Restlessness set in after the double show and Lucas took off
hitchhiking, retracing parts of his early wanderings. It was different
now, of course—his age and his vision on one hand, the changes in
the country itself on the other. Lucas visited his former boss on
the ranch in Jackson Hole, who had subdivided the land into
"ranchettes." Lucas made a U-turn and, having a credit card in
his pocket, caught a flight from Denver to Houston.

In May 1978 Covo de Iongh presented Lucas's recent paintings.
A reviewer commented that "only short of a retrospective could an
exhibit afford such a range by a contemporary artist."[21] The follow-
ing month Galería Arvil in Mexico City featured Lucas's works on
paper and canvas.

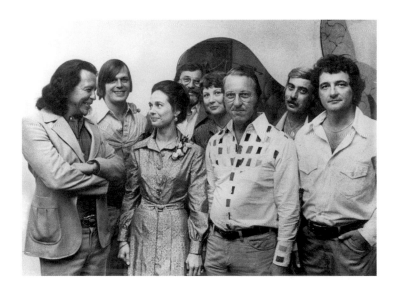

fig. 32 Fritz Scholder, Lucas
Johnson, Betty Moody, Charles
Pebworth, Victoria Andrews,
Arthur Turner, Stanley Lea and
Lamar Briggs at inaugural open-
ing, Moody Gallery, Houston,
September 13, 1975.

fig. 33 Lucas Johnson with a
day's catch of a swordfish,
Acapulco, Mexico, c. 1977.

Lucas had begun working in the summers at the Marcums'
place in Oaxaca in 1976, savoring the chance to live in the country
that fed his spirit and in a culture that had seduced him since his
arrival. In the fall of 1979, a group of drawings and paintings collec-
tively titled *Íconos de Oaxaca* (1977–1979) went on view at Moody
Gallery. Images ranged from a harvest of grasshoppers in the
Oaxaca *milpas* (small cornfields) to mysterious figures. One review
noted the "haunted faces, magicians and marketplaces familiar in his
work,"[22] and another concluded, "Carefully developed and worked,
these paintings make a greater impact in the sum of their parts than
on the inherent merits of their content alone. Johnson is reaching
into the crevices of reality and coming out with visual poetry."[23]

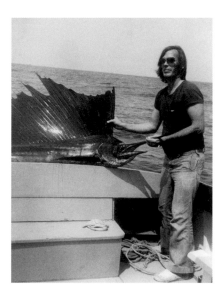

fig. 34 Lucas Johnson, cover of *Antaeus*, no. 48 (1983).

fig. 35 Lucas Johnson, Francesca Stedman (seated), Bob Camblin, Nancy Echegoyen, Patricia Covo Johnson, and Carla Hubbard, at opening of "Cinq X Cinq Houston," Paris, November 1986.

fig. 36 Lucas Johnson and his dog Brandy, Key Street studio, Houston, c. 1986.

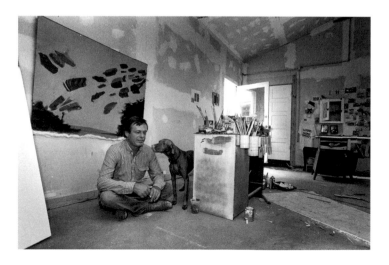

1980–1990

Although Lucas showed sporadically with Galería de Arte Misrachi in Mexico City until the early 1990s, Moody Gallery in Houston was his exclusive US representative after Covo de Iongh closed at the end of 1978. His Houston studio provided a comfortable refuge for concentration, while the annual visits to Oaxaca were energizing and productive. After the Marcums left Oaxaca, Lucas continued to make short trips to Mexico. He would tell friends such as restaurateur Bill Sadler, "My feet are turning south," and off they would go a few days later—through Monterrey or Tampico, to Veracruz and Morelia, Zacatecas, and San Luis Potosí.

Painting was always present, but during the early 1980s Lucas devoted much of his time to printmaking, starting in the summer of 1981 when he was invited to Anderson Ranch in Snowmass, Colorado, to work with master printer Bud Shark. Back in Houston, Lucas explored silkscreens, monoprints, and different etching techniques at Little Egypt Enterprises, working with David Folkman and Penny Cerling. Among the works of this period is the suite of four etchings titled *Bottom Feeders* (1980–1981, pp. 106–107). At this time, too, Lucas experimented with clay, which led briefly to working in bronze. And always there were drawings in ink and washes, and collages that ranged from landscapes to underwater visions. His first exploration of the orchid plant came in a delicate wash drawing dated 1988 (p. 108).

The most significant event of 1985 in Houston's art community was "Fresh Paint: The Houston School." The exhibition was organized by the Museum of Fine Arts, Houston, with senior curator Barbara Rose taking the lead. Debates raged over whether there was such a thing as a "Houston School," and if so, who or what it was. The exhibition, which opened in January, featured paintings by forty-four artists. Lucas was represented by *The Apparition* (1981, p. 45), an acrylic and oil glaze on panel. Responding to the curatorial request for a statement about influences and sources, Lucas wrote a list of seventy-one items that included artists, writers, musicians, friends, events, books, and objects: "Among my sources, not necessarily in order of importance, are: Che Guevara, Pablo Neruda, Joseph Conrad, Willem de Kooning, Ben Shahn, the Master E.T., Gabriel García Márquez, Bob Dylan, Mathias Goeritz, Leonora Carrington, B. Traven, Bill (C. W.) Truesdale, the Emancipation Proclamation, Brown v. Board of Education, Lenny Bruce, William Faulkner, Conlon Nancarrow, Daniel Halpern, Black Mesa, cadmium red, cerulean blue and the space shuttle."

That fall Moody Gallery held an exhibition of his paintings, the first in three years. A review carried the descriptive subhead: "Artist combines the abstract with uncanny Old World ability."[24]

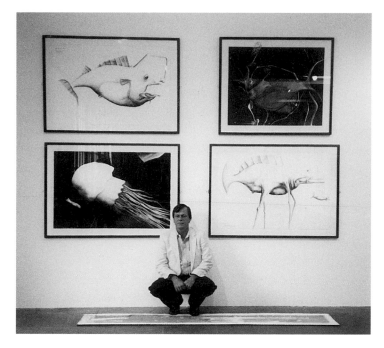

Combining his love of the ocean and of drawing, Lucas worked on a series in silverpoint, ink, and ink washes titled *Gulf Coast Estuary Series* (1987, pp. 109, 112–114). Alister Warman, director of the Serpentine Gallery in London, saw the series during a visit to Houston. It numbered thirty-nine drawings with images that included fish, eels, shrimp, turtles, imaginary underwater creatures, and underwater landscapes and structures, and the Serpentine exhibited the series in August 1987.

Lucas had a long history of collaboration with writers and small presses. In 1988 curator Janet Landay of the Glassell School of Art, the Museum of Fine Arts, Houston, and author Donald Barthelme organized an exhibition for the school that paired visual artists with writers. Titled "One + One: Collaborations by Artists and Writers," the exhibition spotlighted thirteen artist-writer pairs commissioned to create works for the show. Lucas and poet Susan Prospere were assigned to each other. Prospere wrote an eleven-stanza poem based on the children's fairy tale *Thumbelina*, which read in part:

> she sang in treble for the mole,
> Ladybird, ladybird, fly away home,
> until the mole wanted to hold her forever
> under the earth's surface. Each step darker
> than the other, they set forth together
> to wander through the winding tunnel,
> the mole holding rotting wood in his mouth [25]

Lucas's contribution was an ink drawing in the format of a pop-up book that he titled *The Wide World* (1987, p. 117). He focused not on the narrative of the fairy tale, but on its darker side, "the underworld, other world sense of it," as he said. Prospere said that was at the heart of her work as well. Among the other fortuitous pairings for "One + One" were photographer Sally Gall and essayist Philip Lopate, sculptor Jim Love and novelist Barthelme, and painter Melissa Miller and novelist Beverly Lowry.

The barren but dramatic landscape around Ojinaga, the small Mexican town across the Rio Grande from Presidio, Texas, was the subject of a series of monoprints Lucas exhibited at Moody Gallery in June 1989. He continued to develop similar landscapes in a large group of drawings that he exhibited in February 1990 in Ex-Convento del Carmen, a cultural center in Guadalajara, Mexico, housed in an eighteenth-century former convent. The abstract landscapes of the *Ojinaga Series* (1987–1989) dominated this exhibition, showing townscapes on the horizon behind stone walls (these would develop into the *Monumentos* a few years later) and vast fields of broad horizontal bands. But one of the forty-two drawings on view was very different: the mound of rocks in this large (40 by 60 inches) work in ink on gessoed paper titled *Aftermath* (1989, p. 123) recalls Pol Pot's murderous devastation of Cambodia. The review read in part, "These meticulously executed drawings in pencil, ink and silverpoint, imbued with the same psychological mystery, terrifying figures of his from the 1960s, today suggest a spiritual load."[26]

fig. 39 Fresco, Nancy Kienholz, Wesley Kimler, Lucas Johnson (back row); Ed Kienholz, Au, Sharon Kopriva, and Mike Shannon (front row), The Schoolhouse, Hope, Idaho, summer 1993.

fig. 41 Betty Reddin and Lucas Johnson in his studio, The Schoolhouse, Hope, Idaho, summer 1993. Works shown: several *Drawings from the Underworld* (1993).

fig. 40 Lucas Johnson with some of his orchids, Columbia Street studio, Houston, February 1991.

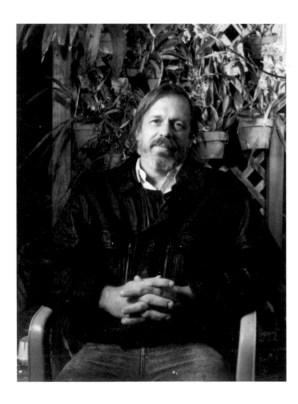

On October 30, 1991, the front page of the *Houston Chronicle* reproduced a photograph taken by the Magellan spacecraft of lava flow from Maat Mons, a mountain on Venus about the size of Hawaii's 13,680 foot Mauna Loa. The enhanced image showing the amazing blood red of the lava against a gray rainbow of smoke and ashes was stunning. On the front page of the Lifestyle & Entertainment section that same day, the *Chronicle* reproduced Lucas's *Evening Sky* (1991),[27] one of the intense paintings from his series on volcanoes on view at Moody Gallery. Their coincidental appearance in the same paper drew a striking parallel between cosmic and aesthetic expressions of forces beyond human control.

1991–1998

Lucas quit drinking and smoking. His health was better, his hypertension under control and his energy level restored. Toward the end of 1990, we had bought a property on Columbia Street where Lucas built the studio he had always wanted: a bright open space with north light, large walls on which to hang canvases, drawers filled with stacks of paper, brushes and paint of every description, pens, worktables, a television tuned to the news, and a stereo playing the music of Bob Dylan, Terry Allen, jazz, and Andean and mariachi songs. The orchids he had been collecting since the 1980s, "hunting" them in Mexico and buying them from growers in Houston, found a haven in the garden outside his studio door.

His passion for this botanical species caught the attention of a
local magazine. "While many growers love orchids for their peacock
splays of long-lasting flowers, Johnson is attracted to the 'pre-historic'
quality of the plant form itself," Mike Peters wrote.[28] "The flowers
are a bonus, and they let you know that you're doing right," Lucas
told him.

Studying and collecting orchids was a pleasure and a learning
experience that, like fishing, gave Lucas a place for meditative quiet
and a reason to break from work in the studio. Eventually, the orchids,
like ocean creatures and landscapes, became a subject of his work.

"It is difficult to separate the man from his art," Nancy Reddin
Kienholz says. "We spent many happy hours together as friends who
occasionally discussed art. Not our own but others, as in 'I like him
or her' and 'I only wish he or she were a better artist.' Then we would
go on cheerfully telling jokes, discussing politics or current events."

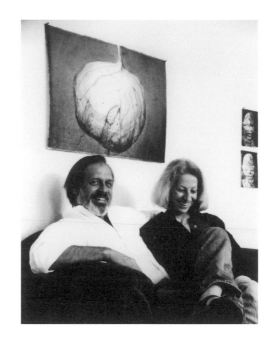

In the spring of 1993, Ed and Nancy Kienholz and Lucas and I
made a trip to Mexico City. The Kienholzes (who had built a studio
in Houston near Lucas's in 1991) were in the midst of creating the
serial work *76 J.C.s Led the Big Charade* (1992–1994, fig. 43), and Mexico,
as Nancy put it, "is the mother lode of Christ pictures." When they
invited Lucas to spend that summer in their Schoolhouse in Hope,
Idaho, Ed asked Lucas if he would draw a picture of Christ for
the series. He did. It is "the only J.C. by an artist we knew and
respected," Nancy says, and, Lucas joked, "probably the only work
of mine that will ever be shown at the Whitney [Museum]."

The Kienholz Schoolhouse, a former property of the Bonner
County school district, had four individual studios that Ed and
Nancy made available to artists. Lucas left Houston for the Kienholz
compound in the middle of June 1993. He took a hundred sheets of
30-by-22-inch Arches drawing paper, bottles of ink, and multiple
brushes, sponges, and pens. On his first day in the studio, he wrote
the word "*bajomundo*" on the worktable. Spanish for "underworld,"
it became the title of a series of drawings that, by the end of the
summer, numbered twenty-two and would continue to develop. This
is not the underworld of Greek mythology or the Christian Bible,
but an "ephemeral other world that exists and influences us," Lucas
said. "I think of it as a parallel world, a dark place but not necessar-
ily a negative one. This other world pulls our strings sometimes. It's
a space we occupy both with our bodies and our minds. It controls
people at certain times of their lives; it can even compel actions
while at the same time providing a way to rationalize these actions."[29]

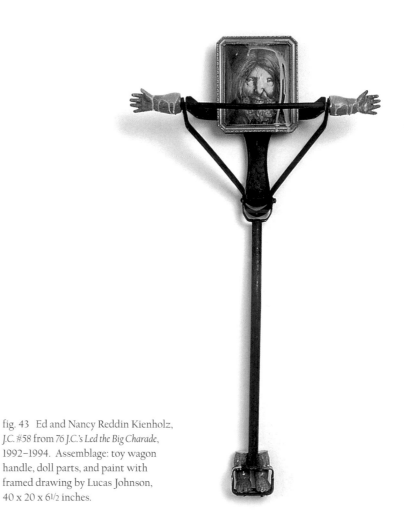

fig. 43 Ed and Nancy Reddin Kienholz,
J.C. #58 from *76 J.C.'s Led the Big Charade*,
1992–1994. Assemblage: toy wagon
handle, doll parts, and paint with
framed drawing by Lucas Johnson,
40 x 20 x 6 1/2 inches.

This underworld of Lucas's is also partly the subconscious, as
Freud explained it, and partly the belief in supranatural forces to
explain otherwise incomprehensible events. In Mexican and other
cultures, it is part of daily life. It moves people to assign godliness

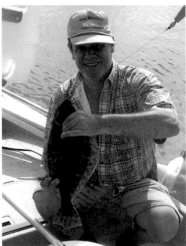

fig. 45 Lucas Johnson with flounder, fishing on Copano Bay, Aransas County, Texas, c. 2000.

fig. 46 Lucas Johnson, *Recuerdo de Marie (Laveaux) [A Memory of Marie (Laveaux)]*, 1994, cast bronze, unique, 17½ x 19¼ x 9¼ inches. Gayle and Mike DeGeurin, Houston.

to phenomena and find mystical explanations for what may be natural occurrences but appear to be irrational or magical events. It explains the eruption of Paricutín in the middle of a cornfield in Michoacán in 1947 that buried everything in the surrounding valley —except for the steeple of the village church—in a thick blanket of lava. It is the explanation given by farmers who view the appearance of rocks in their *milpas* after a rain not as a product of erosion, but rather as the natural process of the rocks' growth.

Lucas was in Idaho to work, but as always there was a lot of time to play, too, including fishing in the daytime and poker games after dinner. Nancy recalls:

> Ed had a rule that our studio was closed until 5:00 p.m., at which time the artists from the school would show up at our compound. We would retire to The Billy Bar to play pool; afterward, Lucas would barbecue something for dinner for four to sixteen people. Then we played games. We were poker players, Ed, Lucas, and I. I never could "read" Lucas, so I enjoyed playing with him. He was a good bluffer.
>
> Since Lucas liked coffee and fishing, he would go to the marina for coffee every morning and got to know the local fishermen. Though I have lived in the community for thirty years, Lucas got to know and made friends with people I had never heard of. He was often up the creeks or rivers with his Idaho fishing buddies. Ed and Lucas spent many days trolling Lake Pend Oreille for Kamloop trout. I don't remember if they ever caught "the big one."

Following the exhibition of *Drawings from the Underworld* (1993) at Moody Gallery in the spring of 1994, the series was presented by the Contemporary Arts Museum of Houston, the Galveston Arts Center, and the Art Museum of South Texas in Corpus Christi.

Another series of work was born that summer of 1993 and developed in the following year in Idaho. Lucas and Irish artist Brian Maguire drove around the state "to relieve the boredom," Brian says. He continues:

> We drove around the mountains, visiting flea markets. We came up against the right-wing extremists who contribute to both the Montana Militia and the Aryan Nations. It was our sense of revulsion at their racism, misogyny, and anti-Semitic rhetoric that informed our bogus shopping. Lucas made a series of drawings of the militia. I made a number of paintings of [the militia members] and their guns.

Lucas began a series of portrait heads—imaginary and composite portraits of people he encountered in the local flea markets and cafés, in the militia hangouts in Idaho and Montana, and at his favorite bars. A group of these drawings was the centerpiece of an exhibition in January 1996 at the Art Museum of South Texas, Corpus Christi.

The subject of militants reappeared after Lucas spent a month in Ireland in the summer of 1996. He traveled with Brian from Dublin to Belfast, crossing the deep political divide between Northern Ireland and the south, spending time in the Flax Studios, an artists' cooperative in Belfast, and stopping in Portloise Prison in central Ireland to conduct a workshop for prisoners convicted of political and violent crimes. "Lucas was an informed and compassionate observer," Brian recalls. "We rented a studio in the Crumlin Road. Lucas's eye saw the militarization of Belfast. He followed the painter's view of the particular containing the general. His humor and his political liberalism were by no means unique in Texas."

A group of drawings came from those encounters. They include abstracted images of the fortifications along Crumlin Road, nests of barbed wire, and portrait heads of angry, violent individuals, and they explore issues of self-deception, subterfuge, sabotage, and disguise. The group of works dated 1996–1997, was shown as *The Belfast Drawings* at Fenderesky Gallery in Belfast a year later, in January 1998.

Lucas's darker *Underground* and *Belfast* series were but one facet of his work in the 1990s. Another was radically different: the richly colored landscapes of the ongoing *Monumentos Series*, shown at Moody Gallery in 1990, and the volcano paintings—which he said were self-portraits—exhibited there the following year. Though they are unpopulated, a sense of humanity is present in both groups, traces evident in the chiseled blocks of stone scattered on a pastoral landscape and in the walls that surround the furious, fiery mountains.

The orchids also had made their way fully into his paintings after 1996. Still-lifes, the traditional genre to communicate the ephemeral nature of life, "are a classic subject of painting," Lucas said, "but I've never done one before." They began as *memento moris* after most of the orchids we left behind at home died in the winter of 1996 while we celebrated our twenty-fifth wedding anniversary in Chile.

For two weeks we traveled across the Andean country by bus, from Santiago to Punta Arenas on the Straits of Magellan, stopping in towns like Valdivia, Temuco, and Puerto Montt. There was always something to see, do, explore, and taste. With his undying curiosity and enthusiasm, Lucas wanted to see everything, learn the names of everything, and discover how people here lived their lives. The orchids suffered in his absence. A rare freeze in Houston killed almost all the specimens he had collected over the years.

The clay pots with the dead and desiccated plants began to populate his studio tables. He wasn't interested in the garish flowers, as he had told Mike Peters in 1991. He was interested in the structure of the plant, its prehistoric looks, and its remarkable adaptation to environments as varied as the cloud forests of Veracruz and the

fig. 47 Prison at Crumlin Road, Belfast, Ireland, summer 1996.

fig. 48 Brian Maguire and Lucas Johnson, outside Columbia Street studio, Houston, c. 1996.

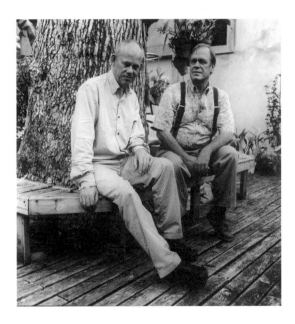

fig. 49 Michael Galbreth, Max Massing, Jack Massing, and Lucas Johnson, Houston, October 2000.

coastal swamps of the Gulf of Mexico. Isolated in the paintings, the orchids appear almost as architecture, the pseudo-bulbs and leaves dry and stiffened like parchment, the roots wrapped around the clay pots, surrogates for the rocks and trees of their natural habitats. In the complex still-lifes from the end of the 1990s, the orchids, like the volcanoes before them, appear as symbolic self-portraits. In these works potted orchids sit on worktables placed in a landscape composed of elements Lucas isolated from the *Volcano* and *Monumentos* paintings, along with the artist's paints and brushes.

1999–2004

In 1999, anticipating the Chinese Year of the Dragon and the new millennium, Lucas was one of three Texas artists invited to inaugurate a new art space in Chengdu, Shizuan Province, China. *Three from Texas* featured works on paper by Lucas (a dragon in the Chinese zodiac), Virgil Grotfeldt, and Weihong, a native of China living in Houston who coordinated the exhibition.

The show was presented in the Upriver Gallery. The director, Chen Jia-gang, had designed the multistoried building for mixed residential and commercial spaces, with the gallery on the ground floor. Artist Zhou Chun-ya, head of the artists union in China and our host, stood with dignitaries from the city, the province, and the Communist Party during the official opening reception of the exhi-

bition on November 16, 1999. After the speeches, a ceremonial ribbon was carried onto the floor by a line of young and very pretty women, who brought an avid glint to Lucas's and Virgil's eyes. The three artists stood with the dignitaries as the ribbon was cut and the exhibition, the first by Americans in Schizuan, was officially opened.

Four newspapers carried announcements of the exhibition in their November 17 editions. In slightly different wording, each described how Lucas sifted Mexican myths and cultural traditions in ink drawings and paintings, and how he had perfected his craft and developed a style that at the time was identified as magic realism.

The exhibition afforded Lucas an opportunity to fulfill a childhood dream of visiting the Great Wall of China. As he and I slowly walked the Wall's lower levels, we kept seeing a delicate-looking man, dressed warmly in Mongolian coat and hat. He was fine-boned, with long and scraggly salt-and-pepper hair that fell to his shoulders.

He appeared to be very old. He smiled as we crossed paths time and again, his face crinkled with glee and his smiling eyes glinting with curiosity. He kept looking at Lucas. As Lucas crossed one small terrace, he and the wizened man came face to face and instantly held out the palms of their hands toward each other, without a word and without touching. An arc of light flew between them. Lucas didn't say much about it, but he was profoundly moved, and the experience stayed with him. Weihong said, "It was good *chi*."

Back in the studio, Lucas began a 60-by-130-inch painting, a landscape in blues with blocks of stone reminiscent of the *Monumentos* series. He said it was the Great Wall of China. At the time of his death, the unfinished painting was untitled.

Lucas also continued painting still-lifes. Moody Gallery had exhibited the first works in the series *Laelias, Schomburgkias and Other Still-Lifes* (1998–1999) in the fall of 1999. In 2001 a large group from the series and selections from earlier series, including the *Monumentos* and *Volcano* paintings, were presented by the Museum of East Texas in Lufkin.

With Betty Moody's blessing, Redbud Gallery in Houston exhibited a mix of Lucas's prints and drawings in May 2002. The work dated from the 1970s to the present, and images ranged from the complex etching *Icarus and His Son* (1989, p. 118) to the nearly abstract drypoint landscapes of the late 1990s. Most collectors had preferred his paintings and drawings to his prints, but gallery owner Gus Kopriva sold almost every work in the unusual show.

We drove to Rockport, Texas, on Friday, August 30, 2002, the way we did most every weekend. We had bought a commercial

fig. 51 Unfinished painting in Columbia Street studio, Houston, 2002.

fig. 52 Releasing Lucas Johnson's ashes into Copano Bay, Aransas County, Texas, September 3, 2002.

fig. 51 Unfinished painting in Columbia Street studio, Houston, 2002.

fig. 52 Releasing Lucas Johnson's ashes into Copano Bay, Aransas County, Texas, September 3, 2002.

property in that Gulf Coast town five years before. Lucas was transforming it, with the idea of eventually making it his primary studio. Like the adobe house in New Mexico and every other place we'd lived in since, that meant major reclamation and upgrading, but the rewards would be worthwhile. The area is one of the richest fishing and bird-watching sites on the Gulf of Mexico. And it was far enough from Houston to be comfortably private.

The plan that weekend was for Lucas and Jack Massing to kayak in Aransas Pass and chase redfish. On Saturday morning Lucas and I drank coffee and talked about what more we needed to do with the place and what we would have for dinner that night—a normal start to the day. Once the kayaks were loaded in Jack's truck, the two were off.

Lucas did not make it back home. He died of heart failure on his way from Aransas Bay to the hospital.

On September 3, with family and friends bearing orchids and sharing memories, we released Lucas's ashes into Copano Bay.

2003–2004

In October 2003 friends Gus and Sharon Kopriva gently cast a handful of Lucas's ashes into Havana Bay to complete his dream of visiting Cuba, his father's birthplace. In March 2004 the Houston Artists Fund sponsored a benefit to raise money for the publication of this book. It was hosted by the Art Guys—Jack Massing and Michael Galbreth—and turned into a celebration by more than five hundred artists, friends, and collectors..

In May 2004 the Rockport Center for the Arts presented a small exhibition, *In Memoriam*, comprising a mixed group of Lucas's drawings from the *Estuary* and *Belfast* series and three small paintings of volcanoes and orchids.

The morning after the reception, a group of us gathered at the Aransas Bird Refuge to dedicate a plaque in Lucas's memory. It was commissioned by many friends and is installed on the observation deck. It reads:

> *Lucas Johnson, October 24, 1940–August 31, 2002.*
> *Artist, angler, birder, and friend.*

NOTES

1. Donald La Badie, "Artist Draws from Mexican Experiences," *The Commercial Appeal* (Memphis), March 13, 1981.

2. "Glimpses of an Artist: Lucas Johnson," video 1992.

3. Galina Vromen, "Iconoclastic Painter—That's Lucas Johnson," *The News* (Mexico City), November 1, 1974.

4. "Lucas Johnson: A Free-Thinking Individual Who Speaks Through Art," KPFT Newsletter (October 18–31, 1970).

5. Alfonso de Neuvillate, *Pintura Actual 1966* [*Contemporary Painting 1966*] (Mexico City: Instituto Nacional de Bellas Artes, 1966).

6. Toby Joysmith, "Drawings Shine at the Sagitario," *The News* (Mexico City), August 7, 1966.

7. Madeleine G. Appel, "25-Year-Old Revamps House, Fills It with Rare, Old Books," *Houston Chronicle*, April 24, 1963.

8. Eleanor Kempner Freed, "Professional, Humanist-Painter," *Houston Post*, March 20, 1966.

9. Robert Denbow, "Folio by Local Artist Due Soon," *The News* (Mexico City), December 19, 1966.

10. Toby Joysmith, "Johnson's Eclectic Promise," *The News* (Mexico City), April 30, 1967.

11. Sally Casis, "Lucas Johnson: A Free-Thinking Individual Who Speaks Through Art," *The News* (Mexico City), December 17, 1967.

12. Marcelina Galindo Arce, ed., "Plástica en Movimiento: Conversación con Lucas [Plastic Arts in Motion: Conversation with Lucas]," *Mujeres* 206 (January 25, 1968).

13. C. W. Truesdale and Lucas Johnson, "*Master of Knives*," (Houston: Hamman Press, 1970).

14. Pablo Neruda, *Pablo Neruda—The Early Poems*, trans. David Ossman and Carlos B. Hagen (St. Paul, Minn.: New Rivers Press, 1969).

15. Carla Stellweg, "La melancolía de Lucas Johnson [Lucas Johnson's Melancholy]," *Excelsior* (Mexico City), April 12, 1970.

16. Toby Joysmith, "The Gallery Goer: Now the New Is Always Out of Date," *The News* (Mexico City), April 21, 1970.

17. Toby Joysmith, "The Gallery Goer," *The News* (Mexico City), November 17, 1974.

18. Charlotte Moser, "Image of Southwestern Art Changing," *Houston Chronicle*, September 21, 1975.

19. Charlotte Moser, "Galleries Cooperate on Two Shows," *Houston Chronicle*, March 21, 1976.

20. Mimi Crossley, "The Direct Route," *Houston Post*, March 21 1976.

21. Mimi Crossley, "Review: Johnson, Stephan, Rogalla Shows," *Houston Post*, March 12, 1978.

22. Mimi Crossley, "Reviews: Johnson, Goodnough, Benglis and the Museum School Faculty," *Houston Post*, January 26, 1979.

23. Charlotte Moser, "Painter Explores Mystery, Poetry," *Houston Chronicle*, January 30, 1979.

24. Carol Everingham, "Powerful Lucas Johnson: Artist Combines the Abstract with Uncanny Old World Ability," *Houston Post*, December 7, 1985.

25. Janet Landay and Donald Barthelme, *One + One: Collaborations by Artists and Writers*, exh. cat., (Houston: The Glassell School of Art, 1988).

26. Luis Carlos Emerich, "Lucas Johnson, en proyección de transparencias [Lucas Johnson, Projecting Transparencies]," *Novedades* (Mexico City), February 16, 1990.

27. The reproduction accompanied a review of the exhibition by Elizabeth McBride, "Lucas Johnson Offers Bloody, Molten, Stony Paths of Life Fire," *Houston Chronicle*, October 30, 1991.

28. Mike Peters, "Raider of the Lost Orchid, Artist Lucas Johnson collects exotic species for the thrill of the hunt," *Houston Metropolitan* (February 1991).

29. Statement for press release, Contemporary Arts Museum, Houston, 1994.

Plastic Art in Motion: A Conversation with Lucas

This interview first appeared in Mujeres *magazine, Mexico City, January 26, 1968.*[1]

Translated from Spanish by Patricia Covo Johnson

The recent exhibition by Lucas Johnson at Misrachi Gallery gave us the opportunity to speak with the young North American artist, who has lived in Mexico for the last three and a half years.[2] He doesn't distinguish between painting, etching, lithography, sculpture, and drawing as mediums of expression. Since 1964 [actually 1962] he has shown in Houston, San Francisco, Washington [D.C.], Biloxi, Cambridge, Philadelphia, and various cities in Mexico— Monterrey, San Luis, and Acapulco—as well as in Mexico City at the Instituto Mexicano Norteamericano de Relaciones Culturales, Instituto de Cultura Hispánica, and at the galleries May Brooks, Pecannins, Sagitario, and Misrachi.

Lucas is an artist with a vigorous personality who knows his craft well and who possesses a profoundly spiritual sense of life, a sense that compels him to decipher life's mystery, feeling the need to recreate, through symbols, the fortuitous magic that determines real events, [all of which is] manifest in his desire for timelessness, for a new sense of the world, and to liberate the spirit.

Mujeres: Why did you choose the plastic arts as your expressive medium?

Lucas Johnson: Because of its mystery. To break its boundaries is essential to me. When you are dealing with the spoken or written language, everyone interprets it his own way. But in painting, for example, [interpretation] isn't a problem in that sense. All responses [to art] are important and [they] establish the communication every human being seeks. In the visual arts, there is no problem of semantics.

M: Do you think your language has passed through different stages?

LJ: I can't confirm that, but I can tell you there have been three important moments [in my development as an artist]: When I faced the mystery of life, which no one understands; when I began to paint and express what I understood; and finally, having exhausted what I understood, when I began to decipher the mystery I am passionate about.

M: Do you know what you want to [accomplish] when you express yourself?

LJ: Yes. To show I have a social conscience. In every one of my works, you will always find [an expression of] my relationship with society, not in the personal sense, but in my preoccupation with what is human or what reveals a lack of humanity. I mean, I try to express myself as a human being, at the level of all men, and to reject the lack of humanity towards our fellow man.

M: What does painting, etching, drawing mean to you?

LJ: Life. I'm interested in the history of figure painting. I want to contribute to it. [I want to] experiment with new techniques and new materials.

M: What techniques do you use?

LJ: Many varied ones. Collage, lithography, drawing, copper etching, oils, acrylics, etc. But when I sculpt, I use stone.

M: When you grab the pencil, burin, or brush, do you know what the result will be?

LJ: All I know is the theme. The rest is unpredictable.

M: Are you a pessimist?

LJ: Not at all. I think I am an incorrigible optimist. Life, such as it is, saddens me, but hope never abandons me. In spite of so many ugly things, I can't help being optimistic. I have faith, enormous faith, in spiritual values. That frame of mind often translates into humor.

M: Do you subscribe to a rigorous discipline in your work?

LJ: I am an idiot. I will work without resting, without a schedule. I begin to paint at six in the morning every day. I generally work fifteen hours a day. Art, to me, is working constantly.

M: Is your goal to be a better painter than anybody else and to make money, or on the contrary, is your goal expressing the world as you see it and reflecting on it?

LJ: An artist needs a little practical sense to cover essential needs. But basically I paint for myself, not for fame. It's impossible in this world for there to be two [Pablo] Picassos, for example. What's important to me more than fame and fortune is resolving my own problems through painting.

M: Are you anguished or satisfied? I mean, in terms of solving the problems of painting as expressions of yourself.

LJ: I'm rarely satisfied with what I do. The only thing I'm sure of is that each time I finish a work, I find I've done something better than before. I think I'm on the rise, but that doesn't mean I've accomplished what I want. There's always something else to go for.

M: So, what is most important to you?

LJ: Looking for new and more profound symbols each time, ones with the deepest content and significance. Art for me, more than about imagination, is about the problem of the internal life, the spiritual values.

M: Do you consider yourself an artist of today?

LJ: Insofar as I belong to, and am to a certain point a product of, the time I live in. However, my passion is for many artists of the past, like [Mathias] Grunewald, [Jan] Brueghel, Fra Angelico, and [Hieronymus] Bosch, who demonstrated that, having developed painting methods to represent reality in a [believable] form, [painting] could, inversely, serve to reflect things no one had ever seen.

M: Are you mystic?

LJ: To a certain point. It's better to say I have a profound religious sense, which doesn't mean I belong to any church. My ambition is to fuse with a transcendent reality.

M: Is art in some way a final stage on the path to liberation?

LJ: Undoubtedly. There are many paths that lead us to liberation. For example, a passive [thoughtful] life that allows us to reclaim innocence. The life of a vagabond is also liberating, as is art. For me, painting is nothing other than an expression of freedom. What's important for me as an artist is to feel free, without compromise or alienation.

M: In your paintings, why the constant image of figures curled like a fetus in the womb?

LJ: With that I try to symbolize the state of being half-alive, like [being] in a catatonic state. There is no consciousness of real life. [People like that] live superficially. They are not capable of crossing the line between the physical life and the life of the spirit, of searching for a life that is constant and uninterrupted.

M: Why?

LJ: Because living in our time is easier than ever before. It seems that people today find solutions without effort and as a consequence forget how to think and even to feel.

M: Should an artist be political?

LJ: Evidently, but only if he's honest. I am a socialist, a social idealist who doesn't subscribe to any of the socialist parties.

M: What matters to you most, the content or the form of a painting?

LJ: Content is the most important. But technique and style are the ways to express it, though, sometimes content changes the form.

M: What is the meaning of the clocks and the fish that appear in so many of your works?

LJ: They are symbols. The clock symbolizes time. I change the hours to signify that time is not measurable for me: it's abstract, atemporal. The fish are symbols of a primitive Christianity—that socialism I care about—but on the other hand, because the dove is so overused, [the fish] are emblems of peace. In some ways it's a contradictory symbol: it's the form of primitive life—life began in the sea—and the first moment of human life, of Adam and Eve. For me, the fish symbolizes freedom. The ocean [is] a seemingly limitless space where peace moves in an almost infinite environment. I've always been fascinated by the sea. I've traveled around the world looking for the sea. Water is a mystery—light and darkness at the same time. Regarding the figures you called the fetus in the womb, that has symbolic meaning, too. Actually, they find themselves in an egg cut in half. They are beings who are afraid and feel protected by the shell; they don't live fully but, as I said, in a catatonic state. They are capable of living, but prefer to remain in this state, to close their eyes because that is simpler and easier.

M: Why do you live in Mexico?

LJ: Because I like it. Here I have peace and tranquility, two things I need to work comfortably. On the other hand, Latin Americans are naturally full of life, where the people in my country are dead as a consequence of the massive concentration [of population], not to mention pollution.

NOTES

1. "Plástica en Movimiento: Conversación con Lucas" ["Plastic Arts in Motion: Conversation with Lucas"], *Mujeres* 206 (January 25, 1968). *Mujeres* was a magazine edited by Marcelina Galindo Arce and published in Mexico City, 1958–1982. Despite diligent efforts, the publisher of the current volume was unable to locate representatives of the original publisher of *Mujeres*.

2. At the time of the interview, Johnson actually had lived in Mexico for five and a half years.

b. 1940, Hartford, Connecticut

d. 2002, Houston, Texas

Solo Exhibitions

2004
"Lucas Johnson: In Memoriam," Rockport Center for the Arts, Rockport, Texas

2003
"A Selection of Paintings & Works on Paper," Moody Gallery, Houston

2002
"Prints and Drawings 1966–2001," Redbud Gallery, Houston

2001
"The Orchid Paintings and Other Still Lifes," Museum of East Texas, Lufkin

1999
"Laelias, Schomburgkias and Other Still Lifes," Moody Gallery, Houston

1997
"The Belfast Drawings," Fenderesky Gallery, Belfast

1996
"Drawings from the Underworld," Art Museum of South Texas, Corpus Christi

"Lucas Johnson," Mulcahy Modern Gallery, Dallas

"Lucas Johnson: A Survey," University of Texas at San Antonio, Division of Art & Architecture Art Gallery, San Antonio

"Texas Artist of the Year," Art League of Houston

1995
"Lucas Johnson," Moody Gallery, Houston

1994
"Drawings from the Underworld," Contemporary Arts Museum, Houston, and Galveston Arts Center, Galveston, Texas (catalogue)

"Lucas Johnson," Moody Gallery, Houston

1993
"Recent Etchings," Moody Gallery, Houston

"Recent Paintings and Works on Paper," Houston Festival, Compass Bank, Houston

1991
"Recent Paintings," Moody Gallery, Houston

1990
"Drawings," Museo Ex-Convento del Carmen, Guadalajara, Mexico

1988
"Recent Drawings," Moody Gallery, Houston

1987
"Drawings from the Gulf Coast Estuary Series," Serpentine Gallery, London

1985
"Paintings and Drawings," Moody Gallery, Houston

1982
"Recent Paintings and Monotypes," Moody Gallery, Houston

1981
"Recent Paintings," Union Planters Bank Art Gallery, Memphis

1980
"Recent Paintings and Drawings," Moody Gallery, Houston

1979
"Íconos de Oaxaca," Moody Gallery, Houston

1978
"Lucas Johnson," Covo de Iongh, Houston

"Lucas Johnson," Galería Arvil, Mexico City

1977

"Drawings," University of Houston at Clear Lake, Texas

"Lucas Johnson," Moody Gallery, Houston

1976

"The Louisiana Paintings," Moody Gallery, Houston

"The New Mexico Paintings," Covo de Iongh, Houston

"Lucas Johnson," College of the Mainland, Texas City, Texas

1974

Galería de Arte Misrachi, Mexico City

1972

Galería de Arte Misrachi, Mexico City

1971

"Lucas Johnson," David Gallery, Houston

"Lucas Johnson," Gotham Book Mart and Gallery, New York

1970

"Lucas Johnson," David Gallery, Houston

Galería de Arte Misrachi, Mexico City

1969

"Lucas Johnson," David Gallery, Houston

1968

"Lucas Johnson," David Gallery, Houston (catalogue)

1967

Galería Edan, Acapulco, Mexico

Galería Sagitario, Mexico City

Instituto Mexicano Norteamericano de Relaciones Culturales, Mexico City

"Lucas Johnson," David Gallery, Houston

"Lucas Johnson," William Sawyer Gallery, San Francisco

1966

Galería Sagitario, Mexico City

Instituto Mexicano Norteamericano de Relaciones Culturales, Mexico City

"Lucas Johnson," David Gallery, Houston

1965

Galería Chapultepec, Mexico City

Instituto de Cultura Hispánica, Mexico City

1964

"Drawings," Woodstock, New York

Instituto Mexicano Norteamericano de Relaciones Culturales, Monterrey, Mexico

Instituto Mexicano Norteamericano de Relaciones Culturales, San Luis Potosí, Mexico

Group Exhibitions

2005
"David McManaway and Friends," The Menil Collection, Houston

"The Natural World," Beeville Art Museum, Beeville, Texas

2004
"Perspectives @ 25: A Quarter Century of New Art in Houston," Contemporary Arts Museum, Houston (catalogue)

"Texas Vision: The Barrett Collection," Meadows Museum, Dallas (catalogue)

2003
"Animals," ArtCar Museum, Houston

"The Potent Line," Williams Tower Gallery, Houston

2002
"Art League of Houston Celebrates Texas Artists of the Year," Art League of Houston

"Houston Works," ARTCO Gallery, Leipzig, Germany (catalogue)

"Project Phoenix," Redbud Gallery, Houston

2001
"Our Crowd Collects," Margolis Gallery, Congregation Beth Israel, Houston

2000
"Crossing State Lines: Texas Art from the Museum of Fine Arts, Houston," Museum of Fine Arts, Houston

"Print Artists: Tembo/Cerling Print Studio, Houston," Stewart Gallery, Boise, Idaho

"Sextablos: Works on Metals, Houston," Redbud Gallery, Houston (traveling)

"25 Years," Moody Gallery, Houston

"Works on Paper," DBerman Gallery, Austin, Texas

1999
"The Aquarium Show," Galveston Arts Center, Galveston, Texas

"Drawings / Prints," Mulcahy Modern Gallery, Dallas

"Goliad: A Cultural Convergence," Presidio La Bahia, Goliad, Texas (catalogue)

"Three From Texas, USA," Upriver Gallery, Chengdu, China

1998
"American Images: The SBC Collection of Twentieth-Century American Art," Austin Museum of Art, Austin, Texas

"Portrait Show," West End Gallery, Houston

Two-Person Exhibition, Mulcahy Modern Gallery, Dallas

"Works on Paper," Mulcahy Modern Gallery, Dallas

1997
"American Images: The SBC Collection of Twentieth-Century American Art," Museum of Fine Arts, Houston

"AMST Collects in the Modernist Era 1972–1997," Art Museum of South Texas, Corpus Christi

Art Institute of Houston

"The Best of Houston's Print Makers," Museum of Printing History, Houston

"Classically Inspired," Hooks-Epstein Galleries, Houston

"Establishment and Revelation," Dallas Visual Arts Center, Dallas (catalogue)

"Flora Bella," Galveston Arts Center, Galveston, Texas

"If The Stones Could Speak . . . ," O'Kane Gallery, University of Houston–Downtown, Houston (catalogue)

"Twelve From Texas," M B Modern, New York

"Spring Sampler: Three Houston Galleries," Transco Tower, Houston

1996
"Art and Art Adventures," Auction, Galveston Arts Center, Galveston, Texas

"Cerling Etching Studio: The First 5 Years, 1990–1995," Transco Gallery, Houston, and Galveston Arts Center, Galveston, Texas

"Interplay: Celebrating Pablo Neruda and His Poetry," Slover McCutcheon Gallery, Houston

"Manif II," Unna Gallery, Seoul (catalogue)

"Rediscovering the Landscape of the Americas," Gerald Peters Gallery, Santa Fe (catalogue)

"Summer Group Exhibition," State Thomas Gallery, Dallas

"Texas Art for Russia," Art League of Houston

"32 Texas Artists," UT Houston Health Science Center Gallery, Houston

1995
"Art Journeys," Art Museum of South Texas, Corpus Christi

"Convergence," Davis/McClain Gallery, Pennzoil Place, Houston

"Drawing from Strength," Transco Tower Gallery, Houston

"Figuration," Virginia Miller Galleries, Coral Gables, Florida

"Genesis in Fire: Works from the Green Mountain Foundry," Glassell School of Art, Museum of Fine Arts, Houston (brochure)

"Texas Myths and Realities: Selections from the Permanent Collection," Museum of Fine Arts, Houston

1994

"The Heights Exhibition," Lambert Hall, Houston

"Landscape Without Figures," Hooks-Epstein Galleries, Houston

"2nd Annual Sculpture on the Green," Omni Hotel, Houston

"Stories," Moody Gallery, Houston

1993

"Conventional Forms/ Insidious Visions," Glassell School of Art, Museum of Fine Arts, Houston

"Dreams and Imagination," Transco Gallery, Houston

"Endangered," Art League of Houston

"Fur, Fins, Feathers and More," Galveston Arts Center, Galveston, Texas

"Houston in Hope," The Faith and Charity in Hope Gallery, Hope, Idaho

"Making Their Mark," Houston Festival, NationsBank, Houston

"Seeing the Forest Through the Trees," Contemporary Arts Museum, Houston.

"Talleres en Fronteras: An Exhibition of Contemporary Art from South Texas and Baja California," Weil Gallery, Corpus Christi State University, Corpus Christi, Texas; University of Texas at El Paso; Universidad Autónoma de Baja California, Mexicali; Centro Cultural, Tijuana, Mexico (catalogue)

"Texas Contemporary: Acquisitions of the 90's," Museum of Fine Arts, Houston

1992

"New Texas Art," Cheney Cowles Museum, Spokane, Washington; and Boise Art Museum, Boise, Idaho

1991–92

"Island Inspired," Stephen F. Austin University, Nacogdoches, Texas; Transco Tower Gallery, Houston; and Galveston Art Center, Galveston, Texas

1991

"Eye to Eye," Transco Gallery, Houston

"Is there still life in the still life, or is nature morte? Part II," Galveston Art Center, Galveston, Texas

"Shadow Images," Hooks-Epstein Gallery, Houston

"Small Landscapes," Inman Gallery, Houston

"The War Show," Lanning Gallery, Houston

1990

"Direct References: Drawings by Texas Artists," Glassell School of Art, Museum of Fine Arts, Houston

"15 Year Anniversary Exhibition," Moody Gallery, Houston

"The Inspiration of Music," Scottsdale Center for the Arts, Scottsdale, Arizona

"1960–1990," Galería de Arte Misrachi, Mexico City (catalogue)

"Tradition and Innovation: A Museum Celebration of Texas Art," Museum of Fine Arts, Houston

1989

"Another Reality," Hooks-Epstein Gallery, Houston; Arkansas Arts Center, Little Rock; and McNay Art Institute, San Antonio (catalogue)

"The Artist's Eye: Fourteen Collections," DiverseWorks, Houston

"Drawing Conclusions," Southwest Texas State University, San Marcos

"Fourth Invitational Plate Show," Judy Youens Gallery, Houston

"Looking at Color," Transco Gallery, Houston

"Messages from the South," Sewall Art Gallery, Rice University, Houston

"Monotypes," Moody Gallery, Houston

Moody Gallery Exhibition, Stephen F. Austin University, Nacogdoches, Texas

"Social Concerns—Can Religion Make a Difference?" Margolis Gallery, Congregation Beth Israel, Houston

"Texas Art Celebration '89," Cullen Center, Houston

"Texas Realism," Art Museum of Southeast Texas, Beaumont

1988

"Conscience and Content," Art League of Houston

"Drawn from Life: Contemporary Interpretive Landscape," Sewall Art Gallery, Rice University, Houston (catalogue)

"The Fish Show," Brent Gallery, Houston

Four-Person Drawing Exhibition, Janus Gallery, Santa Fe

"Houston '88," 1600 Smith in Cullen Center, Houston

Moody Gallery Group Exhibition, Cumberland Gallery, Nashville

"One + One: Collaborations by Artists and Writers," Glassell School of Art, Museum of Fine Arts, Houston (catalogue)

"Texas Artists," Moody Gallery, Houston

"Third Annual Invitational Plate Show," Judy Youens Gallery, Houston

"Twentieth-Century Art in the Museum Collection: Direction and Diversity," Museum of Fine Arts, Houston

"Zoomorphism: Animals in Art," Trammell Crow Center, Dallas

1987
"College of the Mainland Faculty Selects," College of the Mainland Gallery, Texas City, Texas

"Images on Stone: Two Centuries of Artists' Lithographs," Blaffer Gallery, University of Houston (catalogue)

"Line and Form: Contemporary Texas Figurative Drawing," Art Museum of South Texas, Corpus Christi

"Third Coast Review: A Look at Art in Texas," Aspen Art Museum, Aspen, Colorado (catalogue)

"Toy Show," Nave Museum, Victoria, Texas

"Works on Paper from Moody Gallery," Nave Museum, Victoria, Texas

1986
"Cinq X Cinq Houston," Galerie Dario Boccara, Paris (catalogue)

"Collaborators: Artists Working Together in Houston 1969–1986," Glassell School of Art, Museum of Fine Arts, Houston

"Dead Days 1986," Blue Star Art Space, San Antonio

"Houston Printmakers," Goethe Institute, Houston (sponsored by the Art League of Houston)

"Prisoners of Conscience," Amnesty International Exhibition and Auction, DiverseWorks, Houston

"Texas Time Machine," Cullen Center, Houston (catalogue)

1985
"Fresh Paint: The Houston School," Museum of Fine Arts, Houston, and P.S. 1 Contemporary Art Center, Long Island City, New York (catalogue)

"The New Nude," Midtown Art Center, Houston

"One Up," Lawndale Annex, University of Houston

"Printmakers and Their Presses," Houston Public Library, Houston

"Spectrum South: The Malone and Hyde Collection of Contemporary Art," Tennessee State Museum, Nashville

"10 Year Anniversary Exhibition," Moody Gallery, Houston

"Texas Artists: A Group Exhibition," Moody Gallery, Houston

1984
"Artists and Models Ball," Hyatt Regency Hotel, Houston

"Painterly Texas Monoprints," Amarillo Art Center, Amarillo, Texas

"1984 Show," 2 Houston Center, Houston (sponsored by Houston Women's Caucus for Art) (catalogue)

1983
"Altars/Labyrinths—Installations for 'Dia de la Muerte,'" Zero Alternative Space/Tejano Artist Gallery, Houston

"Art from Houston in Norway," Stavanger Museum, Stavanger, Norway (catalogue)

"Colorado: State of the Arts—Selections from Shark Lithography Ltd.," Denver Art Museum, Denver

"Hearts and Flowers," The Art Center, Waco, Texas

"Little Egypt Enterprises," Harris Gallery, Houston

"A Peaceable Kingdom: Animals in Art," Museum of Fine Arts, Houston

"A Salute to Houston Artists," Midtown Art Center, Houston

"Thirteen Artists: A Look at Houston," Georgia State University Art Gallery, Atlanta

1982
"New American Graphics 2," Madison Art Center, Madison, Wisconsin (catalogue)

1981
"Impressions of Houston," O'Kane Gallery, University of Houston

"Little Egypt—Waterworkshop," Roberto Molina Gallery, Houston

"Moody Gallery at Linda Durham," Linda Durham Gallery, Santa Fe

1980
"Annual Faculty Exhibition," Glassell School of Art, Museum of Fine Arts, Houston

"Houston Area Exhibition," Sarah Campbell Blaffer Gallery, University of Houston

"Inside Texas Borders," Corpus Christi State University, Corpus Christi, Texas

"Recent Work by Artists of the Southwest," Gensler and Associates, Houston

1979
"Doors: Houston Artists," Alley Theatre, Houston, and The Art Center, Waco, Texas (catalogue)

"Fire," Contemporary Arts Museum, Houston (catalogue)

"Ten from Houston," The Art Center, Waco, Texas

"Texas Printmakers," Galveston Art Center, Galveston, Texas

"Twenty-first National Print Exhibition," Brooklyn Museum, Brooklyn, New York (catalogue)

1978
"Cowboys, Indians, and Settlers," The Art Center, Waco, Texas (catalogue)

1977
"Artists Make Toys," Art Museum of South Texas, Corpus Christi

"Graphic Collective," ISSSTE Building, Mexico City

"Six Painters Southwest," Museum of Art, University of Oklahoma, Norman (catalogue)

1975
"Master Drawings," Covo de Iongh, Houston

"Six Artists," Moody Gallery, Houston

"Houston Area Exhibition," Blaffer Gallery, University of Houston

1974
Bienal de Morelia, Morelia, Michoacán, Mexico

"Graphic Collective," Compañía de Luz y Fuerza, Mexico City

1972
Galería de Arte Misrachi, Mexico City

Janus Gallery, Santa Fe

1971
David Gallery, Houston

Galería de Arte Misrachi, Mexico City

Gotham Book Mart and Gallery, New York

"Salón de Independientes," Universidad Autónoma de México, Mexico City

1970
David Gallery, Houston

Galería de Arte Misrachi, Mexico City

"Salón de Independientes," Universidad Autónoma de México, Mexico City

1969
"Manscape: Collection of Selden Rodman," Fair Lawn Public Library, Fair Lawn, New Jersey; and Museum of Modern Art, San Francisco

1968
"Graphic Exhibition," Ponce Museum, Ponce, Puerto Rico

"Olympic Collective," Collection of the Mexican-American Institute, Mexico City

"Salón de Independientes," Universidad Autónoma de México, Mexico City

1967
Boston Print Show, Boston

David Gallery, Houston

Galería Edan, Acapulco, Mexico

Instituto Mexicano Norteamericano de Relaciones Culturales, Mexico City

Philadelphia Print Show, Philadelphia

Traveling Group Exhibition, Smithsonian Institution, Washington, D.C.

Union Court Gallery, San Francisco

1966
"Collective Exhibition," Massachusetts Institute of Technology, Cambridge

David Gallery, Houston

Galería Edan, Acapulco, Mexico

Galería Sagitario, Mexico City

"Graphic Collective Exhibition," Pratt Institute, New York

Instituto Cultural Hispano, Mexico City

Mexican Art Annex, New York

Union Court Gallery, San Francisco

1965
New Orleans Museum of Art, New Orleans

Galería Chapultepec, Mexico City

Galería de Arte Misrachi, Mexico City

Galería Pecanis, Mexico City

"Realism from Four Studios," May Brooks Gallery, Mexico City

1964
"All Southern Collective Exhibition," Biloxi, Mississippi

Art Association, New Orleans

Cadmium Gallery, San Francisco

"Eight Draftsmen," May Brooks Gallery, Mexico City

"Graphic Collective Exhibition," May Brooks, Mexico City

1963
Art Association, New Orleans

1962
Galería May Brooks, Mexico City

Collections

Amarillo Art Center, Amarillo, Texas
Andrews and Kurth, Houston
Art Museum of Santa Cruz County, Santa Cruz, California
Art Museum of South Texas, Corpus Christi
Benjamin Franklin Library, Mexico City
Blanton Museum of Art (formerly Huntington Art Gallery),
 University of Texas, Austin
Brooklyn Library, Brooklyn, New York
Brooklyn Museum, Brooklyn, New York
Fibracel de Mexico, Mexico City
General Motors Foundation Permanent Traveling Collection
Greenville County Museum of Art, Greenville, South Carolina
Instituto Mexicano Norteamericano de Relaciones Culturales,
 Mexico City
J. P. Morgan Chase
Los Angeles County Museum of Art, Los Angeles
Malone and Hyde, Memphis
Massachusetts Institute of Technology, Cambridge
The Meadows Museum, Southern Methodist University, Dallas
The Menil Collection, Houston
The Mexican Museum, San Francisco
Museo José Luis Cuevas, Mexico City
Museum of Fine Arts at the Museum of New Mexico, Santa Fe
Museum of Fine Arts, Houston
Museum of Modern Art, Tel Aviv
National Museum, Warsaw
New Orleans Museum of Art (formerly Delgado Museum), New Orleans
San Antonio Museum of Art, San Antonio
San Francisco Museum of Modern Art, San Francisco
Smithsonian Institution, American Graphics Collection, Washington, D.C.
Toledo Museum, Oaxaca, Mexico
United States Embassy Permanent Collection, Mexico City
University of Houston Print Collection, Houston
University of Southern Illinois, Carbondale
Wichita Falls Museum, Wichita Falls, Texas
Wilson Industries, Houston

Teaching Posts/Workshops

2001
Instructor, Rice University, Houston

1994 and 1995
Judge, National Foundation for Advancement in the Arts, Visual Arts Panel, Miami

1988–91
Critique workshop, reviewing student's work in conjunction with faculty, University of Houston

1982
Instructor with David Folkman under the direction of Joel Feldman, School of Art, Southern Illinois University, Carbondale

1981
Painting workshop and lithography workshop with master printer Bud Shark, Summer Program, Anderson Ranch Art Center, Aspen, Colorado

1979–1980
Watercolor and drawing, Glassell School of Art, Museum of Fine Arts, Houston

Book and Periodical Covers and Illustrations

Antaeus, book nos. 5, 6, 7, 8, and 9. New York: Ecco Press, 1972.
Antaeus, no. 44 (Winter 1982).
Antaeus, 48 (Spring 1983).
Halpern, Daniel. *Life Among Others*. New York: Viking Press and
 Penguin Press, 1978.
Minnesota Review, vol. 10 (1970).
Mitchell, Roger. *Letters from Siberia and Other Poems*. St. Paul, Minn.: New
 Rivers Press, 1971.
Neruda, Pablo. *Early Poems—Pablo Neruda*. St. Paul, Minn.: New Rivers Press,
 1969. (*Minnesota Review*, vol. 9.)
"Otello," Houston Grand Opera program, January 1976.
Performing Arts Magazine (Houston) (February 1978).
Toward Winter, Harry Nash & Robert Bonazzi (eds.). Austin, Tex.: Latitudes
 Press, 1972.
Truesdale, C. W. *Cold Harbors*. Austin, Tex.: Latitudes Press, 1972.
Truesdale, C. W. *Master of Knives*. Houston: Hamman Publishing Co., 1970.
Truesdale, C. W. *Moon Shot*. St. Paul, Minn.: New Rivers Press, 1967.
Who's Who in American Art. New York: R.R. Bowker Co., 1973.

SELECTED BIBLIOGRAPHY

2004

Colpitt, Frances. "Regionalism Without Apology." *Artlies* (Summer 2004): 34–37 (illus.).

Perspectives@ 25: A Quarter Century of New Art in Houston. Exhibition catalogue. Houston: Contemporary Arts Museum Houston, 2004.

Pillsbury, Edmund P. *Texas Vision: The Barrett Collection, The Art of Texas and Switzerland.* Exhibition catalogue. Dallas: Meadows Museum, Southern Methodist University, 2004.

2002

Houston Works. Exhibition catalogue. Leipzig, Germany: ARTCO Gallery, 2002.

"In Memoriam." *Artlies* (Fall 2002): back cover (illus.).

2001

Greene, Alison de Lima. "Crossing State Lines: Texas Art from the Museum of Fine Arts, Houston." *MFAH Today* (January/February 2001): 30 (illus.).

2000

Gerst, David. "If I Ran The Whitney . . .," *Canvas* 3, no. 1 (Spring 2000): 20–21, 23–24.

Greene, Alison de Lima. *Texas: 150 Selections from the Museum of Fine Arts, Houston.* Exhibition catalogue. Houston: Museum of Fine Arts, Houston, 2000.

Johnson, Patricia C. "Beyond Borders." *Houston Chronicle*, September 24, 2000.

Sanders, Gail. "Works on Paper." *ArtLies*, no. 27 (Summer 2000): 51.

1999

Edwards, Jim. *ArtLies*, no. 24 (Fall 1999): 52–54.

Surls, James, and Susie Kalil. "Goliad: A Cultural Convergence." Exhibition catalogue. Goliad, Tex: Presidio La Bahia, 1999.

1998

Akhtar, Suzanne. "Artists Draw upon Fuzz, Politics to Present Symbolic Meanings." *Fort Worth Star-Telegram*, June 7, 1998.

Hill, Ian. "Lucas Johnson." *The Irish Times* (Dublin), January 17, 1998.

1997

Legacy, A History of the Art Museum of South Texas, AMST, Corpus Christi, 1997.

1996

American Images: The SBC Collection of Twentieth-Century American Art. New York: Harry N. Abrams, 1996.

Bradley, Deborah. "Houstonian's Work Clearly Heads in a Southerly Direction." *Dallas Morning News*, March 29, 1996, Guide section.

Edwards, Jim. "Lucas Johnson Exhibition Takes Viewers into Strange World." *Corpus Christi Caller-Times*, February 23, 1996.

Gussow, Alan, and Gayle Maxon-Edgerton. *Rediscovering the Landscape of the Americas.* Exhibition catalogue. Santa Fe: Gerald Peters Gallery, New Mexico, 1996.

Holmes, Ann. "Johnson Is 'Artist of the Year.'" *Houston Chronicle*, April 11, 1996.

1995

Johnson, Patricia C. "'Genesis in Fire' Exhibit Revels in the Versatility of Bronze." *Houston Chronicle*, December 27, 1995.

1994

Chadwick, Susan. "Artist Discovers Eloquence, Depth in the Underworld." *Houston Post*, December 11, 1994.

_____. "Artist's Day Has Been a Long Time Coming." *Houston Post*, December 2, 1994.

_____. "Huevos Artistas." *Houston Post*, May 18, 1994.

Holmes, Ann. "Johnson Projects 'Underworld' Imagery." *Houston Chronicle*, December 3, 1994.

Johnson, Patricia C. *Contemporary Art in Texas.* Sydney, Australia: Craftsman House, 1994.

Stellweg, Carla. *Lucas Johnson: Drawings from the Underworld (Dibujos del bajo-mundo).* Exhibition catalogue. Houston: Contemporary Arts Museum, 1994.

1992

Museo José Luis Cuevas. Mexico City: Secretaría de Educación Pública, 1992.

1993

Chadwick, Susan. "Review: Lucas Johnson Recent Etchings." *Houston Post*, March 12, 1993.

Kalil, Susie. "Lost in the Woods." *Houston Press*, September 9, 1993.

1991

Chadwick, Susan. "Houston Artist Returns to Realm of Painting in Exceptional Show." *Houston Post*, November 2, 1991.

McBride, Elizabeth. "Lucas Johnson Offers Bloody, Molten, Stony Paths of Life Fire." *Houston Chronicle*, October 30, 1991.

Peters, Mike. "Raider of the Lost Orchid, Artist Lucas Johnson Collects Exotic Species for the Thrill of the Hunt." *Houston Metropolitan* (February 1991): 21.

1990

Benjamin, Arturo. "Lucas Johnson nuevamente en México." *El Sol de México*, February 9, 1990.

Chadwick, Susan. "Mexican Art Show Fills Void." *Houston Post*, July 25, 1990.

Emerich, Luis Carlos. "Culture Clash." *Houston Chronicle*, February 16, 1990.

_____. "Lucas Johnson, en proyección de transparencias." *Novedades* (Mexico City), February 16, 1990.

Ennis, Michael. "Bold Strokes." *Texas Monthly* (April 1990): 134, 136.

1989

Berryhill, Michael. "Monotypes Reveal Individuality, Versatility of Artists." *Houston Chronicle*, June 9, 1989.

Chadwick, Susan. "Messages from the South." *Houston Post*, December 2, 1989.

Holmes, Ann. "What Artists Collect." *Houston Chronicle*, November 14, 1989.

Johnson, Patricia C. "Politics, Family Life Explored from Various Angles." *Houston Chronicle*, February 25, 1989.

1988

Chadwick, Susan. "Lucas Johnson at Moody Gallery." *Houston Post*, April 3, 1988.

Holmes, Ann. "Lucas Johnson." *Houston Chronicle*, April 19, 1988.

Houston Metropolitan Magazine (April 1988): 82 (illus.).

McBride, Elizabeth. "Houston Letter." *Artspace* (Fall 1988): 55–56.

_____. "In Love with Landscapes." *Houston Public News*, December 7, 1988.

1987

Ewing, Betty. "Expos." *Beaux Arts* (January 1987): 97.

_____. "These Americans in Paris Hit the Town with Art from Texas." *Houston Chronicle*, January 11, 1987.

Holmes, Ann. "There's Plenty Fishy about Lucas Johnson." *Houston Chronicle*, August 1, 1987.

1986

"Cinq Pour Cinq." *Houston Chronicle*, November 21, 1986 (illus.).

Johnson, Patricia. "Art: A Sampling of What's Available from Area Galleries." *Houston Chronicle*, December 14, 1986, Zest section.

Lemaire, Gérard-Georges. *Cinq X Cinq, Houston Texas.* Exhibition catalogue. Paris: Galerie Dario Boccara, 1986.

McBride, Elizabeth. "Three Houston Painters," *Artscene* 7, no. 12 (Spring 1986): 6 (illus.).

Seeman Robinson, Joan. *Texas Time Machine.* Exhibition catalogue. Houston: Cullen Center, 1986.

Tennant, Donna. "Reviews: Houston Letter." *Artspace* 7, no. 12 (Spring 1986): 53–54 (illus.).

_____. "Texas Review: Lucas Johnson." *New Art Examiner* (February 1986): 64.

1985

Everingham, Carol. "Fresh Paint: The Houston School." *Arts Magazine* (Summer 1985): 74–77.

Hauser, Reine. "Review: Hometown Bravura." *ArtNews* (Summer 1985): 103–104.

Holmes, Ann. "New Johnson Works Show Results of Self-Searching." *Houston Chronicle*, November 23, 1985.

Johnson, Patricia C. "Major MFA Show Defines and Celebrates 'Houston School.'" *Houston Chronicle*, January 26, 1985.

Kelly, Moira. "About Lawndale: 'One Up.'" *The Lawndale Inquirer* (October/November 1985): 23.

McEvilley, Thomas. "Double Vision in Space City." *Artforum* (April 1985): 52–56.

Reese, Becky Duval. "Is Regionalism Dead?" *Texas Trends in Art Education* 3, no. 1 (Fall 1985): 13–18.

Rose, Barbara, and Susie Kalil. *Fresh Paint: The Houston School.* Exhibition catalogue. Houston: Museum of Fine Arts, Houston; and Austin, Tex.: Texas Monthly Press, 1985.

1984

Holmes, Ann. "Exhibit to Recognize 'Houston School.'" *Houston Chronicle*, June 16, 1984.

1982

Fox, Catherine. "13 Artists: A Look at Houston." *Atlanta Constitution*, January 29, 1982.

Garver, Thomas and Warrington Colescott. *New American Graphics 2.* Exhibition catalogue. Madison, Wis.: Madison Art Center, 1982.

Holmes, Ann. "Starlite Drive-In Series." *Houston Chronicle*, December 18, 1982.

Scott, Edie. "The Serigraph: Alan O. Smith, Waterworkshop, Houston." *Southwest Arts* (February 1982): 94–99.

1981

Bell, David. "Moody Gallery at Linda Durham Gallery." *Albuquerque Journal*, August 30, 1981.

Johnson, Patricia. "Review: 'Impressions of Houston.'" *Houston Chronicle*, November 13, 1981.

LaBadie, Donald. "Lucas Johnson: Union Planters Art Gallery." *Memphis Commercial Appeal*, March 13, 1981.

1980

Crossley, Mimi. "Recent Paintings and Drawings, Moody Gallery." *Houston Post*, October 3, 1980.

Schjedahl, Peter. "Art and Money in the City of Future-Think." *Houston City Magazine* (February 1980): 46, 56.

Tennant, Donna. "Johnson's Works Reflect Mexico's Culture." *Houston Chronicle*, October 14, 1980.

1979

Crossley, Mimi. "Johnson, Goodnough, Benglis and the Museum School Faculty." *Houston Post*, January 26, 1979.

_____. "Portrait: Houston." *Portfolio* (August/September 1979): 86–88.

Moser, Charlotte. "Painter Explores Mystery, Poetry." *Houston Chronicle*, January 30, 1979.

Tennant, Donna. "Reviews: Exhibition Notes." *Artspace* (Spring 1979): 44.

1978

Crossley, Mimi. "Johnson, Stephan Rogalla Shows." *Houston Post*, May 12, 1978.

Joysmith, Toby. "Gallery Goer: The Inhuman Abstract." *The News* (Mexico City), July 2, 1978.

Lucas Johnson. Exhibition brochure. Houston: Covo de Iongh Gallery, 1978.

Moser, Charlotte. "Reality of Surrealism." *Houston Chronicle*, May 21, 1978.

Neuvillate, Alfonso de. "El expresionismo individual de Lucas Johnson." *Novedades* (Mexico City), June 17, 1978.

1977

"Lucas Johnson Show Will Hang Through December." *Newsletter,* (University of Houston at Clear Lake) (Fall 1977).

1976

Crossley, Mimi. "The Direct Route." *Houston Post*, March 21, 1976.

Moser, Charlotte. "Romanticism, Mexican Bars and Shirley Temple." *ArtNews* (May 1976): 94.

1974

Mendelsohn, Lotte. "Lucas Johnson." *Houston Town & Country* (December 1974/January 1975): 28–29.

Vromen, Galina. "Iconoclastic Painter—That's Lucas Johnson." *The News* (Mexico City), November 1, 1974.

1973

"Lucas Johnson: La Pintura, Como Camino Hacia la Libertad." *Excelsior* (Mexico City), March 7, 1972.

1972

"Gallery Notice." *Inter-American Travel News* (Mexico City), February 25, 1972.

1971

Freed, Eleanor. "The 1% Rule: 20th-Century Goya." *Houston Post*, February 7, 1971.

Holmes, Ann. "Fantastic Artists." *Southwest Art Magazine* (Fall 1971).

1970

Dolin, David. Review. *Houston Chronicle*, c. 1970.

Flores, M. A. "El pintor Lucas Johnson." *Revista Mexicana de Cultura, El Heraldo*, April 26, 1970.

Joysmith, Toby. "The Gallery Goer: Now the New Is Always Out of Date." *The News* (Mexico City), April 26, 1970.

"Lucas Johnson: A Free-Thinking Individual Who Speaks Through Art," *KPFT Newsletter* (October 18–31, 1970).

Stellweg, Carla. "Lucas Johnson Prepares Illustrations for a Book on Kafka." *Excelsior* (Mexico City), April 19, 1970.

_____. "La melancolía de Lucas Johnson." *Excelsior* (Mexico City), April 12, 1970.

1969

Ransom, Harry H., and Thomas Mabry Cranfill, eds. *Image of Mexico.* 2 vols. Austin, Tex.: University of Texas Press, 1969.

1968

"A Conversation with Lucas." *Mujeres* (Mexico City), ed. Marcelina Galindo Arce, no. 206 (January 25, 1968).

Freed, Eleanor. "All the World a Stage." *Houston Post*, February 25, 1968.

Marstal, Ramon. "Exposición de pinturas de la Nueva Ola." *Impacto* (Mexico City), no. 905 (1968): 30–35.

Rabilotta, Alberto. *El Artista.* Exhibition catalogue. Houston: David Gallery. 1968

1967

Anderson, Judith. "Lucas Johnson—Intriguingly Grotesque." *The News* (Mexico City), April 16, 1967.

Casis, Sally. "Lucas Johnson: A Free-Thinking Individual Who Speaks Through Art." *The News* (Mexico City), December 17, 1967.

"David Gallery." *Houston Chronicle*, c. 1967.

"David Gallery Takes It Seriously." *Houston Chronicle*, c. 1967.

Hobdy, D. J. "Lucas Johnson's Babies." *Houston Chronicle*, c. 1967.

Joysmith, Toby. "Johnson's Eclectic Promise." *The News* (Mexico City), April 30, 1967.

_____. "The Gallery Goer's Christmas List." *The News* (Mexico City), c. December 1967.

_____. "Lucas Johnson, Humanist." *The News* (Mexico City), January 15, 1967.

Nelken, Margarita. "La de Lucas #1." *Excelsior* (Mexico City), April 28, 1967.

_____. "La de Lucas #2." *Excelsior* (Mexico City), April 29, 1967.

1966

Denbow, Robert. "Folio by Local Artist Due Soon." *The News* (Mexico City), December 19, 1966.

Freed, Eleanor. "Humanist Painter." *Houston Post*, March 20, 1966.

Joysmith, Toby. "Drawings Shine at Sagitario." *The News* (Mexico City), August 7, 1966.

De la Serna, Jorge Crespo. "En el Campo de las Artes Plásticas." *Excelsior*, (Mexico City). c. 1966.

1965

Denbow, Robert. "May Brooks Gallery Features Four Man Show." *The News* (Mexico City), October 17, 1965.

L. Lucas Johnson. Brochure. Mexico City: Instituto Cultural Hispano-Mexicano, 1965.

Nelken, Margarita. "Colectiva en May Brooks." *Excelsior* (Mexico City), 1965.

HOUSTON ARTISTS FUND

Houston Artists Fund
Board of Directors

Jody Blazek

Joseph Havel

Gus Kopriva

Jane Lowery

Jack Massing

The Houston Artists Fund is an umbrella organization that serves as fiscal sponsor for projects related to the Houston arts community. Houston Artists Fund seeks to encourage art projects by affording artists the freedom to pursue their visions unfettered by administrative burdens. As fiscal agent, the Fund maintains financial records, supervises disbursal of funding, files required tax reports and disclosures, and maintains federal tax-exempt status to assure deductibility of donations in support of artists' projects.

CONTRIBUTORS

Walter Hopps

Walter Hopps (1932–2005), Founding Director of The Menil Collection, Houston, was recognized internationally for his inventive and groundbreaking exhibitions. As Director of the Pasadena Art Museum, Pasadena, California, Hopps produced a number of legendary exhibitions, taking a fresh and independent look at the art historical canon. In 1962 he curated the first museum exhibition of Pop Art, "New Painting of Common Objects," and over the next three years he assembled the first retrospectives of Marcel Duchamp and Joseph Cornell and the first American retrospective of Kurt Schwitters.

Hopps's work as a curator was influential and far-ranging. In 1965 he was Commissioner for the American Pavilion at the São Paulo Bienal, featuring the art of Barnett Newman and six other artists, including Frank Stella and Robert Irwin. In 1972 at the Venice Biennale, he included the challenging photography of Diane Arbus along with the work of five other artists. This marked the first presentation of photography as an art form at the Biennale. Later exhibitions include the 1976 retrospective of Robert Rauschenberg, organized by the National Museum of American Art at the Smithsonian Institution, Washington, D.C., for the nation's Bicentennial. Hopps co-organized a second Rauschenberg retrospective in 1997 for the Solomon R. Guggenheim Museum, New York, and The Menil Collection, Houston, and the James Rosenquist retrospective for the same museums in 2003. Hopps also curated the major Edward and Nancy Reddin Kienholz retrospective for the Whitney Museum of American Art, New York, in 1996. Throughout his distinguished career, Hopps maintained his close and committed relationships with artists.

Patricia Covo Johnson

Patricia C. Johnson was born in Mexico City where she lived until moving to the United States in 1972. She earned a Bachelor of Arts degree in art history from the University of California–Santa Barbara.

She has been the art critic for the *Houston Chronicle* since 1981. Prior to joining the *Chronicle*, she was assistant director of Galería de Art Misrachi in Mexico City (1969–71) and owner/director of Covo de Iongh Galley in Houston (1975–78). Johnson has written articles on Houston and Houston artists for several publications, including *Sculpture International* (Washington D.C.), *Artspace* (Albuquerque), and *Southern Living* (Atlanta), and contributes to *ARTnews* (New York). She also wrote the catalogue on Mexican prints and drawings for the exhibit she curated for the Museum of Fine Arts, Houston, in 1983. She is the author of *Contemporary Art in Texas*, published by Craftsman House (1994), with an introduction by Walter Hopps.

Ms. Johnson received first place in the art history category, Manufacturers Hanover–Art/World Awards for Distinguished Newspaper Art Criticism, in 1986 and again in 1993. In October 1991, she was one of twenty-five national fellows invited to the first Art Critics' Conference sponsored by the National Gallery of Art in Washington, D.C. She has twice been nominated for a Pulitzer Prize in criticism.

Edmund P. Pillsbury, Ph.D.

Dr. Edmund P. Pillsbury is former Director of the Meadows Museum at Southern Methodist University, Dallas (2003–2005), and of Fort Worth's Kimbell Art Museum (1980–1998). Under his direction, major works by such artists as Fra Angelico, Caravaggio, Murillo, Velázquez, Cézanne, Miró, and Picasso augmented the Kimbell's collection of Old Masters, and important pieces of Asian, Egyptian, African, and other schools of art improved the range and importance of the museum's non-western holdings.

Dr. Pillsbury received a B.A. in art history from Yale University in 1965 and earned a doctorate in Italian Renaissance art from the University of London's Courtauld Institute of Art in 1973. His professional training began at the National Gallery of Art, Washington, D.C., and continued at The Cleveland Museum of Art. In 1972 he joined the Yale University Art Gallery as its first curator of European art and as a lecturer in the art history department, where he later became an adjunct professor. During his nine years at Yale, he continued to teach and write in the field of Italian art, while editing works on a variety of subjects. In addition, from 1976–1980, he served as Director of the Yale Center for British Art and CEO of the Paul Mellon Centre for Studies in British Art, London.

Dr. Pillsbury has been the recipient of numerous grants and fellowships and has lectured at universities and museums worldwide. He has also served on numerous boards, including the International Advisory Board of the State Hermitage Museum in St. Petersburg, Russia. Dr. Pillsbury is one of the few museum professionals elected to the American Academy of Arts and Sciences.